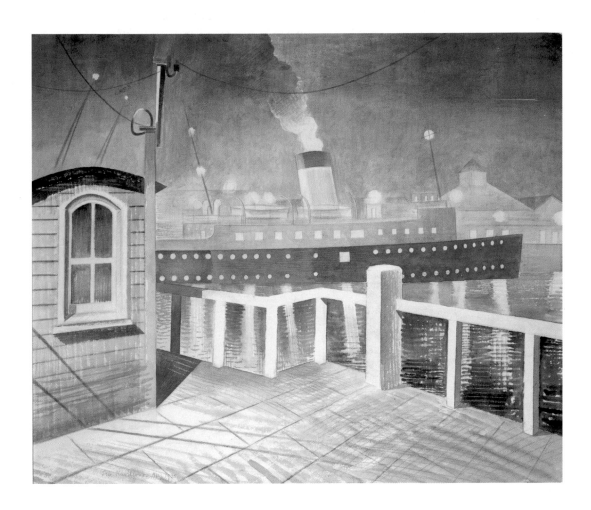

Eric Ravilious

Channel Steamer
c1930s
Watercolour
Private Collection,
The Bridgeman Art Library

About the Author: Julian Freeman is an art historian, author
and critic. A regular reviewer for The Art Book magazine, an
occasional reviewer for other art glossies, and the author and
co-author of Art: A Crash Course and Design: A Crash Course,
he writes the way he teaches, with an irreverence for aesthetic
mystique cultivated over time, but which doesn't quite obscure
the love he has for his subject - British Art.

British Art A walk

Southbank Publishing

round the rusty pier

This edition published in 2006 by Southbank Publishing
21 Great Ormond Street,
London WC1N 3JB

© Julian Freeman 2006

The right of Julian Freeman to be identified as the author
of this work has been asserted in accordance with the
Copyright, Designs and Patents Act 1988.

A CIP catalogue record for this book is available from the
British Library.

ISBN 1 904915 05 1
EAN 978 1 904915 05 8

Design and Typeset by George Lewis
Printed and bound in Italy by L.E.G.O. Spa, Vicenza

Julian Freeman

British Art

southbank
publishing

Acknowledgements

Nothing in life or in art is straightforward, least of all writing a book, for Fate will always intervene. In this case, just as I was beginning, my eyes required major readjustment, not once, but twice. Thanks are therefore not enough to signify my enormous debts, first, to Steven Borkum for watching over my peepers as he has done for years, and for waving warning flags; and then to Mr Christopher Liu and Dr Mike Eckstein for variously rearranging my vision – and, one suspects, my perception – into something functioning and effective. Books are karmic, formative things, and couldn't evolve without human contact: over time and in different ways, Helgi Águstsson, Arsenal Football Club, Giles Auty, Sam Barsam, Kjell-Åke Berglund, Tony Bowen, Nick Bremer, Dylan Carbonnell-Ferrer, Robin Cohen, Dennis Creffield, the late Joe Darracott, Wendy Dash, Olafur Égilsson, Dr Adolfo Gracia, Irving Grose, Vincent Kosman, David Lee, Martin and Sylvia Levy-Nichols, Rachel Lowden, Anne Morris, Arthur Oppenheimer, Dr Winston Pickett, Professor Ronald Pickvance, Peter Rose, Matt Thompson, Professor Michael Tucker, Angela Weight and Frans Widerberg have made unique contributions to this one. Those of them who knew of this project possibly thought I'd never be done with it, but all deserve espe-

cial thanks. Alison Atkinson and Nadia Edmond at the University of Brighton 7 allowed me to develop a Post-Graduate Certificate in Education along lines that have proved instrumental to the outcome of some chapters and, at the Imperial War Museum London, Mike Moody, Jenny Wood, Helena Stride and Roger Tolson, (with other colleagues at IWM Duxford and IWM North in Manchester) have influenced my activities as an exhibition organiser and as a teacher, or both, over time. I am particularly grateful to the staff of the Iniva Library for the opportunity to research their periodicals collection at very short notice. At the Fine Art Society Ltd, London, Andrew MacIntosh Patrick, Peyton Skipwith and Simon Edsor have been unfailingly courteous for years, when I knew I was being a nuisance; more recently, valuable aid and assistance has been given by John Davies, at the John Davies Gallery, Stow-on-the-Wold, Gordon Samuel at Osborne Samuel and by staff at many other private and municipal galleries in the UK. Maurice Blik, Sonia Boyce, Ken and Ruth Campbell, Jackie Clements, John Long, Ian Potts, David Prentice, Robin Richmond, Chris Stevens and Bob White have all kindly provided images for this book, and my very warmest thanks are due to them for their friendship, trust and support. In their different ways, Judith Hawxwell and the musician Paul Tiernan have kept me going in adversity: it is impossible to quantify my respective debts to them. *British Art* would not look the way it does without the excellence of George Lewis's design, the determined support of Nicola Pomery, always indefatigable in her picture research, and of Frances Follin of Genesys, who arrived with editorial cavalry in the nick of time, and whose good humour and patience have been superb. The wonderful Sue Ward nurtured my critical writing and got me into this pickle, and Paul Torjussen at Southbank has somehow managed to oversee the progress of this book with the type of directorial patience inadequately described by the word 'infinite'. I cannot begin to thank either of them enough, but they may have other ideas.

This book is for Estelle, Graham, Alanna and Sarah Freeman, who gave me the love and unselfish encouragement to complete it. It is dedicated to the memory of Keith Clements, 1932–2003, British artist, scholar and dearest friend, who is undoubtedly out there somewhere, laughing at the whole thing.

Julian Freeman
Brighton and Eastbourne, 2005–2006

1
Border Crossings:

A Foreword

Bloody foreigners. Every country in the world has an art history enriched at some time, and in some way, by people who arrive on a long- or short-stay basis, unheralded, as invaders or by invitation, as speculators or investors, or just running for their lives. Inevitably, their cultural baggage comes with them, especially the visual material, to be dispersed like seed: like burrs that cling to the clothing, to fall and become absorbed into the soil of the local cultural back-yard. It's the same in Britain. It always was. Romans. Saxons. Jutes. Danes. Franks. Vikings. Huguenots. Dutch. More Germans. Irish. Italians. Russians. And the rest. They come and go, and sometimes the memory lingers on, to trans-form the superficial into the meaningful, so that before you can bat an eyelid, whole visual traditions are established. Something happens that alters the scene, and these days it seems to happen relatively regularly. This is the basis of British art. Quite a coup, eh?

Such socio-visual interchange is to a large extent the result of North Atlantic geography, and this book is about its still-unfolding results. Just what does make up British art nowadays? What does, what can the term mean now, espe-cially in a twenty-first century in which 'art without frontiers' is being talked-up like nobody's business, by those who would consign national identity – in visual culture at any rate – to the bottom of the heap, in favour of... what? Borderless blandeur? Contemporary critical thinking on the subject remains inconclusive, but there are more than a few commentators who would say that the driving force of art in Britain has passed from the individual into the hands of the state; that what was and still might be achieved by individuals, from all castes and regions, now tends to be governed by the machinery of bureaucracy. In itself, this doesn't augur especially well, but the fat lady is still in the dress-ing room, and so nothing is lost.

Art in a Babylon

For many immigrant artists, the studio conventions of the Renaissance and Enlightenment are hurdles to be overcome at an early stage: they've governed British art education for centuries, but again, it depends where you received your training, if indeed you received any, and who the trainer was. And anyway,

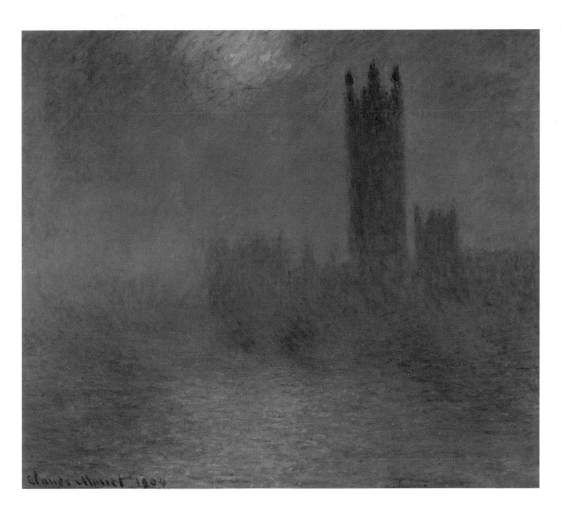

Claude Monet
The Houses of Parliament, London with the
sun breaking through the fog
1904
oil on canvas
81 x 92 cms
Musée d'Orsay, Paris, France.
The Bridgeman Art Library

The 'Mother of Parliaments' executed
by Monet and first exhibited in 1904: 37
paintings resulted from visits to London
between 1899 and 1901

whom do you serve? Who are your audience? Whom do you represent? And why? Will your face fit? Do you need to keep up with the artistic Joneses? Will you decide to bear witness, just because you are there, a stranger in a strange land, with all that may imply (and it may imply a great deal), or will you try to follow the local herd? What will your subjects be? Life in a diaspora (another frequently misused cultural-historical term) at any time is likely to stimulate work that's at least relative to identity, experience or to selective memory, and nowadays, if they care at all, settled British audiences may perhaps expect at one level to be presented with artworks that reflect those things: a pronounced tendency towards narrative imagery, sometimes with unusually combative undertones. For the immigrant, part of the experience of being 'other' can sometimes mean being gawped at, like a freak at the circus. You don't have to be an artist to experience this, but it may help.

Splitting Images

It isn't one-way traffic either: you don't need to arrive to have travelled. British artists have quartered the globe, often leaving the shores of the islands with solid reputations already gained, in purposeful search of new ideas and locations for art-making, far away. This pursuit began before the accession of Queen Victoria (1837), with heat and light among the strongest persuaders, and the impact of what those earliest truth-seekers discovered was often profound, on audiences at home and sometimes elsewhere, sometimes lasting long after the authors had gone to the great studio in the sky. In the eighteenth and nineteenth centuries such big figures included David Roberts, JMW Turner, JF Lewis, Edward Lear, and Arthur Melville; in the twentieth, Michael Ayrton, Michael Andrews, Bridget Riley and David Hockney are among the more significant names, but a lower pecking order conceals considerable material of value, whose worth lies not just in the completed artefact, but in its ability to act as a medium: to synthesise new ideas from far-off sources and bring them back, alive.

The modern world has taken time to evolve, and art and design with it. In Britain, like everywhere else, the evolution of ideas (philosophy, technology,

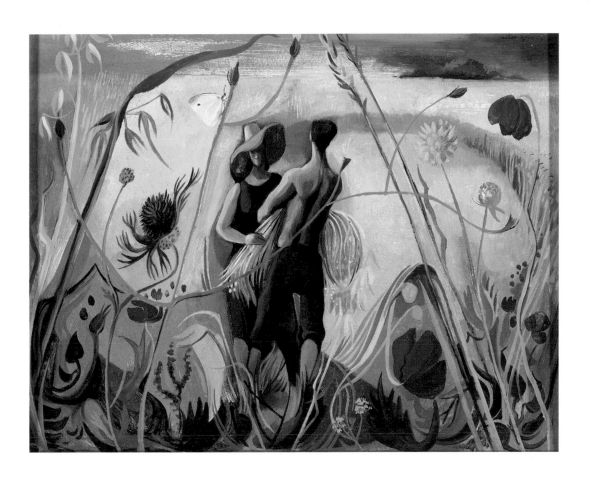

Michael Ayrton
Harvest, 1944
oil on board
32 x 41 cms
Private Collection
© Agnew's, London, UK

Ayrton's neo-Romantic idyll epitomises
Britain in an era in which every type of
boundary was crossed.

and that often overlooked, but fundamental, component of great work, Imagination) has constantly overlapped with ways of seeing and making. All the visual and cultural differences available in British art, past and present, are vital to the people who comprise the nation. At their best they are eloquent about the business of being in Britain, in the past and now, whenever 'now' might be. Moreover, even the shortest migration, from John O'Groats to Land's End, or in reverse, or somewhere in between, can result in revelatory experiences for artist and audience. Like the oldest jokes, impact will depend on nuance; on the way you tell 'em. Long and short journeys, from Norwich to Newlyn, van Dyck to Jankel Adler, Angelica Kaufman to Paula Rego, Glasgow to Japan, RB Kitaj to Sutapa Biswas... the presences of these artists and hundreds of others in a British 'somewhere' has had a critical impact on their work, and on the work of many more still. One thing is certain: the most important beneficiary has been British art itself, and the story continues to unfold, as it has done for centuries.

Going Back

Long before 2000, British cultural memory was even more short term than the 'short-term' advocated in 1957 by Richard Hamilton in his famous unofficial shortlist of attributes for that crazy little thing called 'Pop'.[1] Even taken out of context, the fast and furious momentum with which art and design have progressed since the mid-nineteenth century easily obscures the earliest sources of British art, and it has tended to reflect the best and – rather too often for its own good – the worst of many of its constituent areas. The later nineteenth and early twentieth centuries transformed Britain: not into the crossroads of Europe, for that was a place reserved for Prague, but into the gatekeeper of the New World.

No-one needs 'multi-cultural' arts television programmes rolling over a background score of klezmer, calypso or Chinese flutes, to appreciate the thicket-like art history of cultural immigration... but thicket it is, and in today's takeaway-list-culture world, such infrequent events undoubtedly help to sustain essentially different visual presences in British society. Just as long as you recognise

1. See Weight, Richard *Patriots: National Identity in Britain 1940–2000*, Macmillan, 2002 for a remarkable survey of 'national culture'.

Sutapa Biswas
The Only Good Indian, 1985
pastel, acrylic & collage on paper
200 x 193 cms
Bradford, Museums and Galleries and
Heritage (Cartwright Hall)
© By kind permission of the Artist

Rasheed Araeen
Bismullah, 1988
photography, acrylic & silkscreen on
canvas
154 x 230 cms
Tate, London 2006
© By kind permission of the Artist

'In the name of the priest' (Bismullah)…
**a multi-layered commentary on the
often-skewed impact of religion on
contemporary society**

that when you drop the word 'alien' or 'foreign' or 'different' or (more droppable at present) 'other' you mean marked differences; tangential approaches – by people who were born and possibly grew up outside Britain – not only to experience, but also to the business of making art about experience, often within the same immigrant culture. In this respect, until the late twentieth century, British art education failed to take account of the fact that some non-European visual cultures had long been established in Britain, and that others had continued to arrive, and were developing. To this day, the use of the term 'non-Western influences' in examination questions bears witness: understandable perhaps, but manifestly awkward.

The Melting Pot

Twenty-first-century Britain owns no home-grown artistic style. Every broadly constituent national grouping in the British Isles can realistically lay claim to its own visual tendencies, with or without national dress. Into this, since the 1890s, a relatively swift succession of very different immigrant societies have brought their own visual traditions, styles and tendencies, and have often pummelled and squeezed them to fit within the harsh realities of Western metropolitan life, with one eye on the original source, and the other on a sharpened axe: for some Black artists, especially, there continue to be old niggling scores to settle.

When artists from any racial or ethnic grouping execute abstract work, whatever its source, tendencies or techniques, there's little – aside from its palette, perhaps – to tell it apart from the next person's, and as we've noted, some prefer it that way. The germination and subsequent flowering of 'Cultural History'[2] in Britain since the 1960s has, however, opened new doors for the development of new ethnic art histories. One result of this has been that multi-racial apologists have argued, with some reason, that from the moment of arrival – certainly the better part of three decades after 1948 – the early activities, presence and impact of Black[3] artists were stifled by a range of active and passive discriminatory practices, and that, as a result, what might have been a vital, exciting series of early collisions between different incoming visual traditions and the relatively rock-like, Westernised orientations of longer-term resident Brits were

2. For an excellent introduction, see Burke, Peter, *What is Cultural History?*, Polity Press, 2004 Cambridge, England.

3. Afro-Caribbean, African, Indian, Pakistani and Bangladeshi

to all intents and purposes ground down; swept under the carpet of what some Black artists see as 'a debased multiculturalism', where 'ethnic' in art presumably means the same as 'authentic' cuisine. But the point is fair because it begins to address two of the most important demands on any artist: whom do you serve? And why? Any advanced sense of disenfranchisement will inevitably mean that at some time you'll resort to your axe-grinder. What a Duchampian concept! Goodbye colonial past, and good riddance.

Thanks to Cultural History, all societies now have access to 'the Other'. But just imagine the problems you would have defining the visual 'other'-ness of Welsh, Asians, Scots, Blacks, Irish and Jews, and you've got yourself a shopping trolley full of motley. The impact of imported traditions on what passes for a relatively settled spread of British societies is usually only appreciated at, or close to, the point of contact, real or imagined, and these tend to be ports of entry or major industrial conurbations where employment can be found. This means that, from the start, reaction to immigrant artistic activity is bound to be partial, and will vary according to the welcome (or lack of it) accorded to the newcomers by the settled inhabitants of quite distinct places. As the earliest of the twentieth century's major immigrant groups into Britain, many of the social problems faced by Britain's Jewish artists, especially by those who arrived after 1882, portended many similar experiences faced by later coloured or other immigrant artists, and they also provide interesting examples of assimilationist and integrationist tendencies among people of one faith but of differing Western geographical origin.[4] That experience is partly mirrored by groups of equally dislocated or displaced white observers among other races elsewhere, and Fintan O'Toole offers a useful comparison in the development of contemporary Irish artists during the later twentieth century. The Ireland of the 1950s and 1960s, where they grew up and where they had their first visual experiences, has disappeared. What remains, says O'Toole, is a place '… no less resonant, no less capable of inspiring deep emotions, for the fact that it is just the memory of an old world artificially constructed in the middle of a new one'[5], but to be Irish and an artist today one needs to develop not only a visual syntax capable of collecting the resonance of the religious, nationalistic and geographical Irish past, but also another syntax capable of being frequently reshaped, to allow for new shifts of visual meaning.[6]

4. Jews arrived in Britain with the Normans, were expelled by Edward I, and readmitted by Oliver Cromwell in 1653. The earliest arrivals came from Holland, and until the 1880s tended to be of the Sephardi (Iberian–North African) sect; from the 1880s, their poorer Ashkenazi brethren began to flee persecution in Russia, Poland and the Balkans, and others arrived from Germany and Austro-Hungary. Britain's small Jewish community (about 300,000) is predominantly Ashkenazi today.

5. See O'Toole, Fintan, *Ireland*, from McGonagle D, Levin K and O'Toole F, *Irish Art Now: From the Poetic to the Political*, exhibition catalogue, Merrell Holberton, London, 1999, pp. 21–26.

6. ibid

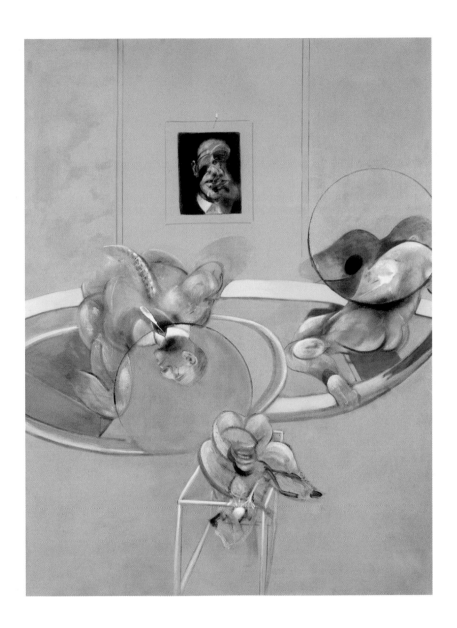

Francis Bacon
Three Figures and Portrait, 1975
oil and pastel on canvas
198 x 147 cms
Tate, London 2006
© Estate of Francis Bacon. All Rights
Reserved, DACS 2002

Challenging from the first, Bacon could
often create an uncomfortable synthe-
sis of personal experience with the
essence of much older narrative tradi-
tions

That place could be anywhere, from Galway to Kilburn to Bradford to Smethwick, the East End or the Gorbals, and the national differences in this analogy are the same for all. Memory, or what passes for it, is a vital function in the establishment of visual practice amongst immigrant or other national groupings. It's what you fall back upon to inform your first works in your new country, and your responses to the experience of attempted integration and assimilation only follow thereafter. Nostalgia. It's a real killer.

Just Off the Onion Boat

Jewish artists only made an impact in Britain after 1900. Pioneering nine-teenth-century figures such as Solomon Alexander Hart[7] and, later, Solomon J Solomon did not come two a penny, but by the early twentieth century both the 'settled' Jews and the immigrants were beginning to gain critical attention, from Jews and Gentiles. In London and elsewhere, William Rothenstein, Alfred Wolmark, David Bomberg, Mark Gertler and the Jacobs Kramer and Epstein struck very different poses in art and life. From the start, Jewish artists were acutely aware of their 'difference', and tried to combine traditional excellence with what they were learning on the side about new techniques or ways of see-ing. Their experience of social situations, where indifference, obstruction or prejudice prevailed, created conditions for self-documentation in ways that ranged from the representational to the abstract, and that might continue for years. Given the importance of 'watch and learn' traditions in Judaism, the application of religious references in the art of these men may seem strange, but it's a fact... oh, and the constraints governing the creation of graven images in the Second Commandment is a red herring.[8]

At some point before his death in 1957, David Bomberg wrote a series of notes on issues that clearly still mattered to him. In one, he attempts to subordinate his Jewish identity and to superimpose in its place his artistic ability by imply-ing that, as a young, British-born Jewish artist in an unforgiving East End envi-ronment, issues of ethnicity, religion and racial origin were secondary when it came to art: everything, he says, boiled down to know-how. Because of their background, the 'proletarian environment... [and] hard upbringing' from which

7. Solomon Alexander Hart (1806–81) was the Plymouth-born son of an engraver, and the first Jew to be elected a Royal Academician (1840).

8. See Exodus Chapter 20 v.3, long con-sidered an impediment to the creation of any simulacra by Jews.

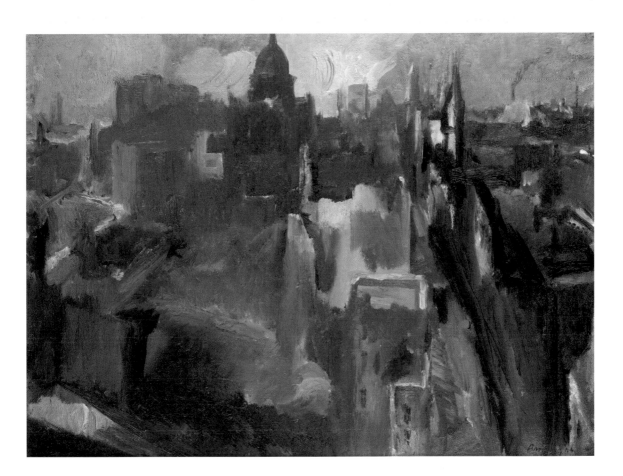

David Bomberg
Evening in the City of London, 1944
oil on canvas
70 x 91 cms
Private Collection
The Bridgeman Art Library

24 they came, Bomberg and his peers were 'Tough awful fruits – with a terrifying precocity – we were not discriminated against on that account – the law of the jungle at the time of our entry to the profession was CAN THE MAN DRAW? OR IS HE A NATURAL BORN DRAUGHTSMAN?'[9] If only it had been so straightforward. Regretfully, the record proves otherwise. Prowess in Art was not Bomberg's only achievement. As a young art student he also worked hard on his boxing, so that he could defend himself and his weaker friends from the slings and arrows of intolerance. Tough awful fruits indeed, and matters improved at a snail's pace.[10]

If Art's primary purpose is to elevate, and only secondly to decorate, many Jews and Africans clearly think the opposite. Second: forget that word 'elevate'. Jewish audiences have tended to subordinate elevation to decoration by citing their own inadequacies as critics, their inability to understand, their self-imposed philistinism, as impediments to understanding. Meanwhile, historically, successive African societies in every part of the continent have treated their own cultural artefacts as easily disposable and replaceable (did Richard Hamilton know this?), and have only relatively recently begun to view them as objects worthy of interest to posterity: Western-type collections were rare in Africa until the later twentieth century.

Brother, Bro

Black and Asian artists have steadily gained a presence within the British art establishment, partly because they gave the British art establishment a well-deserved hammering in the mid-1980s, for what they saw as its failure to recognise or endorse the value of their presence in Britain. Using heavily politicised text to execrate Western 'neo-colonial' society in general, they damned the cultural-historical 'colonial past' and what was described as the marginalisation of Black artists by white society, with the 'perpetuation of subservience', whilst simultaneously making inroads into the preserves of Westernised visual arts.[11] It is a matter of regret that all standard published accounts to date are two-dimensional in such coverage. In the same decade determined efforts were often made by Black artists to establish opportunities to make and view meaningful

9. Wright D and Swift P. (ed)., 'The Bomberg Papers', reprinted in *X: A Quarterly Review*, June 1960.

10. For a study of selective racial discrimination – as close to institutional racism as the British art establishment could come – see Silber, Evelyn, and Friedman, Terry,

'Isolation and Defiance' in *Jacob Epstein, Sculpture and Drawings*, exhibition catalogue, Leeds City Art Galleries and Whitechapel Art Gallery London, Chapter 13, pp. 208–28, 1987.

11. See Araeen, Rasheed (ed.), *Third Text* magazine, issues published during

1987–89, in which such views are regularly set out in different forms.

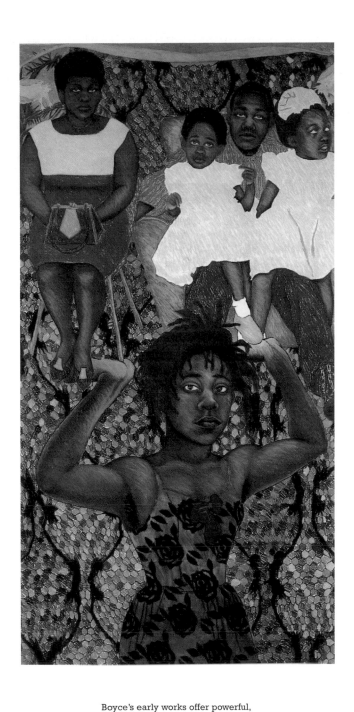

Sonia Boyce
She ain't holdin' 'em up, She's Holding On
(Some English Rose!), 1986
watercolour, pastel and crayon on paper;
218 x 97 cms
Private collection
© By kind permission of the Artist

Boyce's early works offer powerful,
graphics statements about the com-
plexities and complexion of Black
immigrant life in 1960s England

art about Black people, for Black people, and often the results were successful, as the different careers of Eddie Chambers, Sokari Douglas Camp and Sonia Boyce show. But more extreme, less intelligible work can still be marginalised, whatever background you come from and in general, according to the moment, critique can be speculative, fruitfully provocative or intellectually barren. Similarly, you can dance on your enemy's grave as long as you want, but after a while the rhythm is lost through tiresome repetition, and instead one enters the hall of mirrors: a place of momentary, but ultimately transient, experience.

First generation Black immigrant artists still have no place in mainstream British art histories of the 1950s.[12] That the white British art world effectively disdained their presence was a set-back: for some time thereafter they continued to try to act as mouthpieces in the wider world for their own communities, but their work became generally inward-looking: generalist British audiences remained largely ignorant of their activities. Exceptions tended to be artists such as Dhruva Mistry and Anish Kapoor, catapulted to fame by determined minorities, including British cultural institutions such as the Arts Council and the British Council: the sceptical might recognise in such apparently tokenist behaviour a keenness to demonstrate British multiculturalism, which did not exist at the time except as a 'right-on' tendency, and to ignore more accessible artistic activity by generally unsung figures within the provincial/regional communities themselves.

Any use of the past to support assumptions about the achievements in the plastic arts of ethnic minorities, or their representatives, or about their place as contributors to an artistic presence in any land, also begs answers to questions concerning the creative traditions of source cultures. These might enjoy automatic acceptance by outsiders for oral or textual activities, in drama or literature, in song, poetry or music so what then of the visual? And what happens when the culture itself is more comfortable with that perception than with late-twentieth-century artistic activity? How does a Japanese artist in Manchester make waves? Like Hokusai, perhaps?

12. See, for example, Harrison, Martin, *Transition: The London Art Scene in the Fifties,* Merrell, in association with Barbican Art, 2002. Other immigrants are mentioned, but nothing is said of Black artists. Same situation in Mellor, David, *The Sixties Art Scene in London*, Phaidon, Oxford, for the Barbican Art Gallery, 1993.

Who am I?

The issue of national distinctions in British art isn't one of strict geography, but of intellectual approach. I argue that there's nothing wrong with it, it's something to be proud of, and you don't need to wear a Burberry cap to do it. You are who you are, and the dismantling of barriers and bridge-building activity must not also be used to dismantle cultural identity: this is the lifeblood of British art. Nevertheless, some of the issues that dog the cultural assimilation of immigrants are no less important than they were in 1985. Those who would rather go unremarked cannot. All save a handful of Britain's minuscule Jewish community[13] tend not to trumpet their identities in public through their dress, but all other non-white citizens can't avoid recognition, whatever their ethnic backgrounds. In art, however, only the intentional delivery of specific subject matter for predetermined purposes may reveal the origin of an author. The issue becomes more complex as time passes, and, as art magazines devoted to their own cultural orientations openly declare, the children of Chinese, Black, Jewish and an ever-increasing range of immigrants to Britain use their own work to inform or question new (and sometimes over-hyped) issues of politics, culture, gender and ethnicity that have been introduced to the arena as other cultural walls around the world have come down.[14] Add to this the complacency of new audiences: why worry about the detail of older distinctions when so many other aims exist for art itself, including the need to reject (in the words of a current Asian practitioner) '... a hierarchical demarcation between fine arts and crafts'?[15] This is a world away from the later 1980s, when Boyce and Camp were beginning to gain reputations and their white contemporary Julie Held was achieving similar status using Jewish subjects: it also says nothing of the gallant failure of the Indian Arts Council to support Asian artists working in Britain through London's Horizon Gallery during the period 1987–91,[16] or of many similar efforts. Today, similar support organisations exist, but photography, film and multimedia expressions have tended to displace the conventional media used by Boyce and Held, a situation that audiences may prefer as a means to deliver increasingly emotive statements about a range of issues surrounding non-Western ethnic and political status in the wake of the events of 11 September 2002.

13. A true ethnic minority at 0.01 per cent of the entire population.

14. See the excellently produced *Asian Art News* to find regular reference to this type of activity.

15. The remark, by the leading Asian artist Chila Kumari Burman, is taken out of context, but is generally indicative of a tendency that affects artists of all races currently responding to cultural issues in their work.

16. Dogged by the failure of outsiders to support the gallery financially, it folded, but not before helping to establish many new young artists who had been trained in British art schools.

The journalistic potential of photography, film and computer technology is oddly appropriate to the continuing development of the older concept of the artist-as-witness. At its best it's often telling, but many commentators see it as superficial. It depends what you want it to do, and how quickly. It's potentially fast, but it can also inadvertently simplify (and sometimes usefully undermine) some of the more pretentious crapology on offer. Most modern audiences prefer narrative to exploration; they can't keep pace with multimedia attempts to deal with such issues as asylum seekers' use of EuroTunnel trains: in essence, hardly a novel phenomenon in the history of migration into Britain. No: instead, let's go for the quick-fix over the mysterious; realism over perplexity; the graphic, the humorous, the dull, like Langlands and Bell's The House of Osama bin Laden (2003). Here, film and video can come into their own: they are flexible media, single or multidimensional, in the post-Picasso age, and because they are capable of such enormous diversity, they allow audiences to 'think up' and investigate, or to ignore, artistic statements. The cinema, in its various forms, offers huge potential as a bridge to understanding increasingly diverse multicultural experiences in a host of environments and locations. The drawbacks lie in the inarticulate misuse of new media by people who haven't thought through their ideas.

Britain's art, its succession of immigrants and its racial minorities are irrecoverably entwined, and they will stay that way, with all their differences. Together, they present a hard-fought, hard-won kaleidoscopic experience against an often-irascible background cacophony of static, born out of histories that begin in a shambles, at a British port of entry. On the upside, immigration, and internal and external migration, have resulted in powerful and usually meaningful visual assaults on complacency, at all levels. It's all worth seeing and hearing once, and, when roused, newcomers can utilise their own lateral thinking to provoke the torpid into action. Do integrated ethnic groups need new rules of engagement, revamped philosophies so that they can continue to make meaningful art in societies that at root remain alien? Perhaps they should, in Britain of all places, where tradition, memory and nostalgia are such familiar cultural tools. For, as generations die, memory fades and folk-history

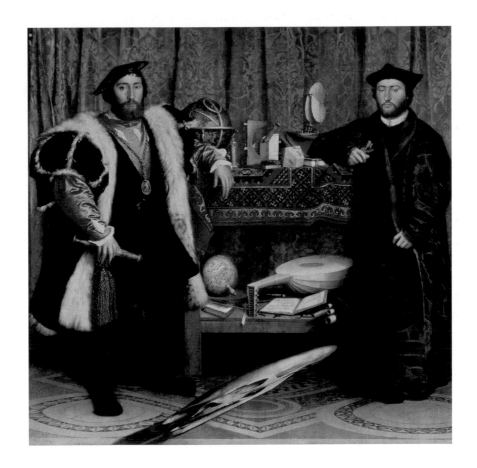

Hans Holbein the Younger
The Ambassadors, 1533
oil on panel
207 x 210 cms
National Gallery London, UK
The Bridgeman Art Library

Henry VIII's eagle-eyed German court
painter: a documenter unsurpassed in
his own era, wherever he worked

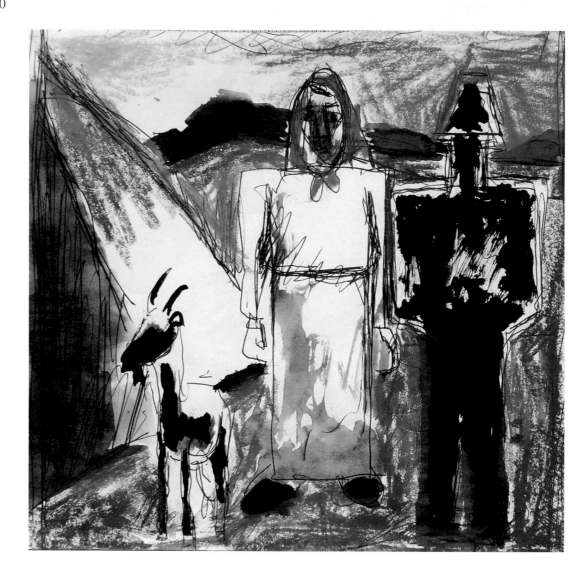

Josef Herman
Couple with a Goat, undated
ink and crayon on paper
20 x 20 cms
By kind permission of the John Davies
Gallery

Herman was an archetypal twentieth-
century border-crosser, coming first
from Poland to Wales via Belgium and
Scotland, and travelling often

takes a greater hold, a meaningful context will still be required to understand the evolution of an extraordinarily hybrid national 'school' – if indeed it's that – created by natives of every type. And, at a broader level, the painful business of integrating what has been perceived as 'other' into that process must not be forgotten. It would be good to be idealist and hope that future British art will be able to move forward buoyed by cultural and philosophical traditions that have been enriched, on Albion's cultural compost-heap, by past movers and shakers and by those who continue to enter the country keen to contribute to pre-existing traditions. George Santayana was right. 'Those who forget the mistakes of the past are doomed to repeat them.' Bear this notorious adage in mind, at all times, and the future may be bright. Bloody foreigners. They get everywhere.

2

The Right Kind of Lines

And what would those be, then? The business of drawing has underpinned artistic activity everywhere since the year dot, and in British art its importance has been paramount in the most general and specific situations since the sixteenth century. Every British aspirant to painterly fame and glory has had to be able to draw and to use this facility as if it were an additional sense: something utterly natural; a means of expression equivalent to, or greater than, an excellent vocabulary, colloquial in any era, and always capable of renewing personal vision. This, of course, is the sum of drawing, in all its diversity, then and now: it must exist, like an ageless and often-changing dialect, depending on who's holding the pencil, paintbrush, pen, charcoal, burin, felt-tip, pastel... or what you will, proof against those who would demean it. The trouble is that there are many who, by their actions, do just that.

Today, drawing happens, as it always has, often with an accent attuned more to activity than something dependent upon any declared technique. In the later twentieth century, the practice of drawing extended itself to move beyond the limitations of accepted practice, to experiences involving unconventional (non-paper) surfaces; unexpected media (how about mud, then?), and an outspoken determination that process might be as important as outcome. Ian McKeever, Richard Long and Hughie O'Donoghue are but three of those who were involved with drawing like this in the 1980s; many more might as easily be cited. Yet despite the real differences in media, scale and outcome, the thing that would seem to link more recent drawing in Britain with the traditional practices that come more easily to mind is the business, yes, the process, of exploration that lies at its heart. The validity of that process then comes under scrutiny. Which is where many things can become rather interesting.

So, why draw? Personal or public record, expression, commentary, promotion, induction, sedition, seduction, reduction or abstraction are merely some of the purposes to which great drawing has been put, but it is certainly worth emphasising that, until the comparatively recent past, drawing has not always been amongst the highest of British high arts, compared, with, say, Fox Hunting.

And the very word 'drawing': what of that? Its turn-of-the-nineteenth century connotations of hard- and soft-leaded pencils, its greasy sharpenings and shavings on

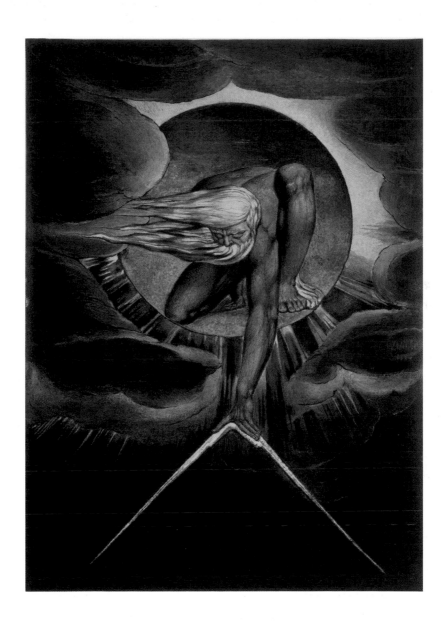

William Blake
The Ancient of Days, 1794
etching with pen & ink, watercolour &
body colour on paper
23 x 17 cms
© Whitworth Art Gallery, The University of
Manchester
The Bridgeman Art Library

studio floors, its putty or pulpy homogenised sliced white bread erasers, the hours spent labouring before casts of antique sculpture, or in the life room, with a tutor whose wit could be compared with that of an antiperspirant roller, the mud of riverbeds, the skeins of emotive lines… all of these have come to mean some very different things, yesterday and today, among practitioners and connoisseurs.

Can You Feel It?

There will be many among twenty-first-century audiences who will relate to drawing as something taught in art schools or academies, perhaps without thinking too much about how long that instruction has been taking place, and how it has evolved, layer-like, as a medium in its own right. Certainly, the emphasis on drawing that has waxed and waned in British art schools since the 1870s (call 'em what you will today: they remain, essentially, art schools) was something that originated in the experiences of a relatively small, but very mixed bunch of individuals. English, Irish and Scottish (but not often Welsh), their perceptions of 'good practice' evolved from lessons learned from studies in the academies and studios of northern European cities, and from travel to Italy, still a magnet for all who sought a new, brilliant blue luminosity. And if you're prepared to acknowledge, but to bypass for a moment, the birth of the Royal Academy of Arts (1768), foreign influence has much to do with many of the elements of drawing with which the British are most comfortable today.

How absolutely splendid. But now open the door to the utterly unorthodox, in the shape of Psychotic drawing and of drawing by Autists. Irrational drawing has no 'processes' but it is too vital to be ignored by anyone claiming an interest in the practice. Similarly, whatever the 'values' of such drawings, they are oceans away from conventional academic practice, and are often too compelling in their imagery, memory and determination to be questioned in depth.

So, back to formality: what 'elements' define it? Any interpretation of the term 'British drawing' will depend on your birth date, and your perception of what drawing sets out to do, always assuming that in fact it sets out to do anything other than be its investigative self: an assemblage of denotative lines on paper, used deliberate-

Dennis Creffield

*Peterborough: Approaching the West
Front,* 1987

charcoal on paper

102 x 93 cms

Tate, London 2006

© The Artist

A 1987 tour of Britain resulted in the
depiction of every English cathedral, in
every weather and light, and a subse-
quent exhibition, to deserved acclaim

ly with a healthy combination of intuition and precision to establish a specific result. In 1946 Collins published a short, pugnacious essay by the multi-talented artist Michael Ayrton.[17] Even today, its effect is not dissimilar to a well-aimed 12-bore shotgun on nearly 300 years of local artistic endeavour: its effect upon publication (and a wide audience) would surely have been interesting at least. Ayrton had a tendency to 'range', and – like most Brits – to group artists and trends into periods of activity or apparent lethargy: not exactly the dreaded '*isms*' with which we are too often beset, but not far off. This may be neither sensible nor fair in today's artistic climate, but hindsight is a wonderful thing, and Ayrton either knew no better (quite likely), or he was determined to make some strong points (more probable).

British Drawing's nationalistic, insular introductory essay sets to work immediately, as Ayrton proposes that the earliest true beginnings of British drawing lay in the 'rhythmic preoccupations' of the Winchester School of the thirteenth century, and of Matthew Paris in particular. Having dismissed foreign interlopers, he traces its later development, via Thornhill and Hogarth,[18] the metal pen and the lead pencil, to the Royal Academy,[19] among whose members were to be found some of the greatest British draughtsmen and women. It is an apocryphal, but nonetheless accurate, truism that the RA's dominance as a teaching establishment waned in the nineteenth century in the face of French influence but, as he tries to establish key figures in modern British drawing, Ayrton talks up the influence of Walter Sickert[20] (friend to Degas)[21] and the stylistic and emotional influence of Blake's follower Samuel Palmer on Graham Sutherland and a few others. The result isn't exactly even-handed, but the idea of 'rhythmic preoccupations' is – for different reasons – at least of interest, and at best profound if we consider the text as a stepping-stone to the present.

So on we go. Ayrton rejects most sixteenth- to eighteenth-century foreign influence, including that of Hans Holbein and Sir Peter Lely, and drawings by later artists whom he feels were not of the best quality. In this category, George Romney, Sir John Everett Millais and Sir William Orpen receive a good slapping. For a finale, Ayrton cruises serenely into a sunset in which William Blake truly becomes The Ancient of Days, with Fuseli his right-hand man, and their descendants a mixture of British romantic artists, ranging through Gainsborough, Constable, Sutherland,

17. Ayrton, Michael, *British Drawing*, Collins, London, 1946 is worth anyone's time, energy and money.

18. Sir James Thornhill (1675–1734) and his son-in-law William Hogarth (1697–1764), widely credited as having been the man who established a 'British School' of art. Look 'em up for yourself'.

19. The Royal Academy of Arts, London, established in 1768.

20. Walter Richard Sickert (1860–1942), became a younger friend of the French 'Impressionist' Edgar Hilaire Germain Degas (1834–1917), and a major mentor for younger British painters of The Camden Town School. More recently, the author

Patricia Cornwell has decided that he was also the serial killer known as 'Jack the Ripper'.

21 The impact of Degas' insistence on the primacy of drawing in the fine arts upon Sickert, and thus upon British drawing, has been known to admirers for decades, but only recently 'talked up' to a mass audience. It's been a long time coming.

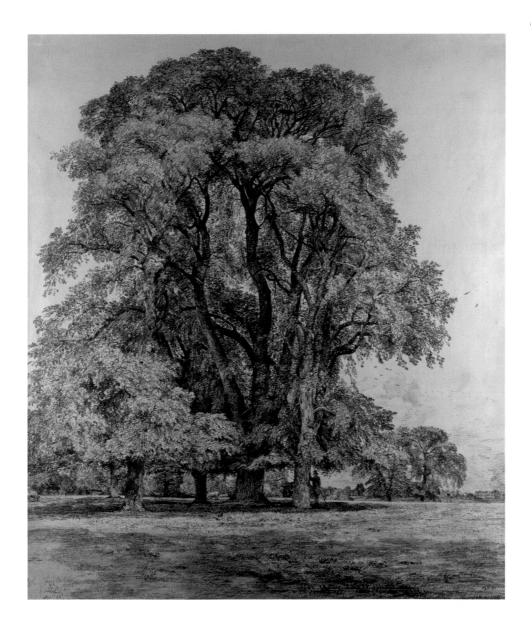

John Constable
Elm trees in Old Hall Park, East Bergholt,
1817
pencil
59 x 49 cms
Victoria & Albert Museum, London, UK
The Bridgeman Art Library

Practice makes perfect. Constable's
draughtsmanship was continuous,
searching and splendid

Paul Nash, David Jones, Edward Burra and Stanley Spencer, to whose work he responds strongly, and to many important others (Ramsay, Cozens, Hogarth, Ward, Martin, Sickert) whom he deeply admires. Wyndham Lewis? Roberts? Bomberg? For Ayrton, these later luminaries did not exist. Time in between may now have relegated Ayrton's book to the darkest alleyways of Charing Cross Road and all their second-hand bookshops, but his pronouncements in *British Drawing* are seminally important, and broadly reflect establishment thinking of the era, such as it was, at least in their xenophobia, which extended to more 'dangerous' elements of foreign influence.[22] British drawing was clearly not an area of endeavour to which foreigners were to be easily admitted; on the other hand, it was definitely something at which true Brits could excel, regardless of whether their strengths lay in the realms of imagination or of objectivity.

The inclusion of such a notion in so dogmatic a series of pronouncements is important, because it provides a link with the drawing of the most determined immigrant artists, such as David Bomberg,[23] or, later, Jankel Adler[24] who felt – perfectly reasonably – that your antecedents didn't matter: what *really* mattered was whether you could draw or not, and that *this* and little else allowed you to hold your head up in British artistic circles. Bomberg *could* draw, and how. For him, this ability was almost a holy attribute: mastering drawing was a true rite of passage, but when it mattered most he was an isolated voice, and his work was widely ignored.[25]

Nearly 20 years later, in 1976 (coincidentally the year after Ayrton's death), the American expatriate artist RB Kitaj organised 'The Human Clay', an exhibition devoted to the drawing of the human figure. Supported by the Arts Council, and mounted in London, 'The Human Clay' to some extent re-emphasised similar qualitative values to those set out by Ayrton. It lauded the incisiveness, the penetratingness of drawing, regardless of the medium or tool in use, and especially where the object under scrutiny was the human figure itself. Kitaj was on the verge of a personal epiphany, about to become immersed in an unusually intensive, and subjective, state of personal creativity, and his catalogue essay was a gawky piece of prose, a misleadingly folksy piece of guile. At one level it debunks anally retentive connoisseurship, and at another appears to pre-empt his own temporary withdrawal from public artistic debate, in the interests of his own work. Within the context of the

22. Ayrton was a painter, sculptor, print-maker and film-maker in his own, just-post-war, time. His later work in nearly all these areas seems tainted with an unhealthy scepticism (at the very least), which makes an appearance in his text.

23. Bomberg was Jewish, born in Britain, to immigrant parents.

24. Adler was Jewish, a well-established European artist, who had been living in France until the German invasion of 1940. He fled to Britain, and lived first in Glasgow, where he was highly influential, and then settled in London.

25. Things changed, but too late for Bomberg, who died in very reduced circumstances in 1957. A general resurgence of interest in his work began during the early 1970s, and its importance is now assured in the annals of British art. Not bad for the son of an immigrant.

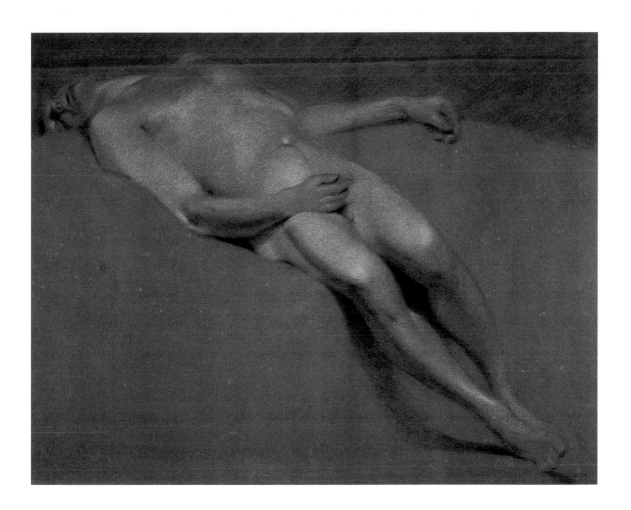

John Constable

Study of a Recumbent Male Nude
(Undated)
chalk on paper
61 x 46 cms
Victoria & Albert Museum, London, UK
The Bridgeman Art Library

exhibition, Kitaj brought together a series of 'failed' figure drawings by well-known artists, simply to demonstrate how very hard it is to reach the heart of the subject, in whatever spirit it may be drawn: subjectively or objectively.[26]

'The Human Clay' was literally 'epochal'; it captured for a short time the results of differing practice in drawing in Britain through the 20 previous years, in over 100 works by as diverse a range of artists as it was possible to secure. Most images prompted questions about the myriad ways in which it is possible to draw and arrive at a representation of the human form, in all its three-dimensional permutations, and the breadth of exhibited work indicated a range of entrenched visual traditions, from the Slade School's broadly objective-scientific search for form and structure, to new 'truths', such as those propounded by Bomberg and his pupils at the Borough School of Art, seeking the essence of form; what he called the 'spirit in the mass'.[27] Nonetheless, the names in between – Jim Dine, Lucian Freud, Leonard McComb, Helen Lessore, Maggi Hambling, Adrian Berg, to name only a few – were at least as interesting.

One of the more doctrinaire artists to exhibit was the ex-Slade professor, Sir William Coldstream, whose government-commissioned reports of 1960 and 1971 had resulted in an overhaul of art education that granted art schools, and especially the newer polytechnics, the power to propose and run their own tailor-made courses, subject to validation. The resulting freedoms, combined with the spread of Minimalism, and associated event-based (or 'non-event'-based) activity during the later 1960s and early 1970s, spelt the indefinite suspension of drawing in some institutions. If it survived it was lucky, and might as easily have been relegated to the extremities of Foundation studies.[28] At the Slade itself, Coldstream had previously determined the nature of the college's analytical drawing, and, through his stylistic successor, Euan Uglow, an almost hermetic process of precisely observed mark-making, dogged point by dogged point, to convey space. Such practice became the exception rather than the rule. Elsewhere, real efforts were made to obstruct all elements of conventional art and design practice.[29]

Expressive practice rattles the bars of such structured cages, marking, incising, rubbing and scumbling, with charcoal, powder and paint, but the arrival of the

26. Kitaj, RB, intro *The Human Clay,* exhibition catalogue, Arts Council of Great Britain, Hayward Gallery, London, 1976.

27. Among these were Frank Auerbach, Leon Kossoff and Dennis Creffield.

28. For the record, Brighton was a case in point, where representational drawing had all but disappeared with the physical removal of the old school of art, and its rebuilding, with the impact of Coldstream, had done the rest. Drawing as a discipline had no proper connotations in Fine Art practice there for several years, although it was extensively practised on the parallel Foundation course (now long since defunct).

29. Hold your hand up, Terry Atkinson, for the behaviour of Art and Language at Lanchester Polytechnic, now the University of Coventry.

Sir William Orpen
On the Irish Shore
pen, ink and watercolour on paper
56.6 x 78.8 cms
© Leeds Museums & Galleries (City Art
Gallery) UK / The Bridgeman Art Library

Augustus Edwin John, OM
An Irish Peasant, c1910
pencil on paper
34 x 24 cms
Private Collection
© Agnew's, London, UK

Probably executed in response to the
'Celtic Revival' – John's affinity with
Ireland was brief but powerful

Keith Clements
Drawing of Duncan Grant, 1978
umber conté on paper
58 x 39 cms
Private collection
© Reproduced by kind permission of
Jackie Clements

Keeping it local: in 1978 the
Eastbourne-based Clements visited
Charleston farmhouse to research his
biography of Henry Lamb. This drawing
of the elderly Duncan Grant resulted,
one of five made just before Grant's
death months later

Coldstream Report heralded an unholy explosion of Minimalist or event-based activity, and – among some tutorial staff – a comparable reduction in the perceived need for the teaching of drawing. Interestingly, there was something of a backlash: many students sought to reinvest in their drawing skills, having discovered that 'new media' could often be equated with 'meaninglessness'.

Nevertheless, to over-emphasise the expressionism of the Borough is to neglect the even-handed approach needed to reasonably survey the many other, varying visual values to be found in modern and contemporary British drawing. Ayrton's puritanical thesis needs first to be repositioned to admit what can best be described as the presence of poetry in many forms of drawing since the 1880s, and then to admit also the more recent influence of immigrant artists upon British culture in general. 'Poetry' in this context might result as easily from subjective/romantic or emotive creativity as from strictly analytical observation, or from a combination of both or of other factors, but it is also important to remember that this position has its downside. In recent years 'drawings' have been made that are barely worthy of the name, ranging through the traditional, to more expressive medial interpretation, to activity that cannot be described as anything more than dreadfully vapid.

Seen like this, the history of drawing in Britain performs fascinating oscillations. Subjects range from figures, through interiors to landscape, with still life per se barely in evidence, or featured only as a device. Colours and media are as important as they were centuries before, for Holbein, Rembrandt and many others. Orpen's pencil, Gwen John's use of ink, Muirhead Bone's precision, Eric Kennington's discovery of pastel, the liberated use of different mixed media by David Jones, Henry Moore and Anthony Gross, the inclusion of gouache by Joan Eardley, Linda Kitson's wax crayons, Lanyon's blackly-worked shapes clawing for air and weather, and, later, the graphite additions and overlays of David Tress, seeking similar escapes: all offer meaning and responses that prove the enormous potential for graphic experimentation once observational skills have been absorbed. One may look, but may not always see. This isn't simply the tip of the iceberg: it's the proclamation of drawing as an essentially graphic medium. Into this we can feed the caricature of Hogarth, Gillray and Rowlandson, and the youthful, jobbing ink drawings of later luminaries such as Poynter and Burne Jones, before the Dalziel family arrived, and

Paul Nash

Chaos Decoratif, 1917

ink and watercolour on paper

25 x 20 cms

The Bridgeman Art Library

© Manchester City Art Gallery, UK

One of Nash's drawings made as an
official war artist in 1917: drawing was
fundamental to all of his practice

after them the artists whose use of line made drawing attractive enough to be worthy of emulation by twentieth-century schoolboys just by being there in Hulton comic-book illustrations – Frank Hampson's *Dan Dare* and John Worsley's *PC 49* among others. Not great names to conjure with, but worthy of some imitation, and therefore important as first steps on the long road.

Twenty-first century drawing is rooted in the past, simply because of the strength of its antecedents: despite the attentions of some commentators, it doesn't always admit the barren, formless scribblings of younger artists as drawings, whether for work in progress or as the finished article, but it does reveal some sturdier talents of the later twentieth century as capable of drawing the right kind of lines. Adrian Wisniewski, Andrzej Jackowski, Christopher Le Brun (sometimes); and in your locale there are others also, making meaningful drawings like that first novel. We always have at least one inside us, it isn't something that comes naturally to everyone, and there is always room – and usually an audience – for more.

However, think about this. Drawing, as coloured shape, line, form or structure, now rises increasingly often to the surface of so many contemporary paintings. Bigger artworks, including sculpture, quite often include a linear, narrative, 'drawn' quality that one century ago was deemed worthy only of watercolour or other preparatory studies made before beginning those all-important academy paintings. Without drawing, these modern images simply couldn't cut the mustard, and sometimes they don't. But, while it is important to acknowledge that grotesquely inflated reputations have been carved by some contemporaries working this seam of explicit narrative imagery very hard,[30] elsewhere, fine drawing underpins work by artists such as Alison Watt; witty work by Callum Colvin depends no less upon a total understanding of the medium's finest precepts, and it's a fair bet that there will be equivalents for these Scottish artists elsewhere in the British Isles, not least among its more recent immigrant populations. Saleem Arif Quadri regards drawing as fundamental to his entire output. Sonia Boyce's earliest activities depend on drawing for her narrative, graphic and expressive qualities. And you've only to examine Chris Ofili's work to know intuitively that his aptitude for drawing made him into a somebody. The elephant dung is neither here nor there.

30. Artists such as Peter Howson, whose cro-magnon men and women inhabit the drawn, dystopian societies of his jeremiads.

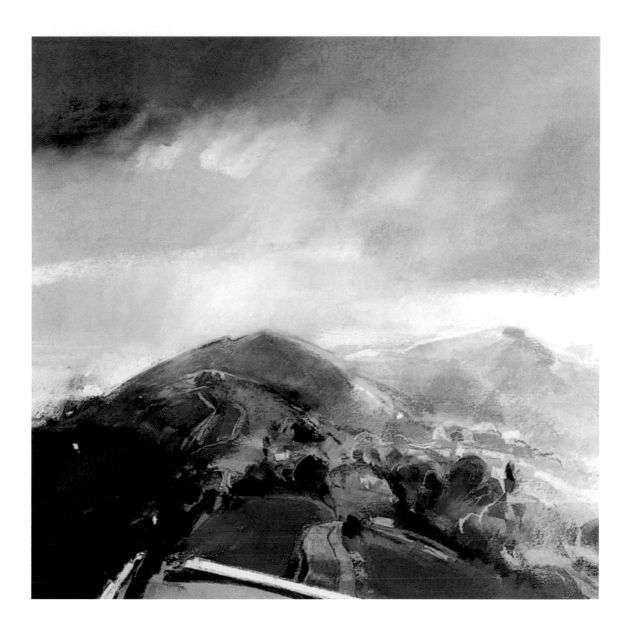

David Prentice

English Air – Aureate, 2004–5
pastel on paper
84 x 84 cms
Private collection
© Reproduced by kind permission
of the Artist

50 The business of drawing in the UK is neither whole nor complete in this summary. Rather, like most grass-roots activity, it is work in progress: something to be returned to, in the knowledge that most of what's happening is interesting for what it is, worthy for what it exacts from experience, and exciting for what it is capable of suggesting or projecting. If this sounds tame, so be it: the excitement is in the activity, or, if you can't be sure that you can do it, the nearness to it. To try is to achieve in this case, and this kind of achievement breeds unusual, often intuitive, understanding. Let's just call it indispensable, and leave it at that. On second thoughts, let's do it.

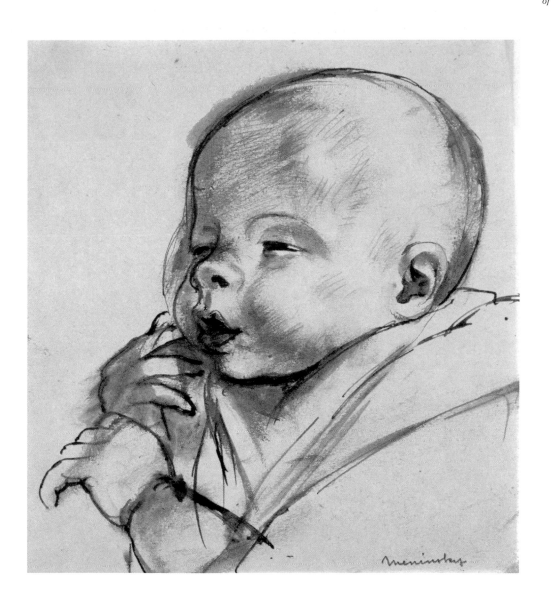

Bernard Meninsky
A Baby, c.1920
pen and ink wash on paper
21 x 19 cms
The Bridgeman Art Library
© Leeds Museums & Art Galleries
(City Art Gallery) UK

3
Hands Across the Water:

Ireland

John Long A. RHA
Two figures at a table, 1998–9
oil on canvas
66 x 114 cms
Private collection
© By kind permission of the Artist

The magnet of the Slade lured many
Irish artists across the twentieth centu-
ry. A more recent talent, Long's paint-
ings are secured by intense and careful
observation learned from the teaching
of Euan Uglow

There's an argument that says that Ireland and its culture should have no place in a survey like this; that what is Irish runs contrary to most things that can possibly be termed British. It's easy enough to understand the existence of this view, bathed as it usually is in the ghostly green light of centuries of Anglo-Irish history (if you aren't fussy about the exact meaning of the word 'Anglo'). In the same time frame, and against some odds, however, inescapable affinities between the two countries have developed in art and design across the best part of three centuries, and to attempt an undoing of some truly tight cultural knots doesn't always make sense. It's much better and more appropriate to accentuate the positive, and there's a lot of it.

If it doesn't already do so, Murphy's Law should somewhere attack the intrusion of politics into artistic matters, and certainly, of the several Irish art histories, there are now those in which the North–South political divide is best ignored, and which instead promote the existence of four-way visual traffic across the best part of two centuries by artists and their works, moving North–South and vice versa, in Ireland itself, and across the Irish Sea, in both directions, with different personal and aesthetic objectives, to different ports. In local and national terms, there have been long historical moments when the artistic direction of the two land masses has been fully interconnected, even though those conditions may evolve from highly contrasting or divergent viewpoints.[31] In the wider history of Irish art, nationality is often (reasonably) subordinated to ability. For example, the greatness and appeal of eighteenth- and nineteenth-century Irish painters such as James Barry and Daniel Maclise is best understood when viewed against technical developments in England, Scotland and the near-European continental countries. But Irish art works best when it admits the scent of human and natural existence, whatever its aroma, and more recently, wherever that may take place, at home or abroad: the work of Yeats and Charles Harper prove the point at different times, in different eras.

So, artworks made in Ireland during the period 1900–40 were often important for reasons that were likely to have been caused by their authors' awareness of the curiousness of their own position: the paradox of their geographical *distance*, their *removal* from Europe, and by their artistic *nearness* to it. In this respect, the eventual flowering of Irish art in the twentieth century bears some comparison with a

31. Tate Britain is almost Hiberno-phobic in this respect: hardly a whiff of the impact of these quite frequent peregrinations upon Society, Irish or English.

similar series of events in Iceland – countries that in artistic terms have real affinity, and that are in many ways still separated by little more than a single consonant. Add to this a further duality: an increase in Irish subject matter and of local colour in art and design, giving weight to what might be termed a form of national *fin de siècle,* a drawing down of blinds on a long era in which Irish artistic activity was hardly seen as such; when it was nearly subsumed into the larger culture of mainland Britain.

Finally, and in some ways inextricably linked with all this, came the first results of truly Irish creativity in the wake of the 'Celtic Revival' that ebbed and flowed from the 1880s until the early twentieth century. In that era, literature, poetry, music and – finally – art were used to provide cultural manifestations of Ireland and Irishness in an Irish setting that was becoming increasingly politicised. Taken as a whole, the artefacts of the Celtic Revival, or 'Irish Renaissance', were, and remain, a vital and combustible mixture of anachronism and potential, a source of interest and energy combined, for several generations of twentieth-century Irish artists, and for their contemporary successors. A century later, in the 1980s Irish artists working with one eye on political events in Ulster began to undertake similar searches for specifically Irish subject matter, the better to create eloquent, modern embodiments of Nature, life and living: 'traditional' but vital themes in Irish art, and unique in the Irish world view, presented as commentaries on the Irish condition in the late twentieth century, and which support scrutiny against a wider background of contemporary European art.[32]

So... how do you capture that intrinsic 'Irishness' in Irish art? What is it? When do you know you're in its presence? In the world of contemporary consumer culture, a stranger to Ireland is likely to assume a set of utterly misleading national characteristics, delivered through the use of exaggerated speech forms, mimicry and dialects, and set in a pseudo-Celtic soundscape, where an ocean of stout laps timelessly against the rims of legions of pint glasses, accompanied by drums, fiddles and pipes. Nice interlude, eh? But wrong, and a long way from home if you're trying to find solutions that you can relate to 'now'.

Anyone seeking a sure visual, contextual understanding of Ireland needs to experience its physical appearance, and a visual-historical starting point is best gained by

32. See McGonagle, D, O'Toole F and Levin K, *Irish Art Now: From the Poetic to the Political*, Merrell Holberton, London, 1999, with others. This is certainly the best, recent, most compact and lucid introduction to contemporary art in Ireland, descriptive and provocative in turn.

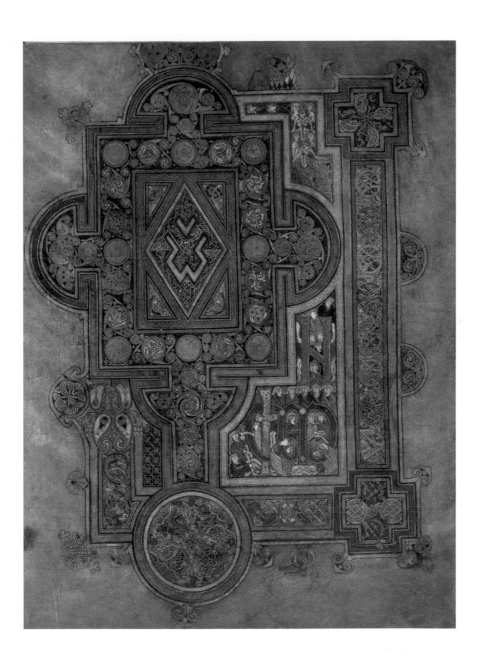

Book of Kells

MS 58 fol.188 Opening words of the
Gospel of St Luke, Irish
vellum
33 x 25 cms
The Board of Trinity College,
Dublin, Ireland
The Bridgeman Art Library

building an intuitive/sensory awareness of something of the place itself. In this respect, the lives and works of twentieth-century artists such as Paul Henry and Jack Yeats are good, early visual reference points from which a student can safely work. More recent painters, such as John Keane and Charles Harper, have used those well-trodden paths to send messages about History, in styles that differ totally from one another. More recently, new media have allowed artists such as Willie Doherty (b.1959), Abigail O'Brien (b.1957) and Alice Maher (b.1956) to move away from convention, but to develop similar themes, using even more recent ideas and attitudes, and to challenge much older orthodoxies, including religion and sexuality. All include the vital human elements that draw the *idea* of Ireland through any number of transformations: that is, not simply the representation of human beings in pictures, but the vital need to imagine human presence, living in tandem with, in awe of, in bondage to, Nature, and to the twentieth-century metropolis. You may not see them, but they're there just the same, inhabiting any one of so many contrasting, conflicting, challenging geographies or metropolises, amid unfolding emotional responses to those experiences, with all their major routes, back passages and blind alleys; and responding to the outside world, through the impact of 'the past' in all its variable glory.

Like everywhere else, Ireland has its academy of art,[33] and like everywhere else, independent bodies have sprung up in the course of time to challenge entrenched establishment positions.[34] Ireland owns a 'formal' or 'conventional' Irish art historical chronology, in which familiar terms such as 'early', 'middle', 'later', Celtic, Norman, Reformation, Protestant and Catholic are bandied about freely, to indicate the social background of art and architecture without necessarily considering the invasive, sometimes repressive, conditions in which those terms came to be present on the island. That goes for the inhabitants too. It may seem innocent enough to start most Irish art historical chronologies with the Books of Dimma or of Kells and their decorative, illuminated lettering, but the road is winding, not straight, as a good timeline ought to be, and the wheels have an annoying habit of falling off the wagon every so often. Better to forget that timeline, and imagine a rather sketchy ellipse, into which we have to admit the development, in the twentieth century, of art as a political tool.

33. The Royal Hibernian Academy (RHA) was formed from an amalgamation of other Dublin exhibiting societies in 1823.

34. Of major importance was the formation in 1943 of 'The Irish Exhibition of Living Art', whose founder members included Le Brocquy, Jellett, Hanlon and Evie Hone, amongst others. The IELA gave the finger to the RHA, on the basis that art and artists mattered more than an establishment line. It only took a century to get there…

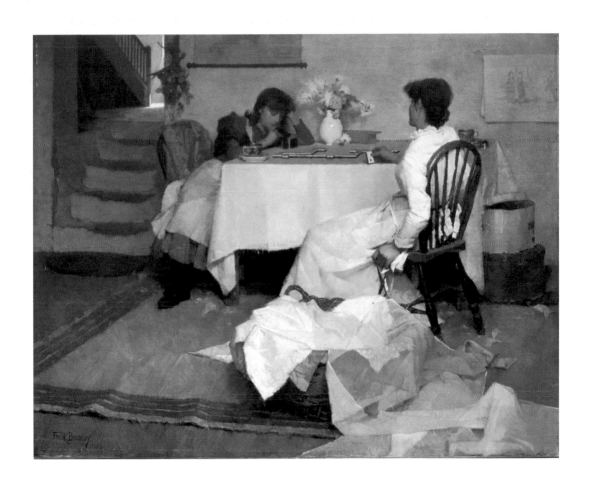

Frank Bramley
Domino!, 1886
oil on canvas
89 x 112 cms
Crawford Municipal Art Gallery,
Cork, Ireland
The Bridgeman Art Library

The use or rejection of 'modernist' idioms[35] to deliver visual messages about politics and religion has become an important part of art in contemporary Ireland. At the same time, it's worth considering that, whilst both those subjects have offered many possibilities for visual statements or commentaries, by authors of every type, and whilst individual British and Irish artists made personal work in response to the highly mobile political situation in the 1920s, and have done so more recently in the North, the creation of provocative political imagery has been at its crudest on the end-of-terrace walls of Northern Irish streets, and not in the form of 'high art', intended for the gallery. One thing is certain: there's a lot of 'baggage' here, and not all of it will be claimed quickly.

Q: Discuss the qualities inherent in twentieth-century Irish art. A ticklish business, even though some parts of the answer have been touched upon. Today's Irish art can contain similar 'lyrical' and 'mythological' qualities to those extolled by early twentieth-century writers and artists, and these are by no means elements of a larger nostalgia trip. Those same features continue to beguile viewers and artists alike, insiders and outsiders, and they throw us a line to Ireland's more recent art history; to a consideration of the ways in which what we now call 'Irish Art' came to be, and why, in the early twentieth century, the country's artists were only beginning to understand the quintessentially primeval nature of Ireland, when most other European painting was already moving towards indigenous developments from Impressionism.[36]

Sound and Vision

The translation of 'Ireland' into visual dialects requires an ability to learn vowels and consonants, the 'soft and hard' components used to send and receive visual messages, and this mixture of myth and harsh reality uncovers tonal nuances. Ireland can be every inch the rolling Emerald Isle, but to represent its topographical grandeur and, much more difficult, its innate mystery, requires some subtlety. Unusually, until the early twentieth century most landscape paintings by indigenous artists did not achieve this: they were very much a matter of observation, and it's curious that the ideas and theories of Edmund Burke, arguably Romanticism's main man, and the author of *A Philosophical Enquiry into the Origin of our Ideas of the Sublime and the Beautiful*,[37] remained relatively underdeveloped among eigh-

35. *Styles* is too strong a word to describe some of the rubbish offered up from time to time, in the name of art, in Ireland or anywhere else.

36. For example, Hilary Pyle, *Irish Art 1900–1950*, exhibition catalogue for Rosc Teoranta, Crawford Municipal Art Gallery, Cork, December 1975–January 1976, specifically pp. 9–16.

37. Edmund Burke (1757); *A Philosophical Enquiry into the Origin of our Ideas of the Sublime and the Beautiful*.

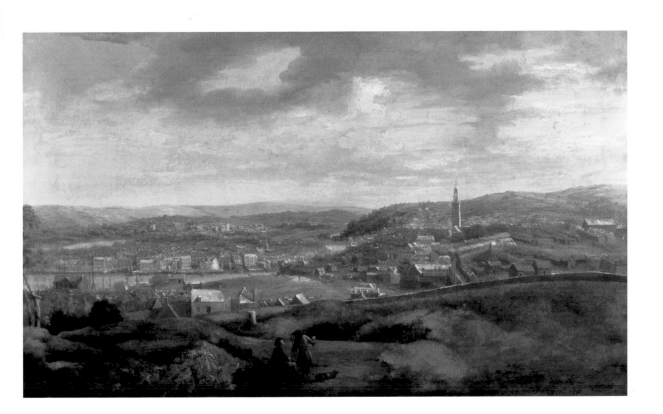

Nathaniel Grogan
View of Cork, 1780
oil on canvas
73 x 120 cms
The Bridgeman Art Library
© Crawford Municipal Art Gallery,
Cork, Ireland

Like so many provincial artists, Grogan
used his home town as a topographical
subject

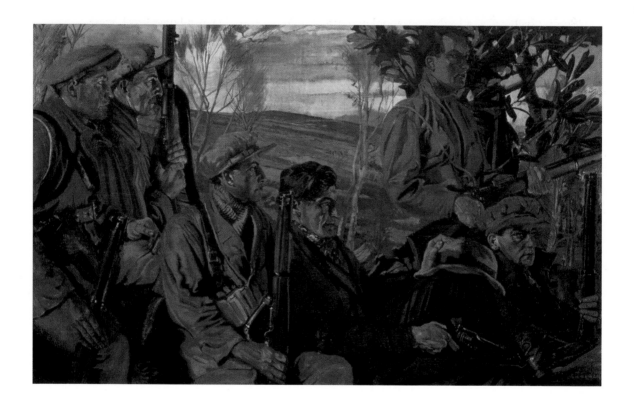

Sean Keating
Men of the South, 1921
oil on canvas
127 x 203 cms
The Bridgeman Art Library
© Crawford Municipal Art Gallery,
Cork, Ireland

One of the first important Irish political
images to find its way into a major
canvas, Keating's irregulars powerfully
convey their era, location and purpose

teenth-century artists in his homeland. Only around the start of the nineteenth century did the arrival of expressive drawing and painting as a medium, promoted by Europeans and delivered by their acolytes, open up new possibilities for the depiction of the country's different life- and landforms. Work executed in Ireland began to be about Ireland, and to look like Ireland.

'Seeing Ireland' is a highly personal experience. To do it justice at a basic level, your Sunday Painter needs a lot of white and a range of blues, for big clouds, big sky, sea and lakes. English watercolourists such as Edward Burra (what's the betting that he was drawn to The Burren by its similarity to his own name?) needed Payne's Grey in abundance. Elsewhere, warm and dark greys, purples, chrome yellow and yellow ochre, and middle and dark greens will go some way to catching the constant changes in light on the mountains and in the peat fields, in the flat coastal plains of Wexford; indigo and still more blue for the mountains of Wicklow and of Connemara, as portrayed by the Welshman David Tress; the rocks of Clare, the purple volcanic heave of West Cork. Earth colours lie beneath the green fields everywhere, the high cliffs or the rocky tumble into the water. Drawn carefully or deeply scored by repeated mark-making, the soft weather and the squally showers slashed by sunbeams can be coaxed to the surface.

There's a problem. This works brilliantly, but on one side of the coin only. By their mere existence, later twentieth-century activities in art and design, such as those in New Media, have demanded comparison with the success of traditional methods of expression, of call and response. It doesn't do to rush, however, and it should go without saying that video and performance platforms would have no place had others not broken down the undergrowth long before.

The Impact of Henry and Yeats

Before the emergence of Paul Henry and Jack Butler Yeats, there were Irish painters and sculptors, but no major painters of Ireland: no instantly recognisable icons in Irish art. Henry and Yeats were very different in all that they did and made, and with hindsight they should be seen as a powerful and necessary pair of agents for visual and artistic transformation in their own time: others came before, and have followed after. Before them, the best-known national figures appear from the

eighteenth century at the earliest,[38] and their importance, especially in the Victorian period, is as much to do with the fact that they were able to stand head and shoulders above the rest of the pack, as because they were there at all, making art early in their careers for clients from social castes similar to those they would later find in England. That art should flourish in Ireland, in unfavourable economic conditions, often remote from London society, was something of a phenomenon. The effect of distance upon the development of art education, on technical sophistication, and the commercial value of the handiwork that the best Irish artists could execute was a major problem for the home side. It is hardly surprising that raw economics caused the most ambitious among the local talent to leave Ireland for England during the course of the nineteenth century, and in real terms their departure meant an absence of proficient artists whose work might exist as benchmarks for those eager to learn. It was a problem only properly addressed in the 1880s. Of the leavers, many became domiciled in England and enjoyed varying levels of success. Among the greatest of these, in painterly idioms that ranged from the topographical to the mythical, were James Barry, Francis Danby, William Mulready, Daniel Maclise and Nathaniel Hone. In sculpture, there were fewer still, with John Henry Foley topping the list, and few others behind.[39]

At first glance, the younger Henry and Yeats were merely perpetuating this condition. Henry was born in Belfast, and Yeats in London.[40] However, both were exposed to French painting and the backwash of Realism during their art education (it was Whistler for Henry; Fred Brown and the Salon des Indépendents for Yeats) and each was successful in London and in Dublin, but their techniques are poles apart. Where they differed from their predecessors was that, as their careers unfolded, they came and went, backwards and forwards, between Ireland and England. Both were to spend long periods – years in Henry's case – in the West of Ireland, Henry in Achill, Yeats in Sligo, utterly seduced by their subjects. Henry's harmonious colours, his wide, high skies with their almost-biblical cloud towers (was Ireland a painter's Babylon, an Atlantic West Indies?) glowering over mountains or bog-land, and his consistent ability to suggest the biggest elemental Irish vistas on small-scale canvases, are a world away from the compact impact and expressionism of Yeats' flashing palette-knife, his sometimes lurid colour contrasts and his easy switches between the ebb and flow of metropolitan life and the sea, adrift or ashore. This difference doesn't matter. What *does* is that their art was modern, of its time, and fun-

38. Some student readers may not like having to think about an era so long ago, but sometimes you have to bite the bullet. There was a world before 1933.

39. Foley was responsible for the figure of Prince Albert, on London's Albert Memorial; working with him on the Memorial project were his fellow Irishmen Samuel Ferris Lynn (1834–76) and John Lawlor (1820–1902).

40. Yeats was the brother of the poet WB Yeats: an all-rounder, he wrote his own prose and plays.

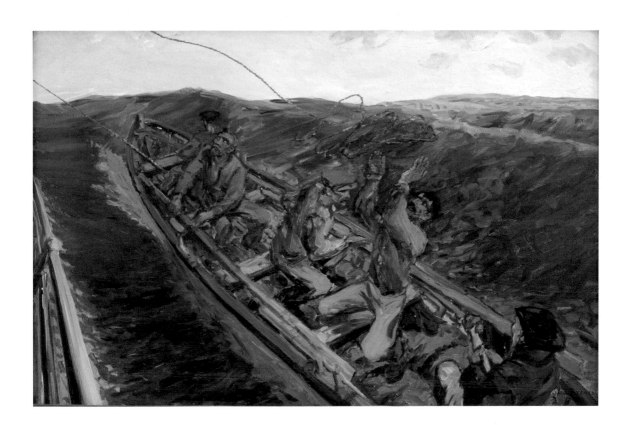

Jack Butler Yeats
Off the Donegal Coast, 1922
oil on canvas
61 x 91 cms
The Bridgeman Art Library
© Crawford Municipal Art Gallery,
Cork, Ireland

The energy of Yeats' expressionism
appears in this marine painting,
unusual in his output

damentally expressive at root. It was about living and experience, and in this respect the two form convenient bookends, a context for the other Yeatses, for the literature of Joyce and others, and much art in between and afterwards.

Henry and Yeats opened the big barn doors of early twentieth-century Irish art to reveal open fields in which their peers could evolve more distinctly as authors, using new themes and different ways of seeing, in portraiture, in narrative painting, where meanings can be two-a-penny, and eventually in sculpture also. 'Art-in-between' begins to be more intelligible. In-between Britain and Ireland, that is. A clear divide begins to establish itself between the extensive range of neo-French styles and techniques excellently practised by John Lavery, Walter Osborne, Edith Somerville, Frank Bramley, Roderic O'Conor and those who sought specifically Irish subject matter, found it, and delivered it with a strong feeling for specifically local colour. The best representative examples are prosaic and sanitised but are deservedly well-established: portraitists such as Leo Whelan, Charles Lamb, Sean Keating, and, in sculpture, Oisìn Kelly, were very important in their genre, simply because they established such subjects and gained acceptance for them among contemporary Irish audiences. Their people have presence, reserve, formality, character: recognisably Irish at a basic level, as opposed to po-faced (if beautiful) protestant gentry, or to the legendary figures that populated eighteenth- and nineteenth-century narrative painting and sculpture. You have to start somewhere. Those works were the remnants of the first wave of nationalist introspection generated by the Celtic Revival. To an outsider in the 1970s, their presence, the facility of their authors, and of their historical importance were all self-evident, but coupled with interest and pleasure was surprise at the relative void, the time-warp in which they were situated: of their academicism and their relative isolation against the swiftly changing face of contemporary art practice, and the developing network of support for contemporary Irish art.

The most important changes within Irish art of the era after 1950 reflect a concern among Irish artists of every kind to develop themselves internationally. There is a view that the effect of this is to undermine the fundamental cultural responses of artists to Ireland herself; that this will erode their sense of 'Irishness' (here we go again), but this seems likely from a rather different perspective: the failure of too

Paul Henry
Rain on the Bog
oil on canvas
36 x 41 cms
Private Collection
The Bridgeman Art Library

many artists to function as conduits for visual and sensory experience, simply because they are unable to 'feel' as deeply as they should. In Ireland of all places, this is an unhappy situation. The migratory processes that gained Ireland so much, through the examples of Evie Hone, Mainie Jellett and, later, Louis Le Brocquy and Anne Madden are too important to be negated through sheer ignorance. Travel and its influence are vital features in their works, in the shape of an expansive openness to subject that lacks visual constraints. Others followed. Tony O'Malley, Charles Harper, Pauline Flynn and Bernadette Kiely are random examples demonstrating ways in which travel does more than broaden the mind.

And then there's sculpture. Whatever impact Irish artists have made in two dimensions, Ireland has never had a sculptor of the stature of a Chantrey, a Thorneycroft, an Epstein, a Hepworth, a Sandle. At a time when the smell of oil paint is regrettably less evident in the studio, with a growing interest in, and study of, new technologies, and with three-dimensional design in the ascendant, weaknesses in carving, casting and welding may be redressed. Irish public sculpture has been resurgent in every region since the 1990s, and in the gallery the better ready-mades and artefacts have proved to be more communicative than paint, or even graphic media, in certain circumstances. What happens next is an open book, and how 'next' is expressed is also very much a matter of Time. Time, past, present and future was never more potent than in the hands of Irish authors, yesterday, today. And tomorrow?

John Long A. RHA
Still life with Pewter Jug, 1994–5
oil on canvas laid on board
23 x 30 cms
Private collection
℗ By kind permission of the Artist

4

Scotland

It's hard to imagine just how unexciting the art of the British Isles would have been without the presence of Scotland. Joined politically since James VI and I (in 1603), and hip and thigh since the 1707 Act of Union, the impact of Scottish art and design has been seismic south of the border for the better part of 250 years. If you don't believe it, look. In that time some altogether startling talents have emerged, not just waking up the neighbours, but also making waves in deepest Europe.

In more recent times, a simple comparison between the twentieth-century art histories of Scotland and Ireland reveals some other interesting disparities. While the Celtic Revival was in full flow at the turn of the nineteenth century, you would have been pushed to decide whether the centre of all the shenanigans was located in Ireland or Scotland. The way the Scots tell it, their artists had been there, done that, and the tee-shirt had been in the laundry basket for quite a while before the Irish built up a full head of creative steam. A survey of some of today's key Scottish collections would confirm that such claims aren't mere braggadocio. The era represents one more historical moment in which Scottish artists were not just looking around them, to the south or towards Europe for newer ideas, but were being proactive: physically making the journeys and the contacts, and forging links from bases at home or abroad.

In Scotland, as in Ireland and Wales, the excellence of much of the craftsmanship dating back to the Viking period tends to speak for itself. It attests to the presence of talent and ability in that era; an alertness occasionally so intense that in the later twentieth century the profound artistry of artefacts such as the twelfth-century Lewis chess pieces surely proved as magical for children and non-arty adults as they seem to have been for British sculptors from both sides of the border, such as Anthony Gormley or David Mach.[41] What neither of the latter can match is the peerless painting that emerged from Scotland from the later seventeenth century onwards. Taken as a whole, it may look like an enormous leap but it isn't: regardless of politics and religion, Scotland was surely blessed in the art that emerged from it.

Any assessment of Scottish art[42] necessarily takes into account the migratory tendencies of its practitioners, together with a willingness among art-minded Scots to

41. Or is it that we're just all kids at heart? The Lewis Chessmen were the source of *The Saga of Noggin the Nog* by Postgate and Firmin (1968), still enjoying cult status all these years after their 1968 outing and their transformation into fabulous animations for BBC Children's television: see www.smallfilms.co.uk/noggin to get the full effect. As for Gormley, look him up. It's too tiresome, but Mach is another kettle of fish, Scottish and droll to the quick, and his big, big multiples surely owe as much to the depths and breadth of past achievements, such as the Chessmen, as they do to the superficialities of Pop art.

42. Non-initiates will surely find Murdo Macdonald, *Scottish Art*, Thames & Hudson, London and New York, 2000 a highly accessible starting point. Follow it with Duncan Macmillan's *Scottish Art in the 20th Century 1890–2001*, Mainstream Publishing, Edinburgh, 2001.

accept new ideas more readily than those people to the south, and a paradoxical tendency not to spend money on them. The relatively late establishment of the Royal Scottish Academy (1826) suggests that, for some time, the better Scottish artists were doing well enough in London, and that, when it came, the emergence of the RSA may have resulted less from any determined desire for partition, as from the lack of elbow-room at Piccadilly, and the collective need to ensure that reputations and traditions were sustained north of the border, whatever the glister of Burlington House.

Aside from important issues of repute and hard cash, other local factors did and still do affect Scottish art. For instance, it's fair to say that the Scottish public were and remain highly colour-conscious, and that their subjective and emotional responses to work developed by artists who employ wisdom combined with a colourist's eye are more open and generally more warmly welcoming than the more reserved responses to be found south of Berwick. The existence, success and imitation of the 'Scottish Colourists' of the early twentieth century tend to confirm this notion, but we only have to examine a spread of work from the early eighteenth century to see how that situation began to develop.

Unlike artists in Ireland, Scottish artists undoubtedly benefited from the country's physical linkage with England... but, as with Ireland, there came a period in which the mixture of Scottish art and politics proved potentially problematic for the English. This situation was caused by the appearance of the Tartan in portraiture, largely because of its very strong associations with the Jacobite Rebellion of 1745–6,[43] after which right-wing English politicos chose to identify its wearers with sedition: with revolt against the crown. For such people, the appearance of the kilt was a clear visual statement about the political positioning of the wearer in relation to the Hanoverian monarchy of the day. It took half a century or thereabouts, and the activities of one of Scotland's very finest portraitists, Henry Raeburn,[44] for the tartan to regain acceptance by outsiders when it appeared in the portraits of Scottish worthies but, when he painted them, they looked both glamorous and respectable. When in 1822 the novelist Sir Walter Scott engineered a Royal visit to Edinburgh by George IV, the event may have been designed to bury some rather chipped hatchets on both sides,[45] but it also effectively confirmed Scotland's distinc-

43. You know – the one led by Bonnie Prince Charlie: *Speed Bonnie Boat.* That's Charles Edward Stuart to sticklers for accuracy. He lost out, for reasons that have no place here.

44. Interesting, isn't it, that the brilliant and prolific Raeburn was born *after* the 45, and

was thus distanced from it, and from the savage, brutal aftermath of the Battle of Culloden. He was therefore able to work on a 'clean' canvas, and his explosive portraits of the Highland Chiefs McDonnell of Glengarry and The McNab perform transformative wonders on notions of 'the past' in Scottish visual iconography.

45. See Bindman, David, *Inventing Britain: British Art and National Identity,* Tate Publishing, London, 2004, p. 8.

Joan Eardley
Street Kids, c1941–51
oil on canvas
103 x 74 cms
The Bridgeman Art Library
© Scottish National Gallery of Modern
Art, Edinburgh

Josef Herman's social subjects influ-
enced Eardley's earliest Glasgow
images

tiveness as a geographical and political entity,[46] and an artistic one also. Scott unwittingly pointed the country towards a position in which its art and artists might generally and realistically be said to have been more proactive and exploratory than their English counterparts. That this situation prevailed for over a century is surely one of the most remarkable features in the history of British art.

Scotland's artistic self-discovery went a long way in tandem with England's, and began a full half-century before Raeburn's birth. Classical taste and the influences of the Grand Tour[47] were strong in both countries during the early eighteenth century, and were especially evident in the activities of the architect and designer Robert Adam. Adam managed to keep a foot in both camps for, in his designs for great country houses north and south of the border, he astutely gauged the very real differences in taste that existed in England and Scotland, resulting in building projects that used local materials to suggest the existence of an often mythical, but highly believable, Scottish architectural vernacular, which affected national sentiment. In the same period, the painter Allan Ramsay provided portraits that were every inch as good as anything executed in London, some of them of breathtaking ability, including that of his wife *Margaret Lindsay*. This type of directness, to be found in work by Ramsay, and – spanning the turn of the century – that by David Wilkie emphatically establishes Scottish portraiture as something much greater than a tendency.

Wilkie transformed Scotland's narrative tradition, in all its manifestations, into an influential factor in British art. His career spans the full impact of the Enlightenment and the evolution of Romanticism in art, and his paintings, with their entrenched social themes and pointed wit, are arguably the most rounded culmination of the influence of Hogarth on high art. Where, in English painting, George Morland's images are folksy and charming, in Scotland Wilkie's are the real deal: hefty presences that disdain the merely decorative, and whose characters demand attention past the weigh-in, and well into the final rounds, to tell stories that might not always sit well among polite society. Compare Wilkie's *The Blind Fiddler* (1806) with Joseph Wright of Derby's *Experiment on a Bird in the Air Pump* (1768) and you'll do more than wonder whether Wilkie is giving the finger to Wright, in a deliberately fustian version of the other image, with all its dramatically 'enlightened' overtones. And it gets better.

46. We have only to look at the situation as it now exists, with a steadily devolving state, and a rather over-budget Assembly Building, to conjecture how matters may end, perhaps sooner rather than later.

47. The Grand Tour has a history of its own. Grand Tourists were usually the sons of wealthy Britons who were sent to Europe to vitiate their baser instincts and (it was hoped) to replace them with a rather greater intelligence in, and understanding of, classical antiquity, philosophy and the arts. As a result, British architecture and artificial landscapes benefited enormously, as did those who designed them.

James McBey
Moray Firth
etching
24 x 18 cms
© Aberdeen Art Gallery / Family of James
& Marguerite McBey

While Scottish narrative painting of the Victorian era runs happily in tandem with similar imagery available down south, as well as with much work executed in France and Belgium, there are important differences elsewhere. There was no Scottish contemporary of Constable, nor of Turner: nor were there equivalents until the end of the nineteenth century, in the shape of William McTaggart, and they had to wait for nearly a century for Joan Eardley. Nor were there any true Scottish Pre-Raphaelites, but what you never saw, you never missed. On the other hand, Scotland spawned the orientalist David Roberts and William Dyce, both of whom gave so much in different ways to the English, including direction to their search for the exotic, to their innate nostalgia, and – in Dyce's case especially – to their belief in art as a formal, almost scientific process.[48] Throughout the British Isles, the Past was of fundamental importance in every area of narrative painting, whether the subjects were romantically fictitious or grounded in fact or probability. In Scotland, mid-nineteenth century artists such as Nasmyth, Bell Scott, Faed, and, later, Orchardson, charted courses in which painterly facility and wit were of equal importance in images whose key components combined Scottish national pride, nostalgia and narrative illustration. They were as contemporary in their styles as in their treatments of the past in their subjects, and they make very interesting comparisons with English paintings of the same period. Among the greatest but contrasting images of this time were William Bell Scott's extensively titled *In the Nineteenth Century the Northumbrians Show the World What Can be Done with IRON and COAL* (1855–60), James Drummond's imaginative *The Porteous Mob* (1855), and Thomas Faed's *The Last of the Clan* (1865). Any of these might as easily have been compared with the social situation in Ireland, and whilst Victorian painting in Scotland might not have been as rich in its variety as its English counterpart, its practitioners were remarkable for their skills. Remember, we are talking about a country whose population rose from about 1.6 million in 1800 to 4.1 million by 1899, and more or less stayed that way. Indeed, viewed as a sector of its population, Scottish artists (never mind its designers and architects) move sharply into the focus of their nineteenth-century contemporaries at this time, precisely because of the distinctive abilities and activities of specific groupings within an artistic landscape whose radius is impressively wide.

48. William Dyce played a major role in establishing the criteria that would eventually govern the benchmark skills employed in English municipal schools of design. Regrettably, he was way off the mark and, unfortunately, the situation didn't improve especially quickly. For details, see the impeccable Macdonald, Stuart 1971, repr. 2004, *The History & Philosophy of Art Education*, Lutterworth, Cambridge.

Thomas Faed
The Last of the Clan, 1865
oil on canvas
86 x 118 cms
The Bridgeman Art Library
© The Fleming-Wyfold Art Foundation

The Scots as Victorians liked to
imagine them.

As Scottish art has evolved since the turn of the nineteenth century, its visual imagery and pictorial syntax, together with the palettes and colours used to develop these, have tended to reflect the country's northern location, when compared with work emanating from England. This north–south axis is a real one, if it is not always evident, and is given substance by east–west differences and variations in work emanating from Edinburgh and Glasgow. Even the intensity of the warm colours on some Scottish palettes can differ significantly from others found elsewhere in the British Isles: to some extent it's a matter of seeing.

Such differences are readily (and sometimes headily) apparent in works made from 1880 onwards, in which new directions in painting and in style became apparent in Scottish art, just as they did in England. The informal influence of Whistler was strong in landscape and portraiture, but so too was that of Impressionism, especially that distilled via Newlyn, and, after 1900, via Cézanne. And if the way you held your brush or applied colour wasn't enough, the physical arrangement of your work became a strong feature of all Scottish painting after 1900. Ideas and responses abound in all art made at this time, from the flattened decorative work that characterises the 'designed' activities of CR Mackintosh and Margaret Macdonald or Jessie M King, through the evolving, ordered impressionism of Samuel Peploe, George Leslie Hunter and of FB Cadell to the deliberate, Cézannesque style of JD Fergusson. Those influences were sought out, as much as they were received, when Scottish artists studied in France, as many did both before and after 1900, or when they travelled even further, like EA Hornel and George Henry, who spent nearly eighteen months in Japan (1893–5), and Arthur Melville, who worked extensively on the North African Mediterranean coast during the 1890s. The chromatic outcomes of those experiences were at least as powerful as the stylistic ones, in and outside Scotland, and are at the core of the attraction that Glasgow painting holds for many to the present. It is interesting to consider the views of some commentators that recent Scottish painting is the result of tendencies, rather than specific influences. If so, Scotland, unlike the rest of Northern Europe, seems to have been largely untouched by the influence (and the primitivism) of Gauguin, and instead has tended towards the realism of Manet, and to the chromatic inclinations of Matisse. This is more evident in Scottish portraiture and figuration (for example James Cowie, Mary Armour) and landscape in oil and watercolour (for example that of

John Maxwell

Night Flowers, 1959
oil on canvas
91 x 61 cms
Tate, London 2006
© By kind permission of the Estate
of the Artist

William Gillies, John Maxwell) of the inter-war period, which bears strong comparison with similar work from all the Nordic countries:[49] despite present inclinations to reject nationalistic tendencies in any form in art, a similar comparison may still be made.

Nationalistic elements, content and traits are contentious issues in any account of British art. They reside in context or memory, or a combination of both: nostalgia. They may be figurative or abstract, and are triggered by content or subject, colour and technique. And they can be intrusive, persuasive, can interfere with art that would be all-embracing, so that only a determined effort will deny such presence, and admit what universality?

Such elements do not constitute contagion, and they are necessary components of any national art scene, if only because they deny a controlling interest to all-embracing internationalism. In Scotland, this has been an important evolution, not simply because the country has done so much to establish British art as a major player in world art, but because post-war, cold war, and postmodern art have all had parts to play in the process.

It fell to Glasgow to be the focus of much wartime and post-war artistic activity in Scotland, partly because of the arrival of the Polish artists Josef Herman and Jankel Adler in 1941. Adler moved south before the war's end, but left the imprint of his own post-Cubist pictorial language on 'the Roberts' Colquhoun and MacBryde, and – in terms of spatial and surface activity – on the young Joan Eardley: Herman was also a profound influence on her. At this time, English artists of a generally older age group were creating Neo-Romantic work that at its best was hauntingly affecting: at least one of this grouping, Michael Ayrton, was making work that can stylistically genuinely be compared to the Roberts', and in its atmosphere to some of Eardley's. In Scotland, Anne Redpath was following a pathway not unlike that of John Piper in England, and there were other strong Anglo-Scottish visual similes in subject, or technique: Earl Haig with Ivon Hitchens, for example. Comparisons like this are perhaps inevitable, and some may find them invidious, but it is important to recognise that this common thread continues into the present, and thus into a twenty-first-century human condition in which the term 'sense of place' has been

49. 'Nordic' means Denmark, Norway, Sweden, Finland and Iceland, and my meaning includes superb work from all these countries.

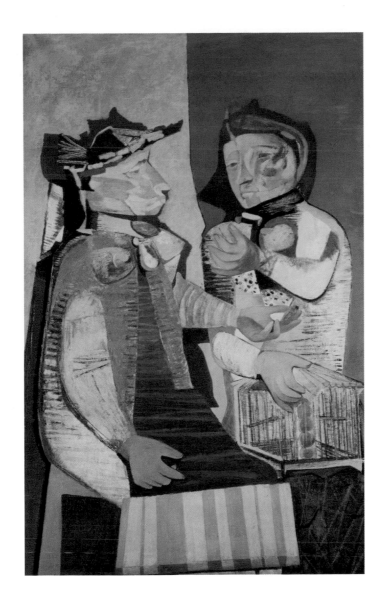

Robert Colquhoun

The Fortune Teller, 1946

oil on canvas

126 x 81 cms

Tate, London 2006

© The Estate of the Artist

A typical example of the way in which
Colquhoun (and MacBryde) were deeply
influenced by the cubist-inflected visual
language of Jankel Adler

allowed to admit objects, shapes and meanings, as well as its original association with topographical locations: Elizabeth Blackadder and Barbara Rae, two very different artists, respond strongly to the exotic, in colour and form, in paintings and prints that may be as distantly esoteric as they are specifically nostalgic or evocative. Sensory or emotive responses are sometimes brought into play when literal meaning is denied by technique.

Since the 1950s, a major player in such activity has been Alan Davie, painter and pianist (or the other way round). Back then, Davie was beginning to paint increasingly complex abstract oils, often architectonic, sometimes misleadingly random, replete with signs and symbols that seem to have run parallel with his devotion to jazz. This combination of the subconscious and the intuitive, and the suggestion of essential, rich musical allusions, are fundamental to any acceptance of Davie's work. The attack of his early paintings resonates with the fiery Be-Bop of Charlie Parker, through John Coltrane's 'sheets of sound' and beyond, and Davie's use of the Renaissance-style triptych as a platform for the delivery of entangled messages might reasonably be interpreted as a figure of reference, just as musical figures in jazz will often refer to a 'known' melody. Since the 1980s Davie has stripped back his process, suggesting clarity with signs and logos, yet sustaining the mystery of painting through the use of obscure meanings and non-Western motifs that are rarely earthbound.[50] It is perhaps fanciful to consider the abstract complexities of some of Davie's earlier work against the tendency of later generations of Scottish figurative artists to shoehorn complex imagery into large canvases... and maybe it isn't. John Bellany, Steven Campbell and Adrian Wiszniewski or, later still, Ken Currie enter the frame here, creating narratives more pointed, more potent and comprehensible, and often more Celtic than anything of Davie's, yet utterly individualistic: unfettered. Viewed as a microcosmic, cross-cut series of images made in a miserable half-century, this small grouping, randomly called forth here, make for potent viewing.

If at one level Davie's paintings of the 1950s and early '60s are taken as an overture to Scottish art amid the tension of the Atomic age, Ian Hamilton Finlay surely mined the etymology of 'Nuclear' within the confines of his garden at Little Sparta, Lanarkshire, where he wrought his own responses to the most paradigmatic visual ideals, perception, realisation and the vagaries of existence itself. Among his carved

50. Davie shared a passion for gliding with his friend Peter Lanyon, who in 1964 died following a flying accident.

Ian Hamilton Finlay
Even Gods have Dwelt in Woods, 1976
stone
230 x 281 x 74 cms
The Bridgeman Art Library
© National Galleries of Scotland Scottish
Arts Council Collection; presented 1997

Finlay's use of landscape, especially
that of his Scottish home, was a key
source for much of his work

and inscribed monuments, many combine power and subtlety, and their legends and rubric compound worldliness with barbed wit, usually at the expense of Authority. In subject matter ranging from the eighteenth to the twentieth centuries, such revolutionary republicanism sometimes stigmatised Finlay during his career, yet this could seem entirely appropriate: he was a Scot (those Jacobins again), a loner, (footnote[51]) and one of the few British artists of the last century to devote his work to meaningful rhetoric that pointed squarely at the inability of human beings to deal with the natural world and its beauties.

In recent years, Scottish painters have continued to work across, and into, pre-existing themes, some more pronounced than others. Among these are forms of narrative art that work at several levels. They range from the local sensory that declares the geographical source of a work (for example, Glaswegians might call a work 'very Weegie') because of its light, or because it resonates with the sense of a particular environment, to those whose monumentality comes not in terms of size but within a grandeur of conception that can range from specifics to a more expansive, general commentary. It would be absurd to suggest that this always happens, and no, the Scots don't have a word for it, but when it does appear they not only do it well, but they range across every boundary. And achieve it through evolving and maturing talent. Without it British art would be nothing.

51. Until 2000 Finlay suffered from acute agoraphobia.

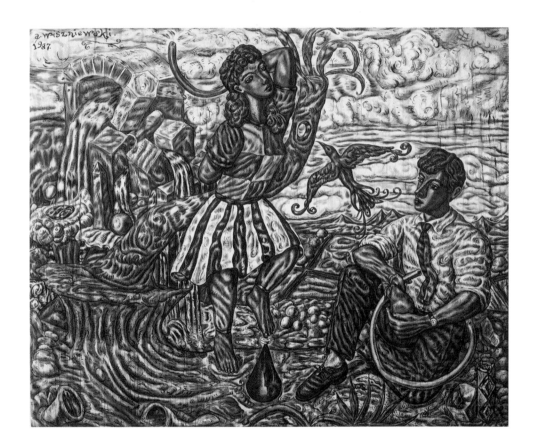

Adrian Wiszniewski
Landscape, 1987
acrylic on canvas
263 x 310 cms
The Bridgeman Art Library
© National Museums and Galleries
Merseyside Walker Art Gallery,
Liverpool, UK

The cycle of life, birth, the universe and
everything, in a quickly painted canvas

5
Wales

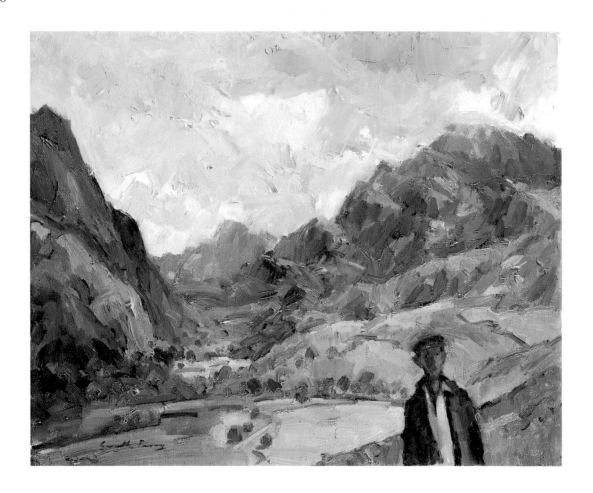

Gareth Parry

Going for a Walk, Nant Peris

51 x 61 cms

Reproduced courtesy of John Davies

Gallery, Stow-on-the-Wold

© The Artist

A short walk in the Welsh mountains:

Romanticism reduced by humour

'The Welsh are naturally gifted and drawn to music and literature, but I am sure that they also have a talent for painting, only they don't know it yet.'

David Bell to Josef Herman, *Related Twilights,* 1975

Shakespeare had a thing about the Welsh, but then he would, wouldn't he, because Gloriana[52] herself was substantially Tudor, and he needed to curry favour with the Boss-lady. The History plays are peppered with Welshmen, usually energetic, noble chaps when they aren't actually Harry, Prince of Wales himself.[53] Whence do they come, these manly paragons? From a place that's an amalgam of some of the wildest and most beautiful parts of Britain, that's where: a combination of the topographical extremities of Scotland, the wildernesses of Ireland, the Yorkshire Moors, the Derbyshire Dales and a few other spots thrown in, all of them riveting as landscape visions. So, one might ask, why in heaven's name didn't they hang around there, to give the place some sort of artistic tradition? Why wait until 1956 before rattling cages? Bright lights? Big city? It doesn't quite make sense.

It's just possible that Wales itself, in all its glory, sound and vision, holds the key: too raw, too majestic, too overwhelming. Until recently, that is.

There are few places in Wales where hills are entirely absent, or where you are far from the sky, or from the way that it regularly encroaches onto the business of Being. You can hide in hill country, and there's a lot of it in Wales. Just to see its extent is to understand its appeal for artists of every type seeking to respond to Nature; for fugitives, running for cover, whatever the threat or as places in which small communities might practise the type of unthinking sectarian conformity so pilloried in the poetry of RS Thomas.[54] Wesleyans. Methodists. Strict. Chapel. Artists.

Wales is a land inextricably attached to England, separated only by natural boundaries of water, more hills and more mountains and what's left of Offa's Dyke.[55] Its wildernesses have attracted all comers since the earliest times, for their remoteness is similar to that of the sacred places of Salisbury Plain or New Grange, allowing an

52. That's Queen Elizabeth I to you: her pa, Henry VIII, was the son of Henry VII, Henry Tudor. His parents were Owen, as Welsh as they come, and Katharine, widow of King Henry V. The rest, as they say…

53. And that's the future King Henry V, that is.

54. RS Thomas (1913–2000) was undoubtedly one of the greatest Welsh poets of the twentieth century, and ranked as highly in any British pantheon.

55. And that's dyke as in long earthen rampart, dating back to the 780s AD, built for reasons that are unknown today, and roughly following the present England – Wales boundary.

easy, yet not facile, combination of Nature and Mythology. For those who wished to physically own Wales, to conquer the principality, Wales was the wild, wild west: Injun Country to Romans and to Edward I's freebooters, the ruins of whose castles pepper Monmouthshire and snake north to Caernarfon and around the coasts. Elements of Arthurian myth and legend continue to bind some of this together, but the ties are becoming fragile today, reflecting the changing face of what were formerly discrete communities. Where indigenous musical and literary traditions have flourished, visual traditions have had to work hard to sustain themselves. One of the chief features of art in Wales is that, in the past, blow-ins – outsiders, and not Welshmen – have contributed to its visual expression as much as, if not more than, Welsh artists themselves. That paradoxical situation has diminished somewhat, but together with other recent demographic problems, including a falling birth rate, it still needs to alter if indigenous art in Wales is ever to be sound and self-perpetuating. That seems like a good idea, however it may fly in the face of political correctness and the rush to become internationalised.

Who do You Think You Are?

Outsiders' perceptions of Wales suffer from stereotyping on a pretty grand scale: not always negative, but you don't have to think very long about this to imagine what they might be: it was a determination to reject, and indeed to transform, such stereotypes as a basis for indigenous art that led in 1948 to the formation in Cardiff of what has been called 'the Rhondda Group', around the émigré artist Heinz Koppel.[56] In 1956 Eric Malthouse[57] was similarly motivated to start the 56 Group (great name) in Swansea that year, as a collective of independent contemporaries. In different ways, both groupings made vital contributions to the progression of art in Wales into the twenty-first century: in the hands of Koppel and of Ernest Zobole the purely mundane transcends industrial reality: others have noted the influence of Chagall, but Zobole's later work especially conveys an inner compulsion that imposes 'outsider' status upon his images of workaday South Wales. Malthouse and his collaborators[58] were less domestically specific in their aims. They wanted to take Welsh art into the wider world, to begin a process of europeanisation, and to reduce what appeared to be an increasing tendency towards an undermining artistic insularity. What did they face otherwise? At one extreme, a long tradition of images of

56. The Rhondda Group evolved at the Cardiff College of Art. They were Heinz Koppel, Ernest Zobole, Charles Burton, Glyn Morgan, Nigel Flower and C Mainwaring; for a view on the impact of those artists, see Cucksey, Roger and Wilson, John (2004), *Industrial South*

Wales: the Poetics of Place, Newport Art Gallery, Newport.

57. Eric Malthouse was born near Birmingham. Appointed to a Lectureship at Cardiff College of Art in 1944, he remained in Wales until his death.

58. The 56 Group were not all Welsh; however, the 'blow-ins' had been working in Wales for some years. They were Eric Malthouse, Michael Edwards, Will Roberts, Robert Hunter, Arthur Giardelli, David Tinker, Michael Edwards, Trevor Bates, Heinz Koppel, Ernest Zobole, John Wright, Hubert Dalwood, George Fairley.

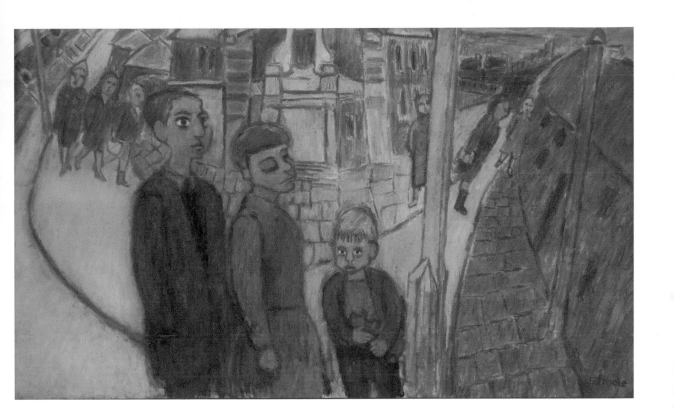

Ernest Zobole
The Family c1960–61
oil on canvas
92 x 153 cms
Private Collection
© Ernest Zobole Trust

the lakeland of Snowdonia and, at the other, an uneven series of sound but unexciting (no one said it was pretty) realist images born of the collieries and heavy industry of South Wales, like the portraits of Alfred Janes or – not quite as good – Evan Walters. As a condition unavoidably caused by the impact of the best part of two centuries of British art history, this sort of realism wasn't helping Welsh art in the post-war era: if successful, the 56 Group could reduce that type of activity to the status of a mere component in a world's-eye view. Malthouse's own work as a painter-printmaker was a natural focus even 13 years later: his generic print series *Façade* (1969) expressed responses to a jazz setting by John Dankworth of Edith Sitwell's 1920s verses,[59] with eclectic origins that clearly acknowledge influences that include Picasso, Matisse, Patrick Heron and Clyfford Still. The group's determination to have done with perceived constraints quickly bore fruit, with a wealth of European and even American connections established, but by the mid-1980s the group had aged: one commentator suggests that its original momentum had been lost.[60] Today, Group 56 Wales continues to invite its membership, which means that internal cohesion will depend upon the elected officers: something that may yet have an effect on the future direction of the art of the principality as a whole.

Away with the Fairies

If the men of 1956 saw their self-imposed task as one of mountain-moving, that isn't especially surprising. Like the Highlands of Scotland, North Wales had been a magnet since the mid-eighteenth century for any artist enthralled by Romanticism and or by the Picturesque, and in Richard Wilson Wales actually had a native who showed the way. Wilson's career is important, because he was amongst the earliest artists to exhibit his work at London's Foundling Hospital (see Chapter 16, Showing Off, Making Waves); because in 1750 he moved to Italy, where he quickly understood the possibilities of Italian light; and because he took a major risk: he decided to paint classical landscapes, and nothing else, using Claude as his example (didn't they all?). Wilson's landscapes are masterpieces of structure, using light, form and space apparently effortlessly, but subtly stating the grandeur of Nature as none of his contemporaries could. If *Snowdon from Llyn Nantlle* (*c*1766) is his best-known painting, it's easy to understand why, and also why it remains so impressive to this day: as William Vaughan has noted, '...by clothing local scenery with classical

59. *Façade* dates from 1922: alterations and several additions were very much a part of its early life.

60. See Rowan, Eric, *Art in Wales: An Illustrated History, 1850–1980*, Welsh Arts Council University of Wales Press, Cardiff, 1985, pp. 123–29, an excellent survey within its own chronological limitations.

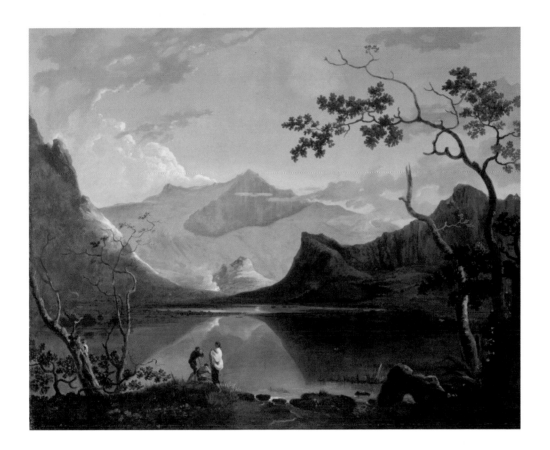

Richard Wilson
Snowdon, 1765
oil on canvas
104 x 127 cms
Nottingham City Museums & Galleries
(Nottingham Castle)
The Bridgeman Art Library

Bert Isaac
Treetop Hill, c2000
acrylic on board
92 x 122 cms
Reproduced courtesy of John Davies
Gallery, Stow-on-the-Wold
© The Estate of the Artist

Powerful use of European visual
language made Isaac an important
Welsh artist and teacher

John Piper
Tryfan, North Wales, 1945–46
ink and wash
The Bridgeman Art Library
© Private Collection

Piper first visited North Wales in 1942,
returned for years afterwards and
travelled the country: his intuitive
interpretations of Snowdonia are
merely one outstanding feature of
his superb output

grandeur Wilson could suggest that the appreciation of natural beauty could be available even to those who had not had the privilege of going to the Roman Campagna.[61] One generation adrift, JMW Turner was enormously influenced by Wilson, visiting Wales five times between 1792 and 1799, and using carefully planned itineraries to visit all the important antiquarian sites. The experience of the topographical differences between North and South Wales, of needing to transform his sketchbook material (indeed, to exaggerate its contents for greater effect in some cases), allowed Turner to improve his style substantially with each successive tour. His more freely rendered work, such as the sketchbook version of *Carreg Cennen* and *Cilgerran Castle* (both dating from Turner's most extensive Welsh tour of 1798) are often as powerful as finished watercolours such as *Crickieth* (sic) *Castle, North Wales* (1835), or other oils of Welsh subjects created back in his London studio.[62]

If the expanse of the landscape vision of North Wales and Snowdonia made the greatest impression on eighteenth-century artists, those of the later twentieth century responded most strongly to its sharp light, and to its ruggedness. Of these, James Dickson Innes and his mentor Augustus John, both native Welshmen,[63] went most interestingly walkabout in 1911, when, at Innes' suggestion, they painted in the mountains of Merioneth:[64] the stylistic impact of Post-Impressionism, and the opalescence of their respective palettes render these small images jewel-like, and as southern-French as others that John had painted at Martigues not long before. For Innes, the place had a compelling attraction. He had a feeling for the area, having painted there during 1910 and, as he was a keen admirer of Turner, the experience almost certainly affected him more than it did his older companion. John had already achieved fame and notoriety, more for his portraiture and for his Bohemian lifestyle than for his painting, both of which were attractive but uneven. Innes never made it that far: he had tuberculosis, and after a career trajectory that was almost manic in its intensity and unusual achievement, he died in 1914. Not the stuff on which reputations are based, perhaps, but when the Swansea-born, East-Anglia-loving Cedric Morris returned to South Wales during the 1930s, *his* standard output, usually closely-observed, sometimes 'visionary', natural subjects and human beings, made way for several landscapes in which the presence of Innes was easily discernible. Interesting.

61. See Vaughan, William, 'The British Landscape Tradition', from *Towards a new Landscape*, Bernard Jacobson Limited, London, 1993, pp. 84–101. Unfortunately, Wilson died poor: look at the collected images from his output and you will wonder why.

62. See Humphries, Peter, *On the Trail of Turner in North and South Wales*, CADW, Welsh Historic Monuments, Cardiff, 2001.

63. Augustus and Gwen John were born in Tenby; JD Innes was born in Llanelli.

64. Merioneth is now absorbed into Gwynedd; the area in which John and Innes worked remains remote, despite fair roads between Bala and Ffestiniog.

Augustus Edwin John, OM
Llyn Treweryn, 1911–12
oil on wood
32 x 41 cms
Tate, London 2006 /
The Bridgeman Art Library
© Reproduced by kind permission
of the Estate of the Artist

Probably the most important figure to work in Snowdonia with marked success was the multi-talented English painter John Piper, who first visited the region in 1943 between commissions to work as an Official War Artist, and in 1944 rented the first of two cottages to which he returned regularly until the end of the 1950s.[65] Piper's inherent need to represent surface texture, weather and the planetary ageing process went much further than facility and excellence: by this stage in his career he was an exceptionally accomplished artist. His Snowdon watercolours can be staggering presences, darkly golden, and exuding the latent power, volcanic heave and arrested form of rock-mass. These paintings are marked also by Piper's beguiling ease of approach: in paintings such as *The Rise of the Dovey* (1944), *In Llanberis Pass* (1945–6), or *Ffynnon Llugwy* (1949) he can range in or pan backwards, and continue to send the unmistakable message that, whatever the distance, here, as a spectator, or using the artist as medium, there can be no question about one's speck-like presence on the earth's grinding surface. The intensity of those interpretations cemented the Romantic aura of Snowdonia: was this what the original membership of the 56 Group wanted to cut off at the root? In the same period, there were alternative visions of the same area in progress, by the young Anglesey-born Kyffin Williams, whose work was developing an expressive power that no one could doubt. 'Piper-esque', or picturesque they weren't, but so what?

The Deep

As Piper was developing his imagery of Snowdon, in South Wales, the also-London-born Graham Sutherland was continuing to mine a seam of creativity he had first uncovered in 1934.[66] From that year, Sutherland's work was transformed by his responses to several locations on the north and south Pembrokeshire coasts, which began to inform evolving work whose location was of only slightly less importance than the changing combinations of biomorphic and unsought, or subconsciously observed, shapes that went into the paintings. Only Wales could give Sutherland this buzz, and it fizzled happily throughout the Second World War and into the 1950s. Sutherland's central position in the evolution of British Neo-Romanticism makes his stay in Wales of particular importance, and, on the whole, posterity has been kinder to the work created in this period than it has to his output after his move to Menton in the south of France in 1955. The extent to which subject matter truly determined Sutherland's activities – in other words, might he have made the

65. For those who must know, Piper's first cottage was at Pentre, in the Nant Ffrancon Valley; his second was above Llyn Ogwen.

66. See Graham Sutherland's letter to Colin Anderson, first printed in *Horizon* magazine, V, April 1942, pp. 225–35, and subsequently reprinted in Alley, Ronald, (ed), *Graham Sutherland*, exh. cat., Tate Gallery, London, 1982, pp. 23–26; also Sutherland, Graham, (ed) 1976, Sutherland in Wales / Sutherland yng Nghymru, Picton Castle Trust and The National Museum of Wales, Alistair MacAlpine, London

John Piper
Newcastle Emlyn, Carmarthenshire, 1981
oil on canvas
86 x 111 cms
The Bridgeman Art Library
© Private Collection

Graham Sutherland
Entrance to a Lane, 1939
oil on canvas
61 x 51cms
© Tate, London 2006

Sandy Haven, Pembrokeshire, richly
abstracted into an all-embracing bed
of green

Graham Sutherland
Welsh Landscape with Roads, 1936
oil on canvas
61 x 91 cms
© Tate, London 2006

Porthclais, near St Davids,
Pembrokeshire, is the scene: a land-
scape stripped back to basics

same or similar works elsewhere? – makes for interesting speculation. His presence in a particular landscape was clearly of benefit to images such as the famous *Entrance to a Lane* (1939), *Gorse on Sea Wall* (1939), *Red Landscape* (1942) and even to more stylised imagery such as that in *Thorn Tree* (1945–46), and the openness of the Welsh countryside, or the enclosures of Sutherland's favourite Pembrokeshire lanes, are evident sources for works that, for the most part, are more layered with meaning, and which drew, literally and metaphorically, on immediate experience, in the most expressively direct ways. Sutherland's own observations concerning his commissions as an Official War Artist suggest the extension of that *modus operandi*. He described his work in heavy industry, both in Cornwall and in the South Wales steelworks as '…a kind of imaginative-realist journalism which in the nature of things had to be done rapidly and without long pondering and reflection',[67] but to see this work as a continuum from the earliest wartime commissions of bombed or destroyed buildings in South Wales is to appreciate that, once entered, Sutherland's Pembrokeshire lane was the source of very much more than intimidating darkness and the cloying aroma of wet foliage; and that the *Red Landscape* might as easily be a throwback to Palmer as a portent of Hell.

So much greater than Sutherland, his exact contemporary, Ceri Richards was Wales' most important twentieth-century artist, a player on an international stage.[68] Richards' childhood background in the Gower peninsula was important throughout his life, and took place at a time when Swansea was becoming a major centre for art in south Wales: in every way the place informed parts of a very wide-ranging output that was drawn from, and coloured by, layers of different stimuli, but Richards' sensitivity to atmosphere was key to his *oeuvre*: he was, and remains, a rarity in British art, simply because he could cut through and cross-reference waves of very different types of creative activity, including poetry and music, and side-step nonsense. If his work pays homage to the modernists who influenced him most strongly – Matisse, Picasso, and Max Ernst loom large, as they did for other artists – the ways in which Richards *used* that influence is most telling. He was a Modern Painter: his marks and hieroglyphs, his handwriting, prove the point, but the ease with which he moves from storm to calm, from bucolic passion to profound stillness, is often astonishing, and for him there is no sin in turning back the pages of art to refer to an older master, to Delacroix especially: Richards' *Rape of the*

67. Extract from an undated letter to Julian Andrews, reprinted in Ross, Alan *Colours of War*, Jonathan Cape, London, 1983, p. 49.

68. See Gooding, Mel, *Ceri Richards*, Cameron & Hollis, Moffat, 2003, for a definitive and beautifully illustrated account of Richards' career.

Ceri Geraldus Richards
Cycle of Nature, 1044
oil on canvas
102 x 153 cms
The Bridgeman Art Library
© National Museum & Gallery of Wales,
Cardiff

Wales's finest modern painter, with
an acute and astute understanding of
existence

Sabines canvases of 1948 and his *Lion Hunt* paintings of 1962–63 bracket a period in which the past makes regular appearances in tandem with newer ideas: Matisse is well to the fore in magnificent canvases such as *The Red Skirt* (1948), some of the spirit of Goya resides in *Do Not Go Gentle into that Good Night* (1956: but make no mistake: this canvas is Richards'), and there are references to Caravaggio in the *Deposition* (1958). These three are merely examples of Richards' wisdom; of the selective process that enabled him to take an old idea several more yards, or even further still. It's something to be found throughout his work.

Few direct references to Wales exist in Richards' work, but there are some signs, especially in drawings and paintings executed in 1944 and immediately post-war, such as *Cycle of Nature* (1944) and *The Force that Through the Green Fuse: The Source* (1945). In the preparatory drawings and paintings for *Cycle* and *The Force*, Richards shakes out Sutherland-like Neo-Romantic forms and refashions them, makes them his own, a transmutation into something bold, less private, less limited, less discreet. This transformative skill, this ability to quietly convert, and to do so without any self-imposed constraints, is one of the surprises and delights of Richards' output. It freed him and enabled him to reflect his serious concern for the things that make the world go round, its discord, its misery, the relief when harmony intervenes, using different painterly languages: there can be few – if any – comparisons with the relentlessness of Bacon's painting of the same era. It meant that Richards might balance his personal reverence for Kandinsky's *Concerning the Spiritual in Art*, with the same Romantic streak that allowed him, first, to form a deep personal friendship with Dylan Thomas, and, in the later 1950s, to move towards a personal synthesis of music and art: always parallel forces that informed his creative activity. It would be Debussy's *Cathédrale engloutie* that inspired him: a sunken cathedral, inspired by the lost churches at Dunwich,[69] but that might as easily have been located anywhere off the Gower coast.

In the High Hills

While Ceri Richards was still in the first flush of development, the remotest, in some ways the most austere, high ground was in the hands of the multi-talented Eric Gill, who famously moved from Ditchling, Sussex, to the heights of Capel-y-ffin, above

69. Dunwich was a prosperous Suffolk town that began to suffer major erosion by the sea in the fourteenth century: legend has it that there are 50 churches underwater, and this inspired the Debussy composition.

Ceri Geraldus Richards
The Rape of the Sabines, 1948
oil on canvas
102 x 153 cms
The Bridgeman Art Library
Private Collection

Hay-on-Wye, in 1924. Other commentators have examined Gill's sculptural, stone cutting, printmaking and religious activities at Capel more exactly,[70] and in this context they are arguably of lesser importance than the encouragement he gave to his follower David Jones,[71] who arrived that June, having just become engaged to Gill's daughter, Petra. Three years later the engagement was off, and so was Jones, back to London, and then all over the shop, painting more prolifically than he had ever done, or ever would do, joining the Seven and Five Society (1928),[72] and in the process establishing himself as one of the most unusual talents in the country: an illustrator, letterer and engraver of extraordinary quality and merit, and a water-colourist and draughtsman with a unique and compelling command of anything he turned his hand to: look carefully, and an unyielding delicacy reveals itself. The Gill–Jones association had commenced in 1921 when, following conversion to Catholicism, Jones had visited Gill at Ditchling, and it is to Gill's credit that he recognised and redirected Jones's talent, following a history of art school false start. From the Capel period, Jones gained an understanding of directness and simplicity that Christopher Wood would have gagged for: *Tir y Blaenau* (1924), *The Garden Enclosed* (1924), and, from later years, *The Terrace* (1929), the frontispiece to *In Parenthesis* (1937) and *Vexilla Regis* (1947–8) prove that point, and show his perfectly developing mastery of pictorial space. At one extreme, Jones's masterpiece is his book *In Parenthesis* (1937), a verse saga of his wartime experiences, written to be read aloud[73] and suffused with Welshness: a testimony to the all-entwining appeal of Welsh myth and legend. At the other was *The Anathemata* (1952),[74] a complex interweaving of historical and religious allusions, as richly informed by ancient Welsh legend as by any other source – including the Bible. In its different way, each represents the extent of Jones's visual acuity; both are testimonies to his unusual brilliance.

Jones and Richards were one-offs: of younger British artists of the 1950s only Alan Davie's work offers evidence of concerns similar to those of Richards. In Wales, the impact of the 56 Group ensured the continuity of abstract art in Wales, disparate in its nature and shared between immigrants and natural-born Welsh artists alike: the work of Terry Setch and Chris Griffin merely serve to exemplify the situation. Setch's career was established long before his first exhibition with the 56 Group in 1975; Griffin's initial interests had more to do with the industrial landscape of

70. See McCarthy, Fiona, *Eric Gill*, Faber, London, 2003.

71. Jones was born in Brockley, Kent, the son of a Welsh father and an Italian mother. His experiences during the First World War resulted in the collapse of his health, but it was because of Gill that Jones developed as an artist.

72. They kicked him out in 1936 when the Society took up more abstract pursuits.

73. *In Parenthesis* (Faber), 1937, was broadcast in 1946, with Dylan Thomas and Richard Burton in the cast.

74. See Roberts, Michael Symmons, (2002), 'Poetry's Invisible Genius', *The Daily Telegraph*, 28 September 2002, available on http://arts.telegraph.co.uk

David Jones
The Terrace, 1929
pencil and watercolour on paper
65 x 50 cms
Tate, London 2006
© Estate of the Artist

One of several similar images, in which
Jones's limpid watercolour technique
and delicate use of structure are self-
evident

Will Roberts
Neath Stormy Clouds / Ty Newydd I
c2004
oil on canvas
61 x 46 cms
Reproduced courtesy of John Davies
Gallery, Stow-on-the-Wold
© The Artist

Picturesque Welsh cottage, reduced by
weather

Glamorgan and its inhabitants, and had to alter with the changing face of the sub-
ject itself: no industry, few pictures of it. Compare these with the canvases of Mary
Lloyd Jones, who grew up in the hill country of North Wales, and there are interest-
ing counterpoints: Griffin's painting has a sense of archaeology, of prior habitation;
Lloyd Jones's doesn't. How do they fare with an older tradition in which the land
and its people were given visual presence?

Blow-ins

In 1945 Will Roberts first met Josef Herman, and at some point in the next decade,
in discussion with Herman, David Bell[75] made the comment at the head of this
chapter. Was Bell discussing the potential for expression in contemporary Welsh
painting? In the same period he also wrote of his profound hope that the visual
momentum evident in the work of the emerging 'Rhondda School' at Cardiff's
College of Art could be sustained: that way, he suggested, lay the future for Welsh
painting.[76] Taken together, the two comments might embrace the direct impact of
European artists such as Koppel, of Herman himself and the visiting Martin Bloch,
upon several artists, and upon Will Roberts especially. Their appearance in a 1981
exhibition that included Zobole, George Chapman, and the younger Peter
Prendergast, suggests that, in the halls of the Welsh Arts Council at least, someone
was thinking seriously about charting an art history for Wales that had little or
nothing to do with London.[77] The specifically 'northern' painting of Bloch, the stat-
uesque peasants of Herman – and of Roberts, who may have learnt much from
Herman, but is surely the more deeply intuitive in paint – and the very different
Welsh romances of Williams and Chapman speak volumes. The part of linkman
played by Prendergast in this show is interesting with hindsight: the structural
informality of the 1980s has moved towards an altogether more fluid expressionism,
reminiscent of Creffield or Auerbach. More recent re-evaluations suggest that in
Wales the not-so-distant past, and a very particular, unusual and very young art
history may finally have created the circumstances for the type of visual vitality so
sought after half a century ago.

75. Later Director of the Glynn Vivian Art
Gallery, Swansea.

76. David Bell, *Contemporary Welsh
Painting,* The Welsh Anvil / Yr Einion,
1951, reprinted in Thomas, Ceri, *Ernest
Zobole: A Retrospective,* p.3; University of
Glamorgan, 2004.

77. See Fraser Jenkins, AD, intro, *The Dark
Hills The Heavy Clouds: an expression of
the Welsh Landscape in Paintings by Josef
Herman, Kyffin Williams, Will Roberts,
Martin Bloch, George Chapman, Ernest
Zobole, Peter Prendergast,* Welsh Arts
Council, Cardiff, 1981.

Will Roberts
In the Library, 1971
oil on board
66 x 76 cms
Reproduced courtesy of John Davies
Gallery, Stow-on-the-Wold
© The Estate of the Artist

**The Herman effect: Welsh locals as with
a European streak**

Bert Isaac
Quarry Exit, c1980
watercolour and mixed media
48 x 61 cms
Reproduced courtesy of John Davies
Gallery, Stow-on-the-Wold
© The Estate of the Artist

6
Cloudy
with Sunny
Spells

Joseph Mallord William Turner
Norham Castle, Sunrise, c1845
oil on canvas
91 x 122 cms
Tate, London 2006

Being commanded to '...feast your eyes on that...' ought only to mean visions of panoramic landscape capable of inducing an immediate state of knee-weakening admiration, and in Britain one is conditioned from birth to see such things in terms of the weather. The French Impressionists had a word for it: 'Effect', or, in the *lingua Franca* of artists, *'effet'. Effet de pluie. Effet de brouillard. Effet de neige.*[78] All jolly good *effets* with which to convey the best of the British climate in paint. Everything but *effet du soleil*, a feature in any case likely to change one way or the other as global warming continues its inexorable progress. But let's not digress, or be despondent about our disappearing source material: most surveys of British landscape through the ages suggest that sunshine was never exactly guaranteed. Is it any wonder that so many British artists, seeking illumination, headed for Italy and the Mediterranean during the eighteenth and nineteenth centuries? In recent years, one might argue with some reason that it doesn't much matter: that any climate is good enough, and that the arrival of Land Art in the later 1960s negated any real need for God's Own Light. You dig?

Simply Heavenly

Let's face it: without the suggestion or documentation of the British weather, the visual impact of much British landscape art would be negated. It is a subject where blanket terminology is inadequate: even the foggiest Whistlerian fog is a blanket only insofar as it covers the land, and, as Monet was at some pains to paint, the *effect* of Light, the luminosity of that experience can be enormously variable. Undoubtedly, the best British landscapes, those most intensely felt, the ones most 'about' the land, depend upon weather, or some representation of climate, as a component, but they also demand that *we* bring something to *them*: our acquired experience of climate, of daily weather and of the excitement that observed natural phenomena – even a great sunset – can still inspire in us.

Simply Sublime

To say that human emotions are complex is just about as ridiculous an understate-

78. So you've forgotten the little French
they taught you at school? *La pluie* = rain.
La brouillard = fog. *La neige* = snow. And
le soleil is that orb that was at its brightest
over Louis XIV.

ment as could be made, but the ways in which we respond to things seen – the things that attract, stimulate, repel or scare – are the key to almost all our experiences in life. What Burke's *Philosophical Enquiry* (see Chapter 3, Hands Across the Water: Ireland) did was to reflect upon the visual equivalents of Love and Hate in considerable depth, and to open up the subject for all comers. Luckily for art, it turned out to be quite a debate. To put Burke's position in disgustingly simplistic terms, he reasoned that if Love stimulated Beauty, through objects and situations that seemed attractive, Hate caused The Sublime, in the form of objects or situations that seemed repellent. Easy enough? It seems a short step from that point to define The Sublime as anything that incorporated natural terror: darkness, downpour, torrents, earthquake, wind and fire, or indeed anything that remained outside human understanding. As for 'The Picturesque', this was something that was interesting and worthy of a picture, but perhaps not much more: as a state of mind or of fact, it lay somewhere between the extremes of The Sublime and The Beautiful, and as a consequence, eighteenth-century thinkers were happy to bicker about the true meaning of the phrase, which was perhaps just as well.

Are You Experienced?

Sublime images can mug us in their intensity; they are compelling, sometimes for reasons we might not have admitted, and many more unusual examples exist than we might at first think. At one end of the scale, Sir John Everett Millais' *The Blind Girl* (1856) may seem mawkish in its Victorian sensibilities, but this remarkable painting reveals its author's acute awareness of, and ability to depict, the appearance, the looming, atmospheric overtones, the chromatics, and even the smells, of Nature. Contrast this with Turner's earlier *Snowstorm – Steam-Boat off a Harbour's Mouth* [...] (1842).[79] Nowadays it's amusing to note one famous and dismissive nineteenth-century description of the painting as 'soapsuds and whitewash', but seen with the hindsight of the twenty-first century, and in the aftermath of 50 years of expressive painting, the emotional aridity of that comment is outstanding. Turner's personal need to express the urgency of his emotional responses before the self-same power of Nature seems completely intelligible. The impact of such work on his contemporary audience was another matter.

79. The full title is *Snowstorm – Steam-Boat off a Harbour's Mouth Making Signals in Shallow Water, and Going by the Lead.*

Sir John Everett Millais
The Blind Girl, 1856
oil on canvas
81 x 62 cms
© Birmingham City Museums & Art
Gallery
The Bridgeman Art Library

Every type of weather, and Millais renders each exquisitely

And here's another moot point. The compound impact of The Sublime on British landscape art – yes, even on the Land Art of more recent years – has been considerable; a lesson so well learned, in fact, that it remains a solid part of our sensory – especially our visual – vocabulary to this day. Where younger Turner offers a distant downpour observed in *Buttermere Lake and Part of Cromackwater* (1798), one hundred years later Norman Garstin's *The Rain it Raineth Every Day* (1889) imparts the drenching experience of a very wet walk home in Cornwall. Successive generations of artists, and their individual visual aims, have made it easy for us to renounce the passivity of the practised onlooker or admirer, and to participate in the experience of landscape and climate. That vague but pressing need for verisimilitude has come to be an integral component of contemporary experience. The greatest images provide some interesting permutations.

Since the later nineteenth century, Constable's masterpiece *Landscape, Noon* (known to many as *The Haywain*), 1821, has been used to decorate every surface imaginable. Parlour walls, undertakers' calendars, table-mats and record sleeves have borne laminated reproductions, and the picture has been variously adapted for television comedy,[80] as an anti-nuclear photomontage by Peter Kennard,[81] and as an advertisement for an English cheese.[82] The poor thing has thus been encumbered with a confusing, multi-purpose collation of 'Englishness' that it certainly never owned when first exhibited. Even now, taken raw, *The Haywain* offers a long look backwards to a highly debatable rural past, and to weather that, even when impeccably rendered, owns all the excitement of bad light stopping play at Lord's. Its huge impact on the French (when shown in Paris in 1823) has its roots in Constable's own assimilation of years of Dutch influence on English painting, several times removed, especially from artists such as Sir Peter Paul Rubens, Jacob van Ruisdael, Jan Siberechts and Aelbert Cuyp. These provided a vital launch-pad for British imitators, glad to be able to imitate a nation of painters who could record or suggest weather so faithfully, and with such infectious luminosity: the dread certainty of that imminent shower in Gainsborough's *Mr & Mrs Thomas Andrews* (c1748–9) is merely one fine example.

This approach had staying power: 60 years later, in 1815, George Robert Lewis would paint *Hereford from Haywood Lodge*, a distant (if proletarian) echo of the

80. Who could forget 'I'm the man from *The Haywain*', when the pictures in the National Gallery went on strike for *Monty Python's Flying Circus*?

81. *The Haywain. Constable (1821) Cruise Missiles USA (1983–1988)* was a series of montages, begun in 1980 by the British artist Peter Kennard, and reprinted with several slogans by nuclear campaigners across the globe.

82. No names, no pack-drill… it was Loseley.

Norman Garstin
The Rain it Raineth Every Day, 1889
oil on canvas
95 x 164 cms
The Bridgeman Art Library
© Penlee House Gallery & Museum,
Penzance, Cornwall, UK

Andrews' cornfield, and one owing a similar technical debt to Dutch mastery. Other country idylls, replete with stacked sheaves or heaped hay, at high noon or evening, have made regular appearances ever since. Samuel Palmer's *Cornfield by Moonlight* (1830) prefigures Ford Madox Brown's *Hayfield* (1850); in John Linnell's *Noonday Rest* (1865) the sky is the limit when it comes to fresh air and a well-earned rest from the morning's hard graft. Where twentieth-century landscapes have sought the visual higher ground, however, their emphasis has been on heights and grandeur, rather than cultivation: John Nash and David Jones are almost alone among early twentieth-century artists with works set specifically among the corn stoops.

Up and Away

It would seem that the high ground is the thing, but don't bet on it. Certainly, British landscape artists since the nineteenth century have preferred to focus on Nature's grandeur, as an objective for record, or for meaning, or as the substance of an artwork without specifically human connotations. As a result, every type of atmospheric quality has been fair game. Importantly, absence of human beings allows the purely decorative requirements of the potential purchaser to come into play: the view can become 'yours'. And if you aren't bothered either way, why portray human beings when cattle will do? James Ward's stupendous canvas *Gordale Scar* (1808) – 'painterly edifice' might better describe it – is surely an emotional milestone in British painting, devoted to the encapsulation of perceptions ranging from the intimacy of stillness and smallness to the ceaseless rattle and rush of water within a deep rocky chasm, open to the sky. Yet Ward's arrival at this wide-open space comes via a wealth of earlier influences, including the Dutch, and a general eagerness to put Burkean theory into practice, in hilly or mountainous regions of Britain. In the later 1700s, Richard Wilson, Philip de Loutherbourg and Joseph Wright ('of Derby') captured different elements of mountainous Britain. Wilson depicted Snowdonia as a mountainous oasis of Italianate, Claudian light, and not as John Piper later – and equally faithfully – recorded the area during the 1940s, slate-strewn and fortress-like, under shifting shrouds of mist and rain. There's a sense that de Loutherbourg was more aware of his buyers' preferences: his paintings of the Derbyshire Dales or the Welsh borders pack as many components of the Sublime into one painting as possible, a series of giant economy assaults on the emotions.

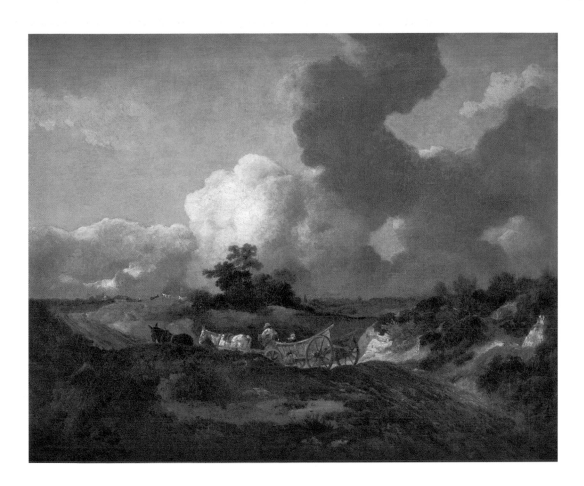

Thomas Gainsborough

*An Open Landscape in Suffolk with a
Wagon on a Track*, 1727–1788
Private Collection
© Christie's Images / The Bridgeman Art
Library

This can also be true of work by Wright, whose more sensitive treatment of light, combining observation, clarity and specifics, undoubtedly affected the ways in which slowly growing audiences came to see Nature through painting. Across the board, the public's perceptions and expectations of places had actually been altered by 'the appearance of things',[83] so that when they visited places they expected to see those locations as artists had seen them. Extend that process by 200 years and ask yourself whether you'd feel the same about your first sight of the River Severn if you'd only known it as a series of vast arrangements of muddy handprints by Richard Long. You never know.

The nagging question of altitude and weather remains, and it is one worth considering. Take a real imaginative leap, and toy with Ward's *Gordale Scar* as a very early warning of the colour field painting of the twentieth century,[84] for at 3327 x 4216 millimetres it challenges not only peripheral vision but also visual and emotional experience. It is certainly an early milestone in a series of continuous developments and changes in art in which clarity and specifics, grounded in observation, were slowly relinquished in many quarters, to be steadily replaced by introspective expression, made manifest in colour, mark-making and the introduction of linear qualities that might be literally transformational: in some hands, the 'natural' became the 'designed', or 'organised'. So, for example, by the beginning of the twentieth century, we find artists such as Harold Gilman and Spencer Gore, working away from the city but, not entirely uncharacteristically, out-of-doors, experimenting with very attractive linear and colour techniques that have little or nothing to do with the experience of Nature, its forms or the elements that underpin them. These paintings were signs of the times: they indicate a real shift in the visual orientations of many British artists of the era, by whom choices might then be made: stay at home and forget about the world, or join those for whom being at one with Nature was becoming an increasingly restless business.

Drawing in

In the face of so many conceptual correctives, the survival of The Sublime in the late twentieth century is little short of miraculous. Yet wildness, wilderness and the extremes of climate remain dominant at the boundary line between earth and sky.

83. See Rosenthal, Michael, *British Landscape Painting*, Phaidon, Oxford, 1982, pp. 45–70.

84. Colour field painting was a contemplative component of *Abstract Expressionism*, established in the USA in the twenty years following 1945. It involves the application of intense, luminous colour onto canvases whose size ranges from the quite large to the seriously substantial. Key players here were Mark Rothko (1903–70) and Barnett Newman (1905–70); the appearance of such works often strongly suggested the physical / landscape / natural distance.

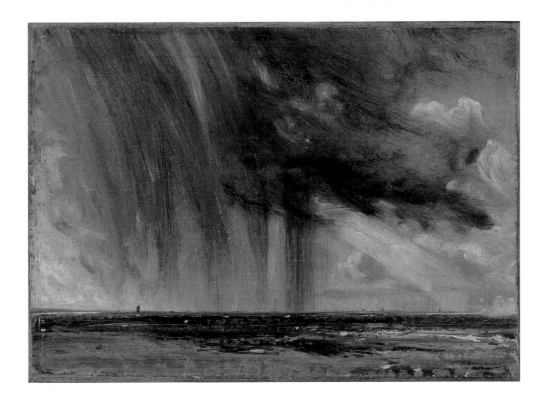

John Constable

Rainstorm over the Sea, c1824–28

oil on paper laid on canvas

24 x 33 cms

© Royal Academy of Arts, London, UK

(Given by Isabel Constable, 1888)

And Constable hated the seaside

Seen from afar, conventionally, as 'a view', or in a format in which distance is an important consideration for reasons that may eventually have *nothing* to do with the landscape, the range of excellent works will always astonish. James Humbert Craig's images of the Irish distance represent an older formula – the appearance dominates the experience. Other painters, such as HH La Thangue and George Clausen, created similarly powerful effects, usually on a smaller scale; but quickly, and certainly by the 1920s, the process was reversed. Instead, artists often chose to communicate visions, aspects, perceptions and feelings, together or apart, through personal technique. For these, landscape was one of many means to achieve an end, but, arguably, the most vital means of all. So, the great draughtsman David Bomberg returned to work after a barren time post-1918: his landscape paintings are amongst his finest, from the harsh, middle-eastern documentation of Palestine, through the heady heat of Ronda, Spain, to *Evening in the City of London*, 1944, an expressive view of a landscape of ruins, from the heights, poetic, potent and nostalgic in one. None of Bomberg's Borough School students[85] has achieved true distinction as a landscapist: Dennis Creffield has come closest, through a lifetime's work in charcoal and paint that has focused on buildings and structure, rather than location or surroundings. More monumental, dissimilar expressions have come from the studios of John Virtue and David Tress, with Virtue's black-and-white paintings often executed on a vast, 'Gordale-ian' scale, with all the determination, and much less restraint; similarly, Tress works *into* Nature, clawing into his surfaces in a mixture of media, creating a thicket of line or impasto, removing it, retreating, beneath mobile, airy skies. His practice is only marginally less intuitive than Joan Eardley's in Aberdeenshire, in sunlight or under snow, where the fickle weather, hot or cold, was at the core of the work.

Tress is arguably the most recent consistent contributor to expressionist landscape painting from Wales, where the impact of the German painter Martin Bloch was strong in the early 1950s, and whose schematic arrangements influenced Peter Prendergast and others: their works contrast with the glutinous hill-and-coastal atmospheres of Kyffin Williams, muted but compelling structures, whose weather was literally laid-on with a knife. Where structure and colour of landscape are often rendered starkly within Wales, however, the world of its borders is another matter. Here, around Malvern, David Prentice has truly occupied the middle ground. In

85. The most notable being Frank Auerbach, Leon Kossoff and Dennis Creffield.

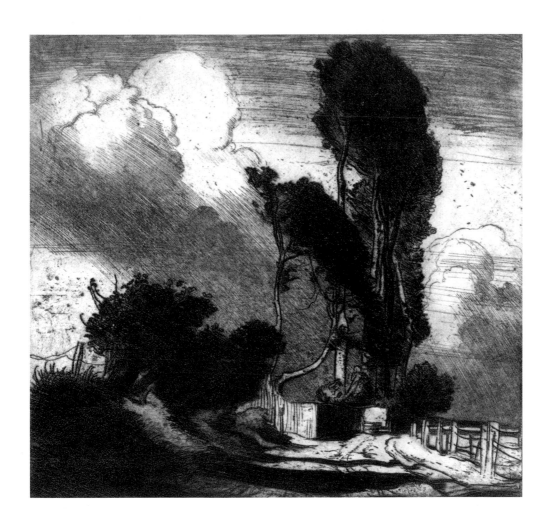

Sir Frank Brangwyn
The Storm, 1904
etching
46 x 48 cms
Private collection
© Fine Art Society Ltd

every weather, the essence of earth and air is fundamental to work that combines experience, often surprise, with spontaneous responses to the view from above and careful observation. Prentice's chosen palette and techniques continuously rehearse pictorial equations that prompt fresh considerations of Nature's phenomena, stripped of detail. The results are entirely in keeping with the outlook of a man in whose work the sky has been a continuous presence, important for much of his career.

Can the Sublime continue to exist in smaller, more intensely felt, still ill-defined, secretive expressions? Graham Sutherland proved that it might, in his famous *Entrance to a Lane*, 1939. Here is summer's calling, a painting where *frisson* exists between woodland cool and warm sun, to offer an awareness of atmosphere that would resurface throughout his career, regardless of reality, in paintings such as *Red Landscape*, 1942, or *Road at Porthclais with Setting Sun*, c1975. Elsewhere, and after 1941 at home at Lavington Common, West Sussex, in a locale that was to a large extent hand-built, Ivon Hitchens created landscapes (with much else) that delivered a sense of the weather, inside or out-of-doors. Even at their most expansive, these paintings can proffer withdrawal and quietness, retreat if need be, from broad brushwork that can as easily be gestural as suggestive of something more specific. What began for Hitchens as a literal response to Nature, in time became representative of it; forms in a personal pictorial vocabulary that were relevant, but at a remove. You may feel it, but, even abstracted, it may have little relevance to 'what was'. The concept is the same to this day for many artists working successfully to combine sensory images. Working in Britain and travelling abroad regularly since the 1960s, David Blackburn – profoundly influenced by Sutherland as a student – continues to execute remarkable pastels, often presented as multiples on a large scale, and most of them land- or seascapes. Individually or consecutively, they combine 'a sense of place' and of climate, often under moonlight or beneath a sky whose surreal aquamarine brightness can usually be captured only in this medium. Blackburn's eye is expansive, farseeing, yet the outcome of many of these works is compellingly personal, absorbing, reflective, precise. One of his contemporaries, Adrian Berg, evolved a comparable method of working, with very different outcomes, using the city as source, specifically the gardens of Regent's Park, London, rather than the wide-open spaces. Inherent in these paintings, as in all Berg's outdoor work, is a profound sense of steady, organic growth, planned and planted perhaps, yet substantially uncontrollable, and constant, from day to day and season to season.

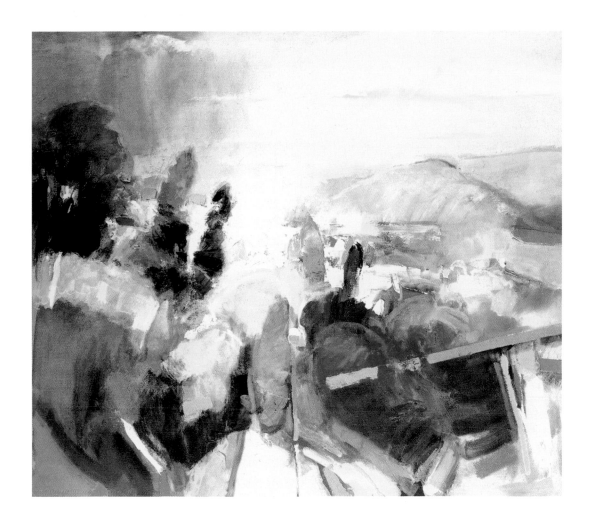

David Prentice
Roseacre II, 2002–3
oil on canvas
13 x 14 cms
© By kind permission of the Artist

Whatever the extent to which The Sublime remains a constant throughout the length and breadth of High Art, the population of Britain remains largely ignorant of it as a theory. In the twentieth century, people often drew upon experiences of national landscape at much lower levels, perhaps in order to inform themselves, to confirm understanding, or to clarify visual needs. Interestingly, they were increasingly enjoined to do all or any of these things after 1918, when Shell fuels and London Transport increasingly used younger, mostly home-grown, artistic talent to promote their respective businesses, by increasing public awareness of the greater British outdoors, and of the real and imaginary benefits of fresh air and tourism.[86] Some of the visual outcomes fall within the realms of what was then quite reasonably termed 'commercial art',[87] but one interesting feature of these images lies in the range of their visual techniques: one may be 'Sure of Shell', but by the 1930s there was little chance of any visitor seeing the location through the eyes of the artist. And, whilst the location may be depicted with reasonable exactitude, the weather rarely intervenes in these advertisements, for, in our increasingly cosy, modern world, who would seriously endure a soaking in the cause of intellectual curiosity?

By contrast, Underground posters are very much at home in all weathers, promoting dry travel to London to the Winter Sales, or the fresh colours of Spring, available anywhere within the circumference of the LT bus and rail network. Indeed, the appearance of realistic weather in LT advertising, together with the clever and sophisticated use of extreme and often unusual colour harmonies in these and other travel posters,[88] suggests an early accommodation reached between audience and advertiser concerning the British climate: that, even *in extremis*, an experience was available to the open-hearted that might bring them closer to artists seeking similar results. It was a process creatively enhanced when the Johns Betjeman and Piper co-published their unorthodox *Shell Guide to Oxfordshire* in 1938, the first of a series that offered True Brits a series of glimpses of their countryside in which its nooks and crannies might reveal as much as its greater houses and cultural sites.

86. For Jack Beddington's part in the Shell poster campaigns, see Bernstein, David, intro, *The Shell Poster Book*, Penguin, London, 1992 and an alternative assessment by Lord Montagu of Beaulieu *The Shell Poster Book*, Profile Books, London, 1998. The Shell Art collection can be researched at www.beaulieu.org. For

Frank Pick's part in the London Underground poster campaigns, the biographical portrait and bibliography offered at www.designmuseum.org are excellent departure points.

87. Today's term 'graphic design' is actually less accurate in some respects.

88. Especially those posters produced for the major railway networks.

Alexander Cozens
Before the Storm, c1770
oil on paper
24 x 31 cms
© Tate, London , 2006

Mind over matter: this is about tech-
nique and atmosphere, not place

Burke would have experienced the most sublime experience of all if he had lived to witness the advent of powered flight, for to fly high over Britain, from anywhere to anywhere, is to receive a myriad of conceptual possibilities. How to record this most transient of experiences when one is never still? Why freeze a mark when in reality it dissolves so swiftly, the passage of an object through air? What is the difference between flight observed from terra-not-so-firma, and the view from above, when we are, after all, still moving with the Earth, experiencing the continuation of the single-letter difference between the words 'lies' and 'flies'? What *did* go through Constable's mind as he stood on Hampstead Heath gazing towards Harrow? He couldn't have been the first viewer to have experienced the same emotions, he wasn't the last, and distance has a relative love-affair with the Sublime: observe the layered combinations of pensiveness, intuition and calm observation in Robin Richmond's paintings of the Dordogne. The weather will have an impact on anything, and especially the eye-to-brain-to-hand appearance or mood of a painting, whether it's a representation of a given place, or an artwork in a specific setting, or any image of the world observed and taken from a machine in flight. More important, ideas like this go a long way to establish individual and collective meanings of terms such as 'the British landscape'. Rarely has the phrase 'it's the way you tell it' been so appropriate, across so vast a range of visions and emotions.

Those of us not built for space exploration have to be content with views of our planet from lesser projectiles, but what sights they are. The downward curve through the mountains towards Glasgow on a bright summer evening; the almost-resistant slow crawl over the yellow ochre East Midlands and Cambridge into Stansted on a late Spring afternoon; the descent into Cork viewed through a glass ellipse full of chromium oxide and the apple green grass of Ireland... all these were denied to the first generations of great British landscape artists, but things changed soon enough. Within the twentieth century, CRW Nevinson, Alfred Egerton Cooper, Claude Rogers, Peter Lanyon and Jeffery Camp are a representative top flight of those who dared to observe the homeland from the air. The potential for three-dimensional recording was always there, but was not always seized, and yet the differences were marked between art whose source is in so many ways truly ethereal and that of their predecessors. Well, it was going to be, wasn't it? Even as a penitent Futurist,

Robin Richmond
Walking Trees, Dordogne, France, 2005
oil on paper on canvas
81 x 132 cms
© By kind permission of the Artist

Home is where the heart is, in this case
France, in a layered landscape rich in
feeling

Nevinson nurtured a modernist visual dialect for some years after 1918, in oils and in lithography, and his wiry lines express the visual tensions of his remarkable *From a Paris Plane* (c1920), a string-and-canvas aerial icon by any standards. The almost-forgotten Cooper made airship flights during the First World War, and his chilling daylight-overcast views of snow-bound tracts of Britain are as remarkable for their existence as for their simplicity: their airiness portends Claude Rogers' 1960s' nightscapes of sodium-lit Greater London, developed from drawings done aboard jet airliners circling the capital.[89]

Lanyon and Camp, very different drummers, offer heady, but utterly alternative, explorations of abstract and particularised sensations, the first high over Cornwall, the second lower over Sussex, where altitude, weather and a range of emotions are intensely conveyed. Camp's mind may have been airborne, but he ventured no further than the blustery cliff edge at Beachy Head, preferring the closely-observed, yet vicarious, observation of hang-gliding to any attempt to experience the real thing. Lanyon was different, a deeply intuitive seeker, first, of the depths of the Cornish landscape, its landforms and coastal verticals, and then its weather, its air currents. For Lanyon, direct painterly experience of land came to offer only one set of answers to the demands of intensely felt landscape. Seeking visual alternatives that were in some senses more universal, he became a keen glider pilot, took the leap of Icarus, and himself became myth in 1964. Long before, in a poem of 1949, surely of earth and air, he had written:

I will ride now
The barren kingdoms
In my history and
In my eye.[90]

Lanyon's wondrous earth-and-skyscapes survey and explore the sensory extremes of England – literally, above and below. Whatever the chosen medium – often constructions in oils and/or mixed media – he sought new channels to communicate with an audience without 'smoke and mirrors', and in the process inspired many others to do likewise.

89. Courtesy of a friendly airline pilot, so Rogers' family lore has it.

90. Peter Lanyon, part-poem, reproduced in Lanyon, Andrew (1990), *Peter Lanyon, 1918–1964*, edition of 500, privately published. Reprinted by courtesy of Mrs Sheila Lanyon.

Alexander Cozens
Moutainous Landscape, c1780
grey and brown wash on paper prepared
with brown ground
24 x 32 cms
The Bridgeman Art Library
© Yale Center for British Art, Paul Mellon
Collection, USA

The many ways in which those artists saw their locations, however confined or expansive, the ways in which they reflected upon their journey to wherever, and – of course – the state of the weather were factors in a bigger picture that remains constantly elusive, external. Perhaps this is one reason for its relative lack of appearance as a major factor in today's art scene: there's too much navel gazing going on. Ultimately, the visual representation of landscape and weather are a sacred conversation between author and viewer; matters in which perception and experience combine at various levels of acceptance to create a unity – for each of us, however long it may last.

Joseph Mallord William Turner
*Rain, Steam and Speed, The Great Western
Railway* (pre 1844)
oil on canvas
91 x 122 cms
The Bridgeman Art Library
National Gallery, London, UK

7
Life, the Spiritual & Everything

140 Conventional wisdom would have it that, even after his death in 1944, Wassily Kandinsky remained the gatekeeper of 'the spiritual in art'. A Russian lawyer-turned-artist, Kandinsky was one of modern art's heavyweights, famous for abstractly practising what he preached; namely, that heightened spiritual experience can be brought into being in an artwork through the author's use of Form and Colour as interdependent factors in its creation. Heavy enough? Sure is, Man. In the early years of the twentieth century, Kandinsky set out an extensive range of the possibilities as he saw them in several theoretical texts covering colour and expression, of which the most famous is probably *Concerning the Spiritual in Art*.[91] It gave every decent (decent?), self-respecting, by-no-means-always-abstract artist in northern Europe an opportunity to reconsider, baby, and perhaps personally redefine approaches to this most challenging of conceptual debates. Kandinsky's writings combined statements of belief with discursive argument, which were intended as encouragement, not as 'how-to-do-it': you were expected to have travelled extensively already, and perhaps even to have arrived – but quite probably at the wrong terminus. This was just as well. Put esoteric subjects such as Spirituality in Art next to Convention and watch them squirm. No one reading Mr K could fail to respond to him, whatever form that response might take: except, of course, the British, who sometimes take a little longer over such things, and often get lost along the way.[92]

Considering the UK's major place in the history of Romantic art, you would expect that over the years many British artists would have sought, and sought to apply, the nearly alchemical essence of spirituality to their work, however different their directions have been as time has passed. You'd be wrong. Not many have made the journey, partly because the field is littered with obstacles, many of them caused by the arrival of abstraction itself, in an area of endeavour in which the very meaning of the term 'spiritual' has forever been open to a huge range of interpretation; partly because more than a few artists were just too bone idle. If that doesn't make sense, ask yourself what Spirituality looks like. How do you recognise it, define it, assess, analyse, evaluate it?[93] What form might it take in *your* work? And who says you're right? Some of the reasons for the comparative failure of British artists to deliberately take up such concerns lie in the traditions of art extant in the UK, and in the general and continuing lack of public interest in such matters. Those conditions have resulted from very different, sometimes local, often private, perceptions of the

91. First published in 1911 in German, as *Über das geistige in der kunst*. Kandinsky then spent the next 30 years living it all out.

92. In such circumstances, Bradshaw's Railway Guide becomes redundant.

93. I know – you thought it was an A level question, and you might be right.

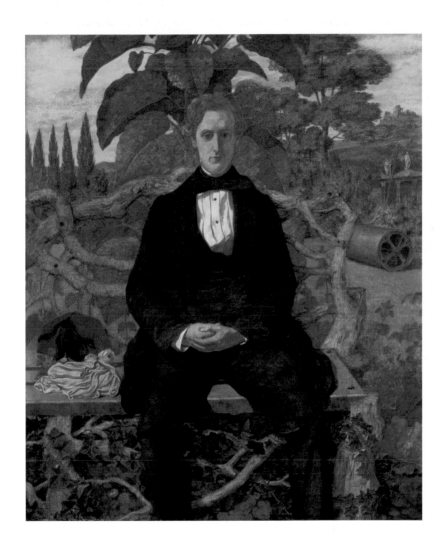

Richard Dadd
Portrait of a Young Man, 1853
oil on canvas
61 x 50 cms
© Tate, London 2006

meaning of 'spirituality', and how it might be realised visually. Exactly how *are* you going to seize your viewer's lapels and shake them hard enough to encourage a visual experience in an altogether undiscovered, superbly heightened visual plane? And, when they get there, presumably by rope ladder, how will they understand what they're looking at if they don't already have just the ghost of an idea? These questions bedevil much of modern art. Acute observation on Earth is one thing, but Heaven is another place altogether, and no one who claims to have been there seems able to tell the same story.

The visual impact of the biggest and bounciest developments in art in Britain after 1945 has tended to obscure some interesting, quieter positioning, before and after the war. The arrival of Surrealism in Britain in the later 1930s enabled artists such as Paul Nash, John Tunnard – and Graham Sutherland – to develop their own sensory pathways, to provoke and sustain a highly focused, yet skewed, approach to the business of being. At the same time, they indirectly encouraged a new, general visual language to develop steadily, and to establish itself quickly within what we now call graphic design, most notably in the hands of Abram Games.[94]

Post-war developments did not follow this route, partly because of the philosophical and mathematical austerity within their conception, which made them altogether pricklier for a public whose spiritual needs had been nurtured by Neo-Romanticism: an extended landscape tradition, with a luscious marrow of purest nostalgia. It would have been hard to debase this in wartime, but new artists in a brave if shaky new world wanted abstract equivalents in their efforts to move on. Sculpture, in many media, seemed to open doors onto several sensory and spiritual pathways, and aside from the monumental activities that were polarised by Henry Moore and Reg Butler, the abstract sculptural reliefs and later architectural work embraced by Victor Pasmore, himself a reconstructed Neo-Romantic, inspired others to pursue similar ideas that were dependent on mathematical purity, rhythm and centrifugal force. Kenneth and Mary Martin were only two of these, aiming for a purification of space that most viewers would describe, possibly enviously, as austere; for harmonious relationships and a mental transfer to the nearest faraway place. Make no mistake: there's nothing literal about such works, and the more they are researched, the more they make sense. Logical progressions like this were bound to challenge

94. Abram Games was the graphic designer who most cleverly manipulated Surrealist visual ideas so that they sustained impact and jokiness, and who was enormously influential on advertising, especially in the 1960s.

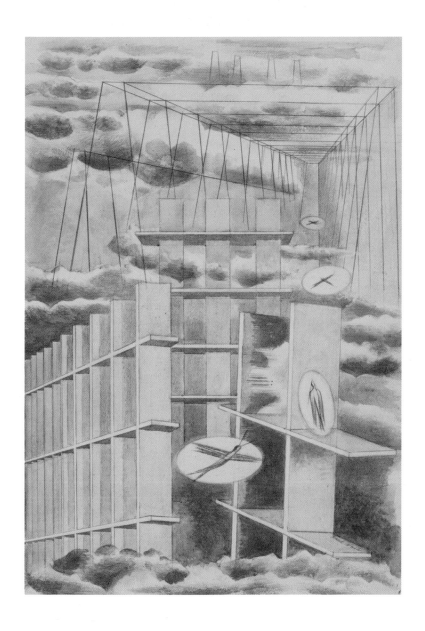

Paul Nash
The Soul Visiting the Mansions of the Dead, 1932
pencil and watercolour on paper
58 x 39 cms
© Tate, London 2006

A conceptual journey by an aspiring aviator?

semi-representational statements anchored in 'spirit of place', and, at their best, to win those skirmishes. And yet, as objects within the history of British art, those new sculptures stand alone, and, even as assemblages of found or cast objects, remain inaccessible to today's quick-fix mentality.[95]

Right on, brother, right on. Today, descriptive art categories such as 'Ethnic' and 'Outsider Art', with their respective, often extensive, multi-cultural associations with Shamanism, can achieve levels of unhealthy misunderstanding in the wrong hands, but the reality is that all are potentially fruitful areas for research, discovery and some considerable wonderment.[96] And that word 'Visionary' is the key: it represents the author's[97] absorption in the spiritual business of creation as much as an involvement with the subject, and, like anything else, the perceptual processes will alter according to the situation. 'Visionary' is a word applied with equal force to so-called 'Outsider' artists as it is to William Blake, or to the Victorians John 'Mad' Martin, Richard Dadd, or Samuel Palmer, every one of whom extended the boundaries of 'convention' in their very, very different ways. An excessive claim? Hardly. The works of more recent, or contemporary, artists such as Scottie Wilson, Rosemary Carson and Madge Gill – say it isn't, though there are as many who make counterfeit assertions. Outsiders will remain among the most interesting and vital representatives of Spirituality in art at any time, often because they are compulsive in unknowing pursuits, operating without conventions or expectations of perfection, to create often remarkable, sometimes out-of-body results. They may never have been There, but You Know That They Know.

Such intuition is a modern business, dating back no earlier than the 1880s. One major problem for Victorian artists and the public was that spectacular grandeur ran out of steam as the railways gradually gained a full head of it. Improved communications meant that anyone seeking breadth of Nature for inspiration, solace, or bog-standard gut-feeling might now reach those parts previously reached only by those Romantic artists determined to capture the Sublimest of moments. Welcome to Snowdonia, or the Lakes, or the Wye Valley, or to anywhere else similar. Did spiritual debasement follow? It's a moot point, but it's certainly true that later twentieth-century publishing overkill has adversely affected the visual messaging of Goldsworthy, Drury *et al.* There are just too many books. Similarly, mimetic splen-

144

95. See Grieve, Alastair, *Constructed Abstract Art in England: A Neglected Avant-garde,* Yale, 2005, which considers this subject lucidly and in depth.

96. See, in particular, Tucker, Michael, *Dreaming With Open Eyes: the Shamanic Spirit in Twentieth Century Art and Culture*, Aquarian / Harper San Francisco,

1992; and Rhodes, Colin, *Outsider Art: Spontaneous Alternatives*, Thames & Hudson, 2000.

97. No, I don't really like the word any more than you do, but it's a useful blanket term to denote a blanket of creativity.

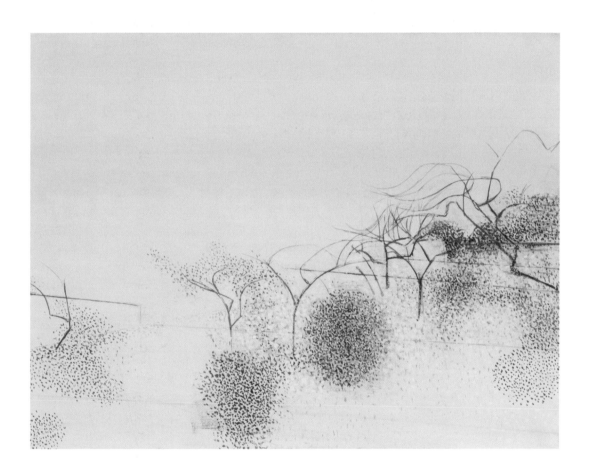

Victor Pasmore
The Gardens of Hammersmith. No.2, 1949
oil on canvas
76 x 97 cms
© Tate, London 2006

The meditative qualities of cold light,
with a hint of nostalgia, on a damp
riverside morning

dour, however wondrous, no longer satisfied High Victorians: James Ward's *Gordale Scar* is an undoubted masterpiece on its own terms,[98] overwhelming in sheer scale, even in its capacity to introduce the sensation of sound – the cascades, the echoes – but it lacked the vital spark necessary for overwhelming, intuitive intelligence: the magic, the mystery. Not even Turner's later works provide this.[99] What was left? The human figure, of course, specifically the female figure. Clothed, before you ask, but still an object to magnetise the imagination. What do you mean, Lucian Freud?

Today, you've only to put the female form on a pedestal to transform your male self into a magnet for every poisoned arrow in the quiver of Feminist extremism, but too bad.[100] Victorian artists (among them several females) looking for ways to symbolise areas of the psyche that weren't brutal, coarse, or scratchy with five o'clock shadow, could fantasise to their hearts' content about the ideal woman: her bearing, nobility, purity, and especially her facial features. Did her bum look big in a bustle? Victorians didn't especially care. A dreamy, creamy complexion with a countenance that could be ambiguously described as (at least) 'angelic' was quite enough to represent… whatever anyone might wish, especially if 'one' was male, according to the setting of the image. Heaven sent, or heaven bound? Don't mock, and remember the absence of abstraction: in such works, late Victorians such as Burne Jones, Frank Cadogan Cowper, Evelyn de Morgan, Eleanor Fortescue Brickdale (yes, wimmin!) and Thomas Cooper Gotch, to name but a very few, used idealised feminine beauty to harness something they thought of as spiritual, and transformed it into something recognisably religious, often with Christian symbolism and qualities; saintly, already.

This wasn't exactly revolutionary stuff. Back in 1833, even before little Vicky took the Throne, Alfred (later, Lord) Tennyson published *A Dream of Fair Women* in the same volume as the rather better-known *The Lady of Shalott*, and it was only a matter of time before someone responded visually to such sentiments. In this case, George Frederick Watts not only launched his own, eventually formidable, reputation, but also created a vogue that others could only imitate. The true impact of what has been called 'The Religion of Beauty'[101] was very considerable indeed, and, as a critical factor in the conceptualisation of Beauty in British art, it was much more extensive than might be expected, having the most powerful impact on Victorian art

98. No, we *know* Gordale Scar doesn't look like that, but Ward exercised poetic licence…

99. Lest we forget, and even if Constable did call some of his paintings 'visions of tinted steam', Turner wasn't an abstract painter: just don't go there.

100. Just call me St Sebastian, why don't you?

101. See Anderson, Gail-Nina, and Wright, Joanne (1994), *Heaven on Earth: the Religion of Beauty in Late Victorian Art*, exh.cat., University of Nottingham Arts Centre.

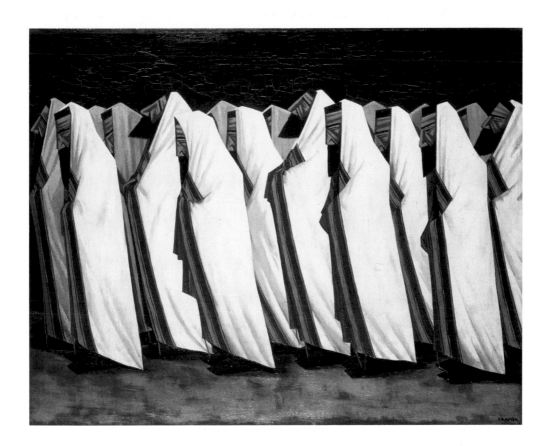

Jacob Kramer
The Day of Atonement, 1919
oil on canvas
99 x 122 cms
The Bridgeman Art Library
© Leeds Museums & Galleries (City Art
Gallery) UK

An austere title, and an image whose
meaning encompasses far more than
mere repentance

John Long A.RHA
Lemon on tabletop, 1998
oil on canvas laid on board
25 x 43 cms
Private collection
© By kind permission of the Artist

Totally observed, totally harmonious composition, from corner to corner. All of a piece

first, through Sir Coutts Lindsay's Grosvenor Gallery,[102] and then in more decorative ways on Edwardian society via the Royal Academy and associated bodies. By the beginning of the twentieth century the concept of *A Dream of Fair Women* had degenerated into a collective title for a series of exhibitions of female portraits, and even into society balls bearing the same theme,[103] yet the idealisation of Woman in British art hardly decreased: it is a compelling element in any consideration of the evolution of the female image in British societies. There are sound reasons to suggest that, though the visual differences between images such as Watts's *Hope* (1886) and Meredith Frampton's *Marguerite Kelsey* (1928) may appear unbridgeable, they aren't; equally, that, through many alterations, the serenity that lies at the heart of 'The religion of beauty' had become so established that it affected some areas of British painting until the 1950s, including the work of artists as diverse as LS Lowry, and Stanley Spencer. Spencer, surely the most spiritual of early British twentieth-century painters, built and sustained his visions (that's what they were) upon a deeply personal sense of religious 'self'.[104] Yet, as time passed, and Abstraction waxed, such explicitly religious symbolism waned.

Where Victorians and their immediate descendants gained spiritual ascent from representations of feminine beauty, abstracted Nature, as an overarching category, has satisfied an alternative need for personal affirmation among many British artists, before and after 1945. Has that denied religion? Sometimes, in its most extreme, traditional and constraining forms, yes. And yet, what you would possibly call a 'religious' approach to the experience of, or search for, Spirituality in all art is inevitable, even if the achievement of that goal has been different in every case. So, the question asked should be 'What do you seek?' The answers that follow will necessarily vary hugely.

If Art were a matter of basic 'call and response', in which appearances were witnessed and then recorded, life would be pretty dull. Luckily, like Jazz, Art is an almost limitless series of opportunities (and so is Design, for that matter), that allow responses or questions about the existence of everything we encounter, in different ways, with differing emphases, whatever the medium we use to put the question.[105] From its earliest forms, religious belief and practice, together with unfolding, evolving uses of Space, have governed the placement and the 'look' of much that is 3D in

102. The same 'greenery-yallery' gallery derided by WS Gilbert in *Patience* (1881), and home to Whistler in particular, as well as the Aesthetic Movement, the Grosvenor Gallery was founded by Sir Coutts Lindsay and his wife, Lady Blanche, in 1876, and folded in 1890 when Lady Blanche finally despaired of Sir Coutts's extra-marital... activities.

103. There were even exhibitions. At least one of these exhibitions was held at the Fine Art Society; records of the balls go on until at least 1926.

104. Lowry's absorption with DC Rosetti's female figures is a matter of fact, and in time he earned enough from the sale of his own work to buy a Rosetti for himself: a muse perhaps? Spencer's case is more complicated, and more fascinating: see Alison, Jane (ed), with Hoole, J (intro), *Stanley Spencer: The Apotheosis of Love*, exh cat, Babrican Art Gallery, London, 1991.

105. In the words of Prof Harry Callaghan '...you've got to ask yourself one question: "Do I feel lucky?" Well do ya, Punk?'

British art and architecture, from its standing stones through its cathedral build-
ings to some of its more recent sculpture. In every era, the organic, the votive, and
the austerely ascetic meet, sometimes in odd alliances, and the Word, or Idea, is
transformed into statement, Form, certainty… always in Space, and always differ-
ent, because of changes in emphasis, as the epochs pass. The results of that type of
(not always logical) practice range from Skara Brae, to Ely Cathedral, to Castle
Howard, to the Lloyds Building, each one serving a different god. No matter the
intention behind the creation, the outcome has resulted from the moment that the
spirit soars into open flight. The only certainties are the inevitability of human asso-
ciation with the outcome, and that, no matter how well planned it may have been,
the outcome always has to make room for circumstance, or intuition. The human
factor?

Conventional artistic practice – if not always wisdom – suggests that, because Life
is a journey, Art should replicate Life. So (rushing ahead), is a search for artistic
higher ground a visual pilgrimage? To the extent that everyone has a different goal,
why shouldn't it be? You can't learn the paths before you make the journey, and
even if you do the trip more than once, there's always the possibility that the track
will be eroded, so that the business of seeking becomes as much a matter for audi-
ence as for artist. And the notion of 'higher ground', or of 'your own space', is as
much real as it is spiritual: it has as much to do with your back garden (or John
Constable's for that matter) or a favourite walk, as with any larger, more infinite
'genius loci', or 'spirit' (or sense) of place. The arrival of sculpture parks in the 1970s,
and of land art even earlier,[106] enables post-millennial viewers to experience 3D
works in ways and locations that simply didn't exist in 1940: so-called 'site-specific'
works have been knocking around since… well, Stonehenge, actually: they didn't
just arrive with the banks of monitors that characterised the expression in the
1980s. 'Site-specific' activity is another example of a way in which different artists
can affect an audience in unforeseen ways, and the success factor of that activity
rides on the real value of the work. Artists as varied in their intentions as Henry
Moore, Ian Hamilton Finlay, or Keir Smith have used, or have had work installed
in, outdoor locations to create situations in painting, sculpture or installation work
that may satisfy or answer specific personal problems, but that offer visual and crit-
ical stimuli to their viewers in wholly different ways. The same is true when the out-

106. See Chapter 14, 'Watercolour'.

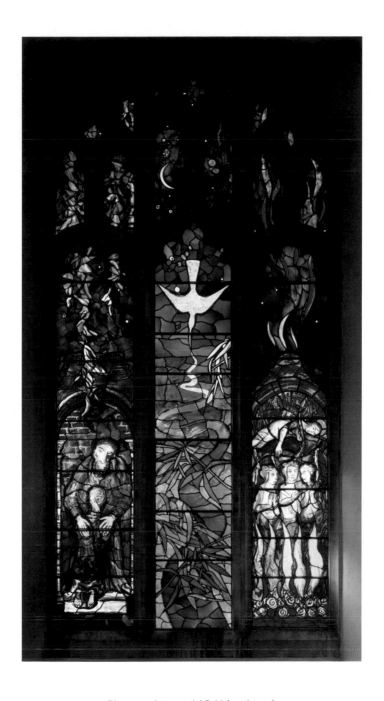

John Piper
Memorial window for Benjamin Britten
(1913–1976) 1979, depicting The Prodigal
Son, Curlew River and the Burning Fiery
Furnace
stained glass
Aldeburgh Church, Suffolk, UK
The Bridgeman Art Library

Piper, a quintessential British artist and
designer, enshrines the memory of his
friend Britten, a quintessential British
composer and musician

Bob White
Between Cloth and Skins 11, 2004
acrylic on cotton duck
146 x 103 cms
© By kind permission of the Artist
Photograph by Damien Chapman

Bob White's recent images exemplify the continuing spiritual and physical potency of the human figure in renaissance terms. His large, alluring paintings are loaded with presence, yet suggestive of concepts that can apparently range from the determinedly conceptual to the purely ephemeral. And then some.

side comes inside, and when those boundaries are deliberately blurred, for example in work by Richard Long, Adrian Berg, Spencer Gore, Vong Phaophanit or Anya Gallaccio.[107] It is often the setting that creates or enhances the spiritual element and causes it to transcend the merely pretty, or, more often, the pretty mundane, and the crossing points for other possibilities are just as productive, especially sub-conscious ones.

Most British artists drawn to spiritual creativity have been prolific in the Land of Dreams, and the list of its tourists goes back a long way, to eighteenth-century blow-ins such as Fuseli, and to his contemporary William Blake, and then forward once more to Samuel Palmer and Martin. Only the word 'visionary' suitably describes their very different activities, which were extensive and remarkable even to their respective peers, in an era in which revolution, millenarianism and evangelical religion sat very uncomfortably together. Once seen, they are never forgotten, and the strength of retinal after-burn is exceptional: phenomenal in its strictest meaning. But where Blake moves into interstellar overdrive, Palmer remains very much a part of his world; his Shoreham paintings, and other images from his travels, offer up clear visions of his 'earthly paradise', to be found in several different English locations. In 1924, nearly a century after Palmer's Shoreham period, Graham Sutherland discovered Palmer's etchings and paid homage to them in an intensely sensitive series of his own.[108] Sutherland brings to his prints a gossamer coverlet of peace and simplicity that conveys a profound and intuitive understanding of Palmer,[109] and his openness and fast-developing responses to such stimuli interlock in all the phases of his later, non-figurative work, including their hallmark spatial distortions, in which viewers may discover distance and proximity virtually simultaneously. The seeds of the great Neo-Romantic dreamscapes of the 1940s were sown here, together with those of an overlapping strain of British surrealism, represented by Roland Penrose, Eileen Agar, Ithell Colquhoun and Leonora Carrington, who tended to follow their own inclinations rather than any guiding light[110] and were arguably less 'about' the Spiritual than 'of' it.

What's romantic about Neo-Romanticism? Just the fact of its existence, because it was so influential. It fed off others, to become an immensely influential percolator of what we can easily call the 'spirit of England' at several different levels. It had no

107. See Alfrey, Nicholas, Daniels, Stephen, Bann, Stephen, exh. cat., *Art of the Garden: The Garden in British Art, 1800 to the Present Day*, Tate Publishing, 2004.

108. See Alley, Ronald, *Graham Sutherland*, exh. cat., Tate Gallery, 1982, pp. 60–61.

109. Alley, *op.cit.*, suggests the influence of Paul Nash: fight about it if you want.

110. Although Agar and Paul Nash were intimately associated for some time.

style as such, but its key players were 'names' who adopted positions and on the whole remained in them. Among their work, Night, Darkness, or waning daylight, feature persistently. Piper used dark skies to emphasise the surface colour and texture of his locations, whatever and wherever they were. Sutherland, almost crustacean in his outlook in 1939, is most responsive to thickets, mines, quarries, the bleakest bomb site available, or in sunsets whose powerful rays might as easily have been viewed across mountainous slag heaps as in the mountains or hills of Wales. Nash's fugitive blues had an impact on the imagery of Edward Bawden, Eric Ravilious and Albert Richards; the darkness of Ayrton, MacBryde, Colquhoun and even Eardley require a special vision in which nostalgia plays only one part; the rest is not the stuff of experience, but above that: acutely sensory, spiritual, at a place where the word 'nostalgia' is something deeply inhaled, heady, available but not always used. Jones at Capel-y-ffyn, or anywhere really; Bomberg at Ronda. Richard Eurich on the Solent shoreline. Later, Will Roberts at Penclawdd. Tress wind-battered in Connemara. And in another post-1945 kingdom, Edward Burra and Carel Weight represented spirituality at its most spectral, endowing banal situations in featureless locations with suspicion and uncertainty that fuse like spiked shards into small flurries of acute unpleasantness: the dark side doesn't have to be your wildest dreams to be made manifest in such deeply unsettling imagery. Only the best can deal with this. Nowadays the truly rarefied find their expression in pure abstraction... but does it work?

Not often, and when it does, such statements are usually hard-won, in the sense that they come from inside, rather than as a direct result of external demand. Talking the talk of spirituality is one thing, but walking the walk can be more strenuous. In painting, Neo-Romanticism has played its part, and the experiential elements of *genius loci* continue to remain at the forefront of intuitive painting, in situations that are ineffably local, and are about experiences that are both internal and external. Chris Griffin in the Welsh Hills, Joan Eardley at Catterline, David Prentice in the Malvern Hills. Adrian Berg in Regent's Park or Sheffield Park. But intuition needn't result in an art of disarray or disorganisation, only a groping process of putting on and taking off, of dressing and undressing in darkness. Intuitive spiritual imagery and energy can rack up in abstract work, as gestural brushwork with clear signs and signifiers, like those of Alan Davie; or of mixed-

Robin Richmond
These are the Rules 1 (Plum), 2005
mixed media on handmade paper on
canvas
431 x 101 cms
© Reproduced by kind permission of the
Artist

Robin Richmond
These are the Rules 2 (Pumpkin), 2005
mixed media on handmade paper on
canvas
431 x 101 cms
© Reproduced by kind permission of the
Artist

media mark-making, as in some of Lanyon's constructions, or in a younger generation of artists such as Hughie O'Donaghue, Kjell Torriset or Robin Richmond: three very different artists capable of major physical or intellectual relocation, plus the ability to allow the most elusive of spiritual and spatial possibilities to gain or decline in meaning within their respective works.[111] Interestingly, all use art history, and the art of the past, to seek new and unrelated responses to the present. All have recent work that reflects ideas and sensations that are both abstract and concrete: Richmond's canvases *These are the Rules* are remarkable examples of challenging paintings that ask as much about text and meanings in spiritual terms as they deliver.

Has sculpture come the same way? No. Forget the 'statuemania' of the turn of the nineteenth century: since the 1960s the commissioning and erection of so-called public sculpture (or what you will) has increased so markedly that the 1990s witnessed the placing of over 650 objects in public spaces.[112] Was this spate of official activity in answer to some groundswell of public desire for visual stimuli? Pull the other leg. To quote Sandy Stoddart,[113] public sculpture remains '...constantly encountered, rarely contemplated' – and to discover the spiritual in three dimensions, in a public place, and fully formed, is rare in work after 1960. Even the commemorative is too often grotesque and ill formed: it's as though literal representation is undeserving, when in fact it still offers real possibilities. Yet barriers can still be crossed by work such as Helen Chadwick's *Of Mutability* (1996), whose background is as powerful a mixture of the spiritual and the sensory as any modern attempt to synthesise the human life-cycle can ever be.

In between, an altogether different artefact offers future possibilities: the artist's book. Sculptural, yet not a sculpture, three-dimensional, and still capable of unfolding in alternative ways, by individuals or in coalition, the handmade, hand-printed, constructed, and not-necessarily-too-de-luxe text has come a very long way since William Morris. In tactile terms the elasticity of The Word offers massive potential in conventional hard and soft format, and can combine with photographic and three-dimensional media to make narrative something that earlier generations of scribes and printers could never have envisaged. At the top end of such activity are artists such as Ken Campbell, whose breadth of vision and activity, as a painter, poet,

111. Torriset was born in Norway; Richmond in America. Both were British-trained and live and (mostly) work in England. O'Donaghue was born in Manchester, trained in England and now lives in Ireland. See Hartley, Keith and others, *Kjell Torriset at the De La Warr Pavilion*, exh. cat. De La Warr Pavilion,

2003; also Hamilton, James, *Hughie O'Donoghue: Painting, Memory, Myth*, Merrell, 2003.

112. See unknown author, *The Epidemic of Public Sculpture, The Jackdaw* magazine, issue 49, June 2005, p. 13.

113. Stoddart (b.1959) is a highly successful contemporary sculptor working in the classical tradition: the phrase was used in a BBC *Sculpture Week* programme on commemorative sculpture broadcast in 1996.

Maurice Blik
At First Light, 1996
bronze
173 x 770 x 275 cms
© Reproduced by kind permission of the
Artist

sculptor and letterpress printer, combine rich sources of imagery to transform the act of turning the pages into something unnerving, often terrifying, spiritual, in the sense that, in the course of his texts, running backwards and forwards, often interlacing ideas and changing forms with colour and type, the future is both tantalising and fraught with possibility.[114] All this is a long, long way from Kandinsky, and it needs to be, but we still need to have travelled to gain something from expressions such as Campbell's books, and those by others like him. From them, new possibilities emerge for human responses to things, to matters, to experiences that we suppose to be beyond our grasp, but which are in fact much nearer to hand than we may think.

114. Campbell, Ken, with an essay by Marcia Reed, *The Maker's Hand: Twenty books by Ken Campbell*, Ken Campbell, London, 2001.

Ken Campbell
Double page spread from *A Knife
Romance*, 1988
Edition of 25 plus artists proofs
50 x 43 cms
Artist's Collection

8
The Devil and the Deep Blue Sea

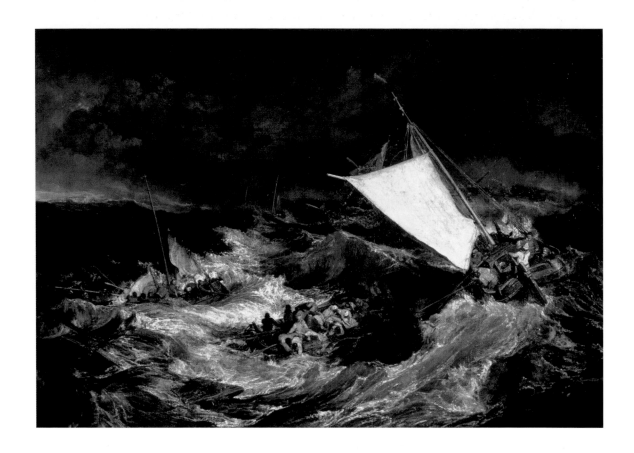

Joseph Mallord William Turner
The Shipwreck, 1805
oil on canvas
171 x 242 cms
British Museum, London, UK / The
Bridgeman Art Library

It is easy to forget that Turner's first
calling was as a marine artist... until
confronted with paintings like this one

So what did the Normans do for us, then? I mean *apart* from the small matter of introducing to this storm-tossed little island a penchant for religious and military architecture of quite staggering stature and beauty (yes, even the military stuff)? They gave all who followed them a serious appreciation of the part played by water, specifically the sea, rivers and boats, in one of the most important invasions in English history, and they famously made that plain in the Bayeux Tapestry.[115] The sea was, *naturellement,* to be the very element upon which the future of the British Isles was to turn, but the Bayeux threads hardly reflect La Manche at its most attractive. Good job, then, wasn't it, that history has been kind enough to deliver artists who have been prepared to rise (and fall) with the tidal challenges involved in tastefully recording the effects of the sea upon British island culture, or simply responding to their own gut feelings, usually without any equivocation, somewhere out there at a point on the coast of Britain. Seaside insomniacs will support this concept wholeheartedly. They will know that the combination of a clear view of the sea (best conditions are about 1.30am on a moonlit night), a cup of tea, and the opportunity to stare at the sight for as long as necessary are to understand why Turner found the experience so riveting; they will easily grasp the ease with which a painter of his growing talent could hit that visual spot with perceptive British audiences, in early works such as *Fishermen at Sea* (1795–6), also known as *The Cholmeley Seapiece*[116] and in so many other marine images. It is also worth reflecting on the general point that whilst practising artists in every field have always kept one eye on the taste of the time, and whilst contemporary visual language (style) has been deployed in marine art of every era, remarkably, when the sea, its vistas, and experience of it are the subject, rule-books are thrown out of the window, and everyone falls back upon gut feeling, the better to convey personal experience in colour, line and paint. Those water-stories are timeless, and we tend to deal with them according to our needs.

British art history contains great sea pictures by painters for whom this activity was big business, and who therefore needed expertise by the boatload. The best of them had exactly that, and the results of their activities tell visual tales uncannily laced with onomatopocia: the boom of the surf, the roaring wind in your eyes and ears, and shot and shell parting your lank hairdo. Broadly speaking, such work ranges through the best part of three centuries of 'shiver-me-timbers' images of wooden

115. The date of the Bayeux Tapestry is uncertain but most commentators give it as the later eleventh century. It would be, wouldn't it, when the Battle of Hastings was fought in 1066. Most of them also urge us to forget the tradition that the tapestry (it isn't a proper tapestry in the traditional sense but a strip of embroidered linen) had any association with Duke William's wife Mathilde, and some say that it had nothing to do with Bayeux at all. You can't trust anyone these days.

116. Come to that, you'll also understand why the German painter Caspar David Friedrich (1774–1840) found similar scenes so absorbing. His audiences found the results of his interest as hypnotic as he did.

ships, starting in the seventeenth century with the van de Velde father and son, both named Willem,[117] through the superb output of Philip de Loutherbourg, and going iron broadside to broadside, wood to wood, all the way through Maclise's re-evocation of *The Death of Nelson*,[118] to early twentieth-century paintings and etchings by Frank Brangwyn. Oh, and by the way, every one of these artists was born outside Britain.

Nonetheless, we tend to ignore the important fact that the sea has temporarily (and here, 'temporarily' is a word of considerable elasticity) commanded the attention of many authors whom one would associate with more landlubberly pursuits. Indeed, in recent years, photographers, sculptors and, more recently, artists using film have made bodies of work or specific works, directly as a result of seaside activity, or as a result of imaginative stimulus: Mark Power's *The Shipping Forecast*, David Nash's *Eighteen Thousand Tides* and Tacita Dean's arrival as a Turner Prize filmmaker all fall within this period.

The subject area of Marine art is as panoramic as the sea itself, and with as many moods. Quite aside from the benchmark activities by the foreign-born artists already outlined, in chronological terms some of the very best home-grown artistic activity ever present in this country has been waterborne or water influenced, and any checklist comes into its own at the turn of the eighteenth century. When they took to the waterside, Norwich School artists[119] (otherwise inclined to Italianate sympathies) paid visual homage to the earlier Netherlandish artists, whilst developing meaningful individual styles. Of these, the greatest was John Sell Cotman, a master of hard-edge watercolour wash (a contradiction in terms perhaps, but accurate), and a great antiquarian draughtsman.

If Norwich now seems remote (it wasn't then) those artists weren't alone. Thanks to Trafalgar, British Marine painting really took off at the start of the nineteenth century. Its grandest moments were bathed in the radiance of Britannia's very real rule of the waves, were almost entirely seaborne, and ranged from unequivocal symbolism, as practised by Turner, to imperially grandiose, illustrative statements by artists such as William Wyllie, who made his name as the country's pre-eminent sea painter as Queen Victoria celebrated her Golden Jubilee (1882). Their pictures, with

117. Having travelled to and from England on independent commissions for donkey's years, Willem van de Velde the Elder (1611–93) and his son Willem van de Velde the Younger (1633–1707) settled in Britain in 1672, having entered the service of King Charles II. They were the best: no question of it, and to say that they set the tone for marine painting in Britain for the next three centuries is, frankly, to grossly understate their real importance.

118. Trafalgar was fought on 21 October 1805, and was immortalised in the fine painting of *The Death of Nelson* (1861–6, The Walker, National Museums on Merseyside) by Daniel Maclise RA (1806–70). Think about the lapse of time between the event and the painting.

119. Most definitions suggest that the Norwich School's period of maximum impact was c1803–30: these artists were a local society, not a stylistic brotherhood.

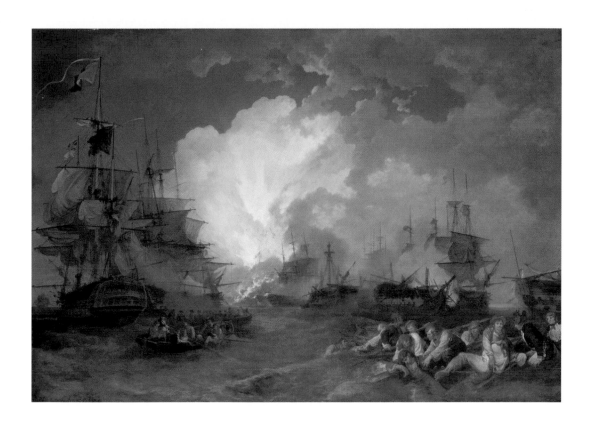

Philip James de Loutherbourg
The Battle of the Nile, 1800
oil on canvas
152 x 214 cms
© Tate, London 2006

many lesser works, were shown in public to an increasing and interested audience, and often bought by many of the new municipal art galleries then being built throughout Britain.[120]

So much for the intellect, but it wouldn't have counted for much had many Britons not begun to experience the phenomenon of the Seaside,[121] in roughly the same period. In 1752 Dr Richard Russell published his famous *Dissertation Concerning the Use of Sea-Water in Diseases of the Glands,* and the wealthy began to turn away from spa towns and head for the shorelines. The railway boom of the mid-nineteenth century did the rest, comparatively quickly, by introducing cheap travel, and thereby putting a huge cross-section of city- or town-dwellers in touch with the nearest stretch of British coastline.[122] The visual and sensory experiences of thousands of people were simply transformed: the beach and the seashore, which for the majority had previously been no more than figments of the imagination, were established within their awareness as real.

This was a revolution. Before this time (unless one was a sailor or a seasoned traveller), the ideal of the sea was less something picturesque, and more something that was romantically Sublime: terrifying in its ever-changing and limitless grandeur. Experience of the Seaside lowered mental and experiential barriers and developed possibilities for all. Here was a wealth of sensory pleasure, from the utterly contemplative to the purely superficial, to be discovered by artists and public alike: that first sight of a limitless, watery distance that had been formerly purely abstract. The nearness of the sea; the proximity of its changing detail. Its timelessness. And its sounds. Its smells. It is kinetic, can be mesmeric. The intrusion of other elements, sights, sounds and smells. Groups of fellow humanoids. Fried food and stale beer. Raucous laughter. The whack and buffeting rush of sea air. The casual rattle of cascading shingle, or the reassuring light crunch of sand.

And above all else, its colour. Blue turns to grey and back again, and every colour in between. Monastial blue for the deep, dark oceanic tones of a ferry crossing and sometimes not even then. Prussian, Azure, Ultramarine or Turquoise for northern or Atlantic waters: see Eric Ravilious. Greens and browns and yellows for the lumpy, scummy surf after a wild sou'westerly, after Charles Conder, the sparkling

120. One of Wyllie's greatest pictorial gifts was his ability to combine the grit and grime of iron ships with the purity of sailing craft, and with a total understanding of the sea. A glance at any of Wyllie's best paintings says much about the reasons for his enormous, contemporary popularity, and offers a focus for comparison with later, fine, yet imitative, work by marine artists such as Charles Pears (1876–1958).

121. See Tickner, Lisa, *Modern Life and Modern Subjects: British Art in the Early Twentieth Century,* pp. 128–35, Yale, London & New Haven, 2000, for a perceptive and analysis of the beginnings of this phenome-non. To develop ideas concerning the social impact of the railways, and much more besides, see the excellent Freeman, Michael, *Railways and the Victorian Imagination,* Yale, London & New Haven, 1999.

122. E.g. the railway from London to Brighton was completed in 1841.

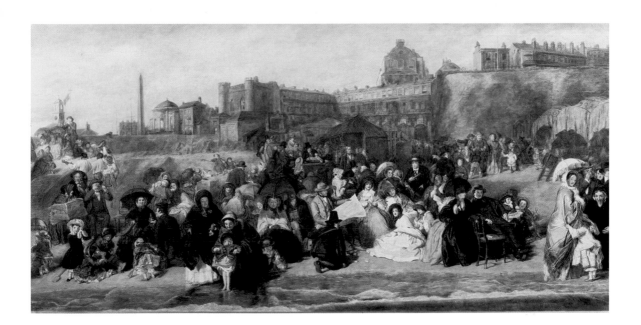

William Powell Frith
Ramsgate Sands, 1854
oil on canvas
110 x 188 cms
© Russell-Cotes Art Gallery and
Museum, Bournemouth, UK/ The
Bridgeman Art Library

deep blues of Laura Knight, the Cerulean of Winifred Dacre Nicholson... take your pick, and make as many changes as you wish. Surf is indeed up, and that deep blue sea is certainly available around the coasts of Britain. Ride the train from Berwick to Edinburgh along the east coast mainline, from St Erth to St Ives, from Chester to Llandudno, from Exeter to Dawlish. Watch it change from Beachy Head, like Adrian Berg; see it lollop onto the beach at Studland, like Vanessa Bell. Know it is at your back, as it was at Turner's, so many times in Wales.

A restless eye needs a background for other ideas related to the seashore, and in nineteenth-century British art all this was beginning. The beach played host to cosy, sometimes-folksy, turn-of-the-century paintings of fisher-folk, executed as far apart as Newlyn in Cornwall and Staithes on the Yorkshire coast. It provided a backdrop for narrative painting by artists such as William Powell Frith, whose *Life at the Seaside (Ramsgate Sands)* of 1854 appeared well before his better-known *Derby Day* (1858). Almost surrounded by sea by its very shape, Cornwall – and St Ives especially – was to become a magnet for artists of every kind, attracted by wind and wuthering. As twentieth-century tourists, Ben Nicholson and the lesser-known Christopher Wood discovered the naive sea-world of Alfred Wallis. There, in the later 1940s, the immigrant settlers Nicholson and his wife Barbara Hepworth would become the implacable enemies of the abstract expressionist Peter Lanyon, many of whose paintings and drawings speak of the essence of the reeling plumes of salty air around the area of West Penwith.

Marine painting and its later, more esoteric descendants are not best served by the irritating British practice of grouping their practitioners into narrowly defined categories. In the end, it didn't matter whether a group had a name or where it was located, or what its group dynamic was. Artists gained reputations on the strength of their ability, and little more. For example, it is certainly important that the long and impressive career history of Laura Knight began with a decade in Staithes (1897–1907), but it is perhaps more important that this period was followed immediately by more than a decade in Newlyn (1907–19), where the proximity of sea and shoreline came to serve as little more than a useful backdrop, and where she made other, more important career decisions concerning her future subjects.

Peter Lanyon
Porthleven, 1951
oil on canvas
245 x 122 cms
© Tate, London 2006

Mid-twentieth century Brits were much exercised by the concept of 'a sense of place', chief amongst them Paul Nash, who preferred the Latin phrase *genius loci* (it was probably snobbery) and whose leanings toward Surrealism would make him important in other ways also. *Genius loci* is that certain, subconscious 'something', that tug, that intuitive understanding, that binds us to a particular location. It was a major consideration for many artists working close to the sea before 1945, especially those with an urge to offer receptive audiences their sharpest visual responses to the elemental experiences of the coastline, of the sea, of ships. Not one was what you'd call a quintessential marine artist, all were experienced practitioners in watercolour, and all of them bar two were touched by, or at least aware of, modernism in some form. This last, unsullied pair were the naive artists Alfred Wallis and James Dixon. Neither man knew the other: the first lived in St Ives, and the other on Tory Island, off the coast of Co. Donegal, but each fully understood the relationship between vessels and the sea, and conveyed this in relatively small-scale works that owed much to a combination of personal experience tempered by considerable imagination. In Wallis's own lifetime his work was of interest to contemporaries because it clearly showed what might be achieved by an untutored approach to subject, uncluttered by 'modernist' tendencies: it allowed unvarnished focus on the maritime experience to many artists who wished to present what they saw pictorially, but with greater emphasis on the feelings involved.

In this time the seafaring tendencies of many artists surfaced. Amongst such gems are the Portslade (Sussex) watercolours of David Jones, and many watercolours by Edward Burra of Romney Marsh and the nearby Kent coast. The composite experiences of John Piper on the English Channel and elsewhere, during the 1930s and '40s, are reflected in an exhaustive series of images and techniques from abstract to figurative, with results that range from homely, collaged mural decorations, through austerely abstract oil paintings, to the deservedly famous *Brighton Aquatints* (1939), and to a range of superb wartime activity in watercolour and oils. In all this, Piper's work may be compared to Nash's: the latter's detached viewpoint, as it related to the shoreline, the equinox and Surrealism were equally meaningful in his landscape and photographic activities, and were a real influence upon the art of Edward Bawden, John Tunnard and Eric Ravilious.

Peter Lanyon
Offshore
1959
oil on canvas
153 x 184 cms
© Birmingham Museums & Art Gallery /
The Bridgeman Art Gallery

Lanyon was acutely aware of Cornwall's
geography, and many of his paintings
and constructions reflect his determi-
nation to express the physical experi-
ences of the Elements onto a picture-
planc

So much of this activity has vanished from today's artistic practice. This isn't because painting is dead (no matter what the lunatic fringe have to say about it), but because for some the effort of becoming seriously sensorially engaged with a two-dimensional surface has too often been bypassed in favour of less intense, less taxing pursuits. Why waste the paint on the sights and smells of Nature when it's all been done before? But no one said anything about its having been done better, although assuredly the examples of others are among the finest anywhere. Many of these works are by artists whose practice has been driven by the storm itself, and for whom the inward and outer experience seems to have one of complete or near-total combustion. Many of Turner's paintings fall into this category, but although *Snowstorm: Steamship off a Harbour's Mouth [...]* (1842) might be the first to come to mind, earlier works such as *Calais Pier* (1803) or *The Shipwreck* (1805) or *Yacht Approaching the Coast* (1832) or the later watercolour sketch of *Yarmouth Roads* (1842) contain at least as much power, however 'frozen' they may initially seem. In these, and in other images across Turner's output, it is sometimes possible to sense a holding back: a need to discover more. Even when he seems to let go, in some of his oils of the 1830s and 1840s, some paintings are held on a tight compositional rein, including *Snowstorm*.

Nearly a century later, the power of Turner's response to the British coast and its weather was matched in some respects, and arguably bettered in others, by Joan Eardley and Peter Lanyon. Both were artists who owned different, yet acutely attuned sensibilities to colour, coupled with wholly individualistic leanings towards personal, expressive truth. Eardley spent most of her working life in Scotland, especially in Glasgow, where she made her name with her semi-abstract images of the Glasgow slums and their inhabitants. From the early 1950s, however, Eardley worked increasingly from Catterline, south of Stonehaven in Aberdeenshire. Her favoured tool was the palette knife, and her lifestyle became – literally – a matter of responses to nature, especially as her health steadily failed. Turner would have envied Eardley the range of her palette, but he would have been astonished at the size of some of her canvases, and the expressiveness of the mark-making that she brought to her drawings, and to oil studies of coastal scenes. Against these, at the other end of Britain, Peter Lanyon fought his own battles with the weather and the Cornish coastal landscape, eventually learning to glide in order to – literally –

Joan Eardley
Wave, Catterline (panel) c1961
oil on panel
50 x 60 cms
Private Collection
© Bonhams, London, UK / The Bridgeman
Art Library

Joan Eardley
Field of Barley by the Sea, c1961
oil on board
107 x 111 cms
© The Fleming-Wyfold Art Foundation /
The Bridgeman Art Library

Eardley's painterly engagement with
the sea increased with the size of her
canvases

heighten a sense of experience that struggled to defy gravity. Much of Lanyon's later work moves away from painterly tradition, through its use of mixed media, yet it also contains a clear, if distant, echo of Wallis, whose 1940s' laptop creations on bits of board and card extended the boundaries of conventional teaching. Matters of finesse can't be applied easily to Lanyon's strongest work: it is physical, and seeks to express such experiences. Together, works such as *Porthleven* (1951), *High Ground* (1956), *Soaring Flight* (1960) and *Turnaround* (1963–4) bracket his achievement.

This stop – start, struggling relationship between the mind, the eye and the shore-line has been unceasing since Lanyon's untimely death, and, at their best, artists working in every medium have continued to turn over the strongest sensory experiences. In painting, these can range from the formal realist statements of older painters such as Richard Eurich or of abstract artists such as Terry Frost; through the extremes of storm and calm in Louise Cattrell's weather-inflected canvases to Mark Power's remarkable photographic statement *The Shipping Forecast* (1992–96). In sculpture, the story tends to be different, for today the Sea is capable of exciting everything from the grotesque posturings of Antony Gormley's 2005 Merseyside installation *Another Place* to the fixity of David Nash's splendidly con-templative *18,000 tides* (1996), which has as much to do with woodland as it has with the shoreline. And then there are those such as Tacita Dean, who have been drawn to investigate the hidden, and the changing qualities, characteristics and conceptual possibilities of sea and shore, both in traditional materials and in film. Well, someone had to make a moving artwork of the one natural feature of life on this planet that moves unceasingly, didn't they? Yet none of these artists, or many of the others drawn to the water's edge, can be said to have fixed their sights solely on this area of activity. Each one pursues other aims: the coasts and all they can offer, whatever the location, are but one element in the visual experience of Britain. Even so, whilst the sea may yet encroach and rise around the British Isles as the world's climate changes, its hypnotic qualities will also continue to compel artists to record its ceaseless motion. And like buoys, some works or series will continue to rise above the merely mundane to prompt visual and cerebral responses to our most enduring surrounding element.

9
Smut:
Art & Industry

Art and mass production have never been easy bedfellows, and since Britain began to reap the benefits of industrialisation at the beginning of the nineteenth century, suspicion and mistrust on both sides have tended to corrupt most attempts at meaningful relationships. That's not to deny the very real importance of key figures such as William Morris and his followers during the later nineteenth century and beyond, but it's not unfair to say that theory and philanthropy have tended to be the losers when they oppose the forces of financial gain. What about the workers? Ha. It's a long story.

Let's start in the mid-1970s, when that part of contemporary British art that managed to filter through to public consciousness was largely Conceptual: that is, the so-called idea was just as important, if not more so, than the 'finished' object, and the public knew about it through the press, for whom it represented money for old rope. Success it wasn't. Scandal it was. In case you were wondering, good visual concepts were in relatively short supply (in some places they remain on the danger-list), and the term 'artworks' referred to experiences such as Richard Long's walks, to ready-mades such as Barry Flanagan's folded blankets or the American Carl André's infamous 'Tate Bricks', and to many others, more or less abject. This path towards enlightenment was unfortunately nurtured by the then Arts Council of Great Britain,[123] through several of its client galleries in and outside London, and by some key independent, but favourably-inclined centres, such as the Tate[124] and the Whitechapel Art Gallery, to name but two. Outside London such activity was mostly considered meaningless, as indeed much of it was. Although it was defended in the pages of most 'dedicated' art magazines, the national press gave the worst excesses of this postmodern junk a lengthy and totally appropriate hammering, thereby opening the door for similar righteously indignant criticism that continues to the present day.[125]

Whatever it may have achieved, Conceptual art increased the distance between its own practitioners and the millrace of the general public. And despite all protestations to the contrary, because a class system of sorts *did* still exist in this country, that gap was at its largest at the working-class end. In a series of attempts (this description is heavily over-simplified) to build meaningful bridges between art and industry, and to reassure and to attempt to interest those at all levels of industrial

123. Some people never learn: the 'nurturingness' remains terrific.

124. In those days there was only one Tate Gallery: the original building at Millbank, London, now called 'Tate Britain'.

125. See – if you can find it – Auty, Giles, *The Art of Self-deception*, Libertarian Books, via Folium Press, Birmingham and Pitman Press, Bath, 1977: a skip-load of well-directed opprobrium, this, if ever one existed. More recently, see *The Jackdaw*, privately published by David Lee, the fulcrum of *Stuckism*.

activity whose perceptions were based upon skill, quality and traditional teaching, English Regional Arts Associations[126] were encouraged to commission artists to go into industrial situations, such as factories, or to other places where art has feared to tread, to make themselves accessible to the workforce, and to record their experiences, usually in painting or drawing. This huffing and puffing gradually subsided during the mid-1980s. After nearly a decade of hard-fought activity (sometimes also hard-won), frequently in the face of tabloid headlines, the end results were low-key, healthy, realistic, and not without a sense of scepticism.[127] Two things were certain: workers preferred art that retained figurative qualities, but were often surprised when artists chose to work in the same medium as that used in the place they were commissioned to record; for their part, artists were usually forced to severely reassess their own activities. Were the residences salutary experiences? Very possibly, and for the artists especially, but how did matters reach this state, and what lessons have been learnt?

When you rub the lamp labelled 'British Industry', what visions emerge from the clouds of green smoke and sparklers? It depends on who you are, but they aren't likely to be picturesque. Since 1980, successive government policies, urban regeneration and European money have literally changed the appearance of industrial activity, wherever it has taken place, outside and in, to the extent that it has sometimes utterly disappeared from areas of the country where formerly it was a force to be reckoned with: coal mining and steel manufacture are merely two of a series of unfortunate examples. Until the early 1980s those old jokes in which the North was described as beginning at Watford weren't entirely inaccurate. If it wasn't exactly Blakean, conventional mind-pictures of 'British Industry' were sealed tight within English Lit, and in associated ideas, so that Dickens' description of the ruined industrial wastelands around Dudley and Wolverhampton endured for decades,[128] Edwardian illustrated magazines and their serialised stories brought to life the local scenery in Arnold Bennett's images of the Staffordshire Potteries, and, taken together, George Eliot and William Morris point several fingers at the extensive and mostly negative effects of industry upon what we would call the demographics and ecology of Britain. Coming later, Orwell's 1930s' Wigan walkabouts have gained meaning for those whose literary understanding extends to a visual awareness of the extraordinary documentary photography of the era, and the 1950s introduced

126. They are now called Regional Arts Boards, but there may no longer be one near you: in the last few years the Arts Council of England has reviewed its financial support to the English regions, and things have changed.

127. See Hercombe, Sue, *What the Hell Do We Want an Artist Here For?*, Calouste Gulbenkian Foundation, London, 1986.

128. Dickens' description of the Dudley wasteland remained completely appropriate even into the 1970s.

Sir Frank Brangwyn
Boatbuilders, Venice,
etching
52 x 66 cms
Private collection

Joseph Wright of Derby
The Iron Forge, 1772
oil on canvas
122 x 132 cms
The Bridgeman Art Library
Broadlands Trust, Hampshire, UK

A modern nativity by any other name

the awkward, workaday world of authors such as Kingsley Amis, Alan Sillitoe and the Johns Braine and Wain to welcoming audiences. In twentieth-century Dublin, Cork and, much later, Limerick, James Joyce, Frank O'Connor and Frank McCourt all ably served to enshrine a sense of place in which nostalgia plays a major role, but none of these admits or offers the substance of purely visual imagery as counterpoints to word-play. Does art, did art, fall short of the power to document the actuality of mass production? Does industry favour narrative, or illustration, at the expense of a search for truth? Is it really down to the way you tell it?

The very word 'industry' is loaded with variable meanings, and as these have developed along with language, so they have in art also. For William Hogarth, whose first print in the series *Industry and Idleness* was made in 1747, industry was bound hip and thigh with commerce, and commerce with all manner of social status: applied social climbing might bring rewards, but it was no less open to hypocrisy, and the opportunity for lampooning in caricature. Nevertheless, by choosing to contrast the Idle and Industrious 'Prentices, and to hold them up as public icons for British eighteenth-century approval or rejection, Hogarth surely recognised the way his world was turning: his printmaking process was an industry in itself, whether he saw it that way or not. The popularity of his prints, their basis in contemporary morality, and their potential to generate open-ended (and multi-layered) interpretation[129] suggest that the wallets of visually interested Britons were fair game. However tenuous Hogarth's arguments or stances were, his prints utilised mass production in the business of public entertainment, in England at least.

In 1756, during Hogarth's own lifetime, the Irish philosopher and politician Edmund Burke (1729–97) published his famous treatise *A Philosophical Enquiry into the Origin of our Ideas of the Sublime and the Beautiful.*[130] No doubt of it: British eighteenth-century industry was certainly Sublime. Forget Blake's 'dark, satanic mills' for a moment: developments in the manufacture of iron and ceramics required furnaces, and so sublime visions of hell descended upon some of the more beautiful features of the British countryside. Few eighteenth or nineteenth-century artists attempted realistic depictions of new industry: they simply weren't money-spinners, and weren't favoured by British audiences, many of whom in any case did not wish to support the gradual wreckage of the countryside at any level. Ah, but

129. See Bindman, David, *Hogarth and his Times*, British Museum Press, London, 1997, pp. 11–32 especially, for a clear introduction to these themes.

130. Treated to a disgracefully cursory survey in Chapter 6: see Vaughan, William, *Romanticism and Art*, Thames & Hudson, 1994 for a full account.

there's one in every crowd. In 1772 Joseph Wright of Derby painted *An Iron Forge,* one of a series of paintings combining themes of science and industry, which were shown publicly between 1766–73 and which cemented his reputation. All Wright's works (including *An Experiment on a Bird in the Air Pump,* 1768) reflect speculative, sometimes provocative, scientific thinking, and *An Iron Forge* is fascinating in this respect. The scene is lit like a nativity, but forget the crib, brother: centre stage is taken by a glowing ingot: a new object of devotion for the figures that surround it. This *is* the modern world, and the muscular iron-master is merely one augury of a super-hero to come. Not long afterwards, Philip de Loutherbourg, fresh from his academy success with *The Battle of the Nile* (1800) employed a similar pictorial arrangement in the powerful industrial painting *Coalbrookdale at Night* (1801). *Coalbrookdale* is as good as any of de Loutherbourg's marine works, and far, far away from his native Alsace: both scenes, highly charged in every way, owe much to Wright's earlier, equally incandescent, *Vesuvius in Eruption,* a sublime subject if ever there was one.

And after this, everything went quiet. Town- and cityscape panoramas appeared during the 1820s and 1830s that showed the spread of municipal building in new industrial centres such as Birmingham, and similar imagery continued to appear into the twentieth century, usually from the studios of provincial journeyman academicians such as Bertram Priestman and Stanley Royle, who were much more interested in atmosphere than in exact documentation (those blue-grey late afternoons around Wakefield; the bright summer heathers above fast-expanding Sheffield put miles between the viewer and the grimly grimy reality of endless back-to-backs), but, irrespective, their work records industrial urbanisation in the English north. They prove, if proof were needed, that, from a distance, George Eliot and William Morris were spot on. Industry and countryside don't go. But what those pictures and those artists also do is to remind us that artists are born in towns and cities, and that their earliest, and possibly strongest, stimuli come from that experience. How else did those cityscapes come about? Whimsy has little part when you're actually at your mother's knee in such scenarios.

Other, more important developments of the themes established by industrial panoramas can be found in paintings by Adolphe Valette and Spencer Frederick

William Bell Scott
Industry of the Tyne: Iron & Coal, c1861
oil on canvas
185 x 185 cms
The Bridgeman Art Library
Wallington Hall, Northumberland, UK

**Something to be proud of: industry and
Empire**

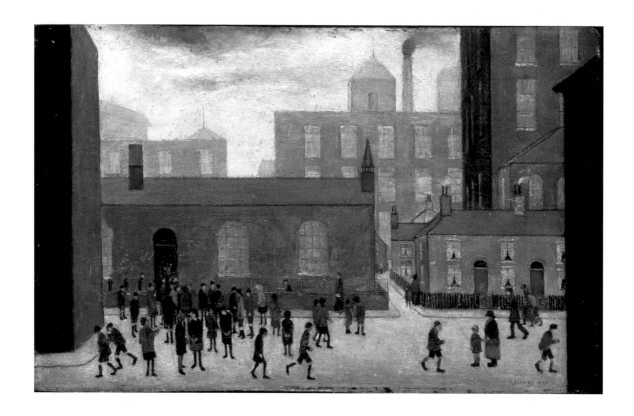

L S Lowry
Coming Out of School, 1927
oil on wood support
35 x 54 cms
Tate, London 2006
© The Lowry Estate

A sensory, sensitive painting, freighted
with possible interpretations, about
education, industry, the future, social
conditions, human relations… all set
amid invasive grey bleakness

Gore. The first, a French 'blow-in', became Painting Master at the Manchester School of Art, the second was an enormously influential figure within the Camden Town Group (1911–13). Gore's King's Cross *Canal Scene* (1912) exists visually at one remove from reality; when he begins to tackle the distant industrial encroachments near Letchworth, Herts,[131] his work veers between decorative uncertainty and Cézannesque selectivity. At the same time, further north, Valette was creating a local impression with his paintings of Manchester's factories and canal-side scenes: it is not hard to imagine how LS Lowry, one of his many pupils, could be so impressed by the way in which Valette dealt with his surroundings that emulation of the master came easily, unthinkingly even. It is also possible to suggest – since no one else has – that Valette's influence may have extended further south, to the studio of the proto-Futurist CRW Nevinson, some of whose early works seem to owe something to the Frenchman. But forget the hangers-on: give the guy a chance. Valette had a style all of his own, developed because of and despite Manchester, and it mostly works. Seen now it has its cheesy moments: sometimes it plods, like its subjects; but sometimes it is utterly all-embracing, quite brilliant. *Bailey Bridge, Manchester* (1913), *India House* (1912), and *York Street Leading to Charles Street* (1913) are prototypical *Coronation Street*. We know this: they speak to us, well away from *The Rover's Return*. And it's more than just the telly talking.[132]

One more thing. It is important to understand that, in his images of Manchester, Valette arguably came closer than any other British artist to a sustained and often intimate catalogue of industrial townscapes: certainly a great deal closer than LS Lowry ever came, in all his locked-out, frozen composites. If Lowry's self-made mythology invites interest in his work, perhaps it is because his images transcend time. They, above all others, have been responsible for the visual lock-down that the British experience each time they are asked how industry might be painted. Aimless figures processing through streets. Alienation. An endless series of winter afternoons. No wonder there are so many surprises awaiting anyone with above average visual intelligence when they travel past Watford for the first time. Lowry may be cute for some, but he does no one – and certainly no one seriously involved in British art full-on – any favours.

Valette was not unique but he was fairly exceptional in his outlook. On the whole,

131. In 1912 Gore was renting the house of his friend and colleague Harold Gilman, also a central figure in the Camden Town Group.

132. See Martin, Sandra, *et al.*, (intro), *Adolphe Valette*, exh. cat., Manchester City Art Gallery, 1976.

but with the exception of the period 1914–1918, British artists working during the century 1840–1940 tended to treat the subjects of British industry, economics and the growth of Empire allegorically, together or apart, so that high art contains very few observed, non-symbolic representations of the country's transformation into an industrial society. The social results of that transformation are there, all right, in paintings such as Turner's *Rain, Steam and Speed – The Great Western Railway* (1845); in a pair of paintings by Abraham Solomon, *First Class – The Meeting* and *Second Class – The Parting* (both 1854); images of markets; or in bizarre paintings intended as social commentary, such as John Martin's *The Last Judgement* (1853), or George Cruikshank's *The Worship of Bacchus* (1860–2). For the first 60 years of the nineteenth century, however, with a few very noteworthy exceptions, depictions of workers at their work were either published as popular prints in lithograph or mezzotint format, or confined to the pages of illustrated magazines where, until the later 1860s, they remained out of harm's way, available for philanthropically inclined readers with social consciences, but definitely not for the walls of the academy: *that* was out of bounds to anything that smacked too much of real life, a foreign body and to be disdained. *Punch* (established 1841), *The Illustrated London News* (established 1842) and especially *The Graphic Magazine* (established 1867) offered a wealth of information for the curious concerning life and working conditions among the lower classes, and utilised fast new printing technologies to achieve this. By the 1880s, the hardships of workplaces from market-gardens to coal mines were regularly placed before the reader.[133]

There is a higgledy-piggledy postscript to the graphic representation of industry, partly because it demands the continued recognition of the inherent part played by physical labour, and partly because of the undeniably charismatic (yes: they cry out to be drawn, and drawn well) qualities of machinery that have endured right up to now.

Call it what you want: endeavour, travail, determination, but find yourself any half-decent (most are decent) Frank Brangwyn drawing or etching of human beings engaged in any type of labour; search for similar images from the burin of William Larkins, or among the paintings or lino cuts of George Bissill, and you'll find that they are all modern subjects, in their different ways. Examine the outcomes of First World War lithographs by Nevinson,[134] drawings of shipbuilding by Muirhead Bone,

133. See, amongst other sources, Pickvance, Ronald, *English Influences on Vincent van Gogh*, Arts Council Publications, 1974.

134. For the series *Britain's Efforts and Ideals in the Great War*, 1917.

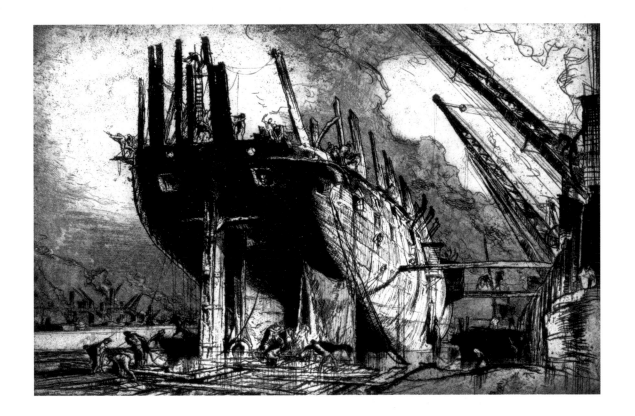

Sir Frank Brangwyn
Breaking Up the 'Duncan'
etching
55 x 82 cm
Private collection

'Dignity of Labour' was an emotive
expression in Edwardian Britain, and
many of Brangwyn's etchings and litho-
graphs convey it expressively, in set-
tings that range from the nostalgic to
the optimistic

woodcuts by Edward Wadsworth or paintings by George Clausen, Anna Airey or John Lavery, and be confronted with a dark revolution: for in the hands of the masters and mistresses, the forge and the press fight their ways to gallery walls. Now ask why so many of these hard-won images have been neglected. What's wrong with the representation of labour? What's wrong with idealisation? If van Gogh could do it, why couldn't we? What was so offensive? And why was this 'offence' not recognised before all that activity in the 1970s and '80s?

When they do make it onto canvas (and unlike illustrations, paintings and sculptures of Victorian industry contain little or no reference to factory life), they come late on the scene, but they can be valuable concerning the business of outdoor labour. Perhaps the most famous of them all was an early arrival, and thus an exception. *Work* (1852–65) by the Pre-Raphaelite artist Ford Madox Brown is a complex series of ideas in which the artist's considered view of social status is interwoven with notions connected with the dignity of labour. Some of this is vaguely discernible in the painting, but there are some bum notes even here, and you'll need to read Madox Brown's own detailed description to understand it more fully. Having done so, you might find this highly wrought and sunny scene of navvies[135] in Hampstead High Street a little less appealing, especially if you veer towards political correctness.[136]

Work had no rivals, on its first appearance or at any time thereafter. If it is seen as a marker, then that might have been a challenge – if posterity knew it – to define the visual nature of Labour, its so-called 'dignity', its place in society, and therefore in art. It is unlikely that anyone responded, but it was certainly followed by works of art that (inadvertently) offer some intriguing comparisons. Paintings by George Clausen, HH La Thangue and others like them develop a nostalgic iconography in the theme of the farm labourer, influenced by earlier French Realist imagery by artists such as Millet:[137] in the theme of *any* labourer, really, if the subject of the work caused something like nostalgic reverie in the minds of viewers. Those were the days, eh? See them grafting, hoeing, fruit-picking, pressing, horny-handed, the old and the young, bent to the plough, bound to, or rebelling against, the English (yes English) heartland, married to it, dying in harness. Yes, even in art, Death himself found a way to the cottage gate. Nowadays these paintings are being re-evalu-

135. OK, hands up: how many of you know the meaning of the term 'navvy'? You should consult a dictionary for initial enlightenment, but this is mere terminology: nothing can prepare you for the real truth of what it meant to be one. Check Terry Coleman's excellent book *The Railway Navvies*, and hope it never happens to you.

136. See Nochlin, Linda '*Realism and Tradition in Art, 1848–1900*', in Jansson, HW (ed.) 1966, *Sources & Documents in the History of Art*, pp. 93–100; also Treuherz, Julian, *Victorian Painting*, Thames & Hudson, 1993.

137. Jean-Francois Millet (1814–75): the French influence permeated the New English Art Club (originally the Society of Anglo-French painters, founded in 1886, of which both Clausen and La Thangue were members).

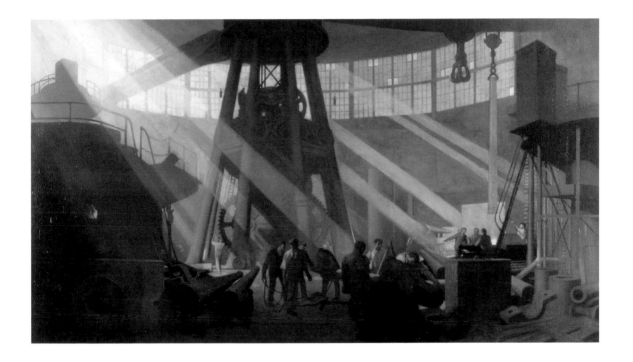

Sir George Clausen, RA
In the Gun Factory at Woolwich Arsenal,
1918
oil on canvas
183 x 318 cms
The Imperial War Museum, London, UK
© Crown Copyright

Clausen at his best, as a great painter
of natural and artificial light, and of
human endeavour

192 ated and awarded infinite sub-texts, the best of which point to their original inade-
quate and inexact qualities as social commentaries, something that was remarked
upon even by contemporary critics.[138]

Similar lack of definition exists in other, labour-related images of the later nine-
teenth century. Attempts were made by Sir Hubert Herkomer to confront British
audiences with working-class issues, such as strikes, or the indignities and uncer-
tainties of casual labour. No workplace was depicted; all was left to the imagination,
and everything was about as far away from the Victorian concept of 'Heaven on
Earth' as it could have been, and it is never entirely clear from Herkomer's images
whether industry or society are expected to recognise responsibility for the lot of the
unemployed road mender. Elsewhere, in Ireland and Wales especially, into the early
1920s, or on the beaches of Britain, images of local 'characters' abound, but aimless-
ly. What were the fisher-folk of Newlyn, of a myriad Irish beaches or anywhere else
for that matter, supposed to be demonstrating to a visually informed audience? The
nobility of labour? I don't think so.

Perhaps the most interesting and provocative British attempts to respond aestheti-
cally to a machine society took place during the twentieth century, when, in every
era, aggressively determined modernist artists approached the subject as energeti-
cally as their own experience of it. It is worth emphasising the use that British
artists began to make of printed texts to draw attention to themselves and their
individual or group aims and ideas, often in semi-industrial formats.

When in July 1914, at the front end of the epoch, Percy Wyndham-Lewis
(1882–1957) announced 'Vorticism' [see Chapter 11], his chief allies were the self-
styled English Futurist CRW (Richard) Nevinson, the trained engineer and Slade
draughtsman Edward Wadsworth, and, at a slight distance, David Bomberg, who
had a love – hate relationship with Lewis. In their separate ways, all believed in the
transformative possibilities of art within a society dominated by machine technolo-
gy, in which attempts to visually represent simultaneous events were – for some –
something of a priority. Bomberg and Wadsworth, especially, produced consistent,
conspicuous and committed work that delivered this ideal before the advent of
Vorticism, during its limited lifespan, and in the period of the First World War that

138. See Holt, Ysanne (2003), *British
Artists and the Modernist Landscape*,
Ashgate Books.

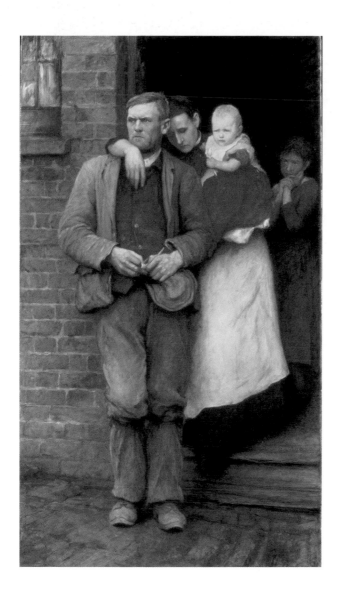

Sir Hubert von Herkomer, RA

On Strike, 1918
oil on canvas
228 x 126 cms
© Royal Academy of Arts, London

followed. People, places, machinery became hard-edged and radically simplified, often through kinetic visions which ranged considerably in size from mere water-colour drawings, such as Lewis's *Red Duet*, to large and imposing canvases, such as Bomberg's *In the Hold* and *The Mud Bath*. Wadsworth's technical skills allowed him to create arresting wood-engravings of townscapes and wartime images of ships bearing 'dazzle' camouflage.

Move on 40 years to compare this with the 1950s' activities of Bomberg's pupil, Frank Auerbach, and we find, at least initially, a similarly investigative process at work, begun at the feet of the master. Auerbach's images in paint or charcoal of post-war building in Oxford Street, London, are intense studies that presage much to come: their tensile qualities show the scene progressively laid bare. The glutinous London clay, and then, as the theme takes on new possibilities, the derricks, drills and the excavations themselves take on a religious sensibility.

In between these two fall the equally remarkable activities of a number of artists among those who were commissioned by various government departments during the First (1914–18) and Second (1939–45) World Wars. It was inevitable that images of industry were sought for the purposes of propaganda, to promote the strength of national identity and effort on the Home Front, but that the outcomes should be so interesting and varied is important. Factories of every kind were por-trayed during the First World War, and some of the most unusual artists were employed to portray them, in all media. Sir John Lavery (oil paintings of tanks and machine shops), CRW Nevinson (lithographs of aircraft manufacture), Charles Ginner and Anna Airey (munitions factories). But while the Royal Navy secured Muirhead Bone to draw shipbuilding work, Charles Pears to paint dockyard work at Rosyth and JD Fergusson to observe similar scenes at Portsmouth, the man with the oiliest hands was Francis Dodd, who drew engine room interiors aboard Coastal Motor Boats and in HM submarines. Altogether, the graphic work was of a very high order indeed: it stretched its practitioners, who all wanted to give as good an account of themselves as they might, in the service of their country. They didn't do it for the money: there wasn't much of that about.

A similar situation existed during the Second World War, but here, planning had

been in place longer, and there were more subjects. Graham Sutherland was commissioned to paint tin mines, William Roberts painted a munitions factory, amongst other subjects, and Raymond McGrath's views of production lines and hangars suggest industrial precision. This war was something else: so different that sometimes the very plethora of objects seems to need recognition as the outcome of vast manufacturing processes.

Of all the officially produced art of 1939–45, industry can claim at least three major, popular successes, all of them based squarely within the realms of figuration and impossible to undertake without a first-rate ability to draw. The first was Laura Knight's *Ruby Loftus Screwing a Breech Ring* (1941), a female figure who was very much the stimulus for an American counterpart called Rosie the Riveter, and who appeared on film. These were indeed iconic women, bending their bodies to the task: literally forging victory.

At an early stage, Stanley Spencer asked for work in the Clydeside shipyards. The results were a series of mural panels entirely devoted to the business of building ships, and the lives (and often the characteristic quirks) of those who built them. Every trade was described lovingly, indeed, religiously, to the extent that Spencer left the final panel unfinished until nearly the end of the war: surely a deliberate nod to Michelangelo, whose *Last Judgement* for the Sistine Chapel, whilst not explicitly a part of the famous ceiling cycle of images, quite literally finished matters once and for all. Spencer's work was all the more astonishing because of its unfettered use of exaggeration in foreshortening and in the seemingly careless, yet studied depiction of smaller details, such as screws, coils of rope, or the raw colour of pounded metal. It is studiously naive, apparently decorative, when in fact it seriously depends on a perfect understanding of the spirit of several early Renaissance painters, and of Cézanne also. Because of their deliberately limited height,[139] and because they often depict activity in the cramped or confined spaces of the emergent ships, human proportions are apt to be distorted, and this is also the case in Henry Moore's drawings of miners working underground.

Moore's figures of miners (1942) are less famous than those in his 'Shelter Drawings' (1940), but it has been argued that they are more real; that they convey

139. See Darracott, Joseph intro. *Spencer in the Shipyard: Paintings and Drawings by Stanley Spencer and Photographs by Cecil Beaton from the Imperial War Museum Archive*, exh. cat., 1981. Arts Council of Great Britain, and many other publications on this part of Spencer's output. The average depth of Spencer's murals was some 50 cms / 20 ins, rising where a central motif became necessary – in the case of Plumbers, Riggers and Burners.

human qualities of endurance, together with Moore's own empathic feelings: he came from a mining family. The fact that the two series have endured, and that the miners are borne on the myth of the Blitz, is perhaps not a bad thing: it enables a sensitive comparison to be made between images in which Moore found qualities of abstract beauty, and which he could develop, and images whose direct connection was with his own past, which perhaps forced him to probe his own subject, and perhaps himself, rather in the way that those 1980s' artists working in industrial placements were forced to. More was required in an unknown, industrial situation than mere technical ability, and he found it.

It had to end somewhere. The 1956 Clean Air Act was a sensible response to the last, truly fatal London smog (1952), and its introduction of smokeless zones meant that smokeless fuels had to be burnt. A further Act of 1968 required taller chimneys for coal-burning industries, so that sulphur dioxide could be more easily dispersed, and a cleaner, healthier Britain would result. Every urban sprawl in Britain was affected. What was that about 'Greenhouse Gases'? In art, these reforms curtailed the social realist patinas of grime that found their way into Eardley's representations of late 1940s' urban Scotland, into Edward Middleditch's paintings of North Britain in the 50s, and that even created a tide-mark in John Bratby's 'kitchen sink' interiors. What did we get instead? Hockney's *Mr & Mrs Clark and Percy* (1970). It makes you think. About the *good* old days, I mean.

Sir Stanley Spencer, RA
Shipbuilding on the Clyde: The Furnaces,
1946
oil on canvas
156 x 114 cms
The Imperial War Museum, London, UK
© Crown Copyright

Spencer specifically requested his
Clydeside war art commission, and
executed a remarkable mural scheme,
in which industry and community part-
ner one another

10

Can You Say that Backwards?

Printmaking

Can You Say that Backwards?

Printmaking

Was the phrase 'Come upstairs and see my etchings' ever seriously used by anyone, outside a stand-up comedy routine, to entice a love-struck female into a moment of sinful passion? If so, good luck to whoever uttered it, but as one of the most ridiculous chat-up lines ever used (usually by Man) it has much to do with the would-be seducer's social status. His evil intentions aside, this blackguard is in fact a stereotype of some long-standing, who considers his aesthetic connoisseurship to be of some substance. As a collector of fine prints, he is far more than a dedicated follower of fashion,[140] and when he mentions his chest size he is probably referring to the container in which he keeps his etchings. In such matters, my dear, art transcends the desires of the flesh, and it would have to: the invitation to visit the inner sanctum dated from the 1920s, but the serious market for fine prints and engravings has been in existence in Britain for much longer.

If proof were ever needed that the prevailing cultures of the mid-to-late twentieth and early twenty-first centuries were predominantly visual, one of the strongest sources of evidence would be the welter of visual reproduction, most recently created in the wake of the huge boom in visual animation that began in the 1990s. Creative imagery has burgeoned, big-time, since the increased availability and consumption of popular computer technology but, in one important respect, little has changed over three centuries: despite the wealth of visual material now available to every kind of consumer for decorative purposes, that process of consumption is effectively little different to what it was in 1700, or earlier. Now, as then, people want images to decorate their homes. In 1700, painting was the highest form of mimetic art, and too expensive to be available at the lower end of the social pecking order. Enter The Print.

Nowadays, technique, subject matter and purchasing power, not to mention the fickleness of taste, have ensured that what the nineteenth and twentieth centuries called 'the popular print' is not what it was. Then, it usually meant a real artwork, or something approaching it, produced in multiples or editions perhaps, but certainly touched by a human hand in the process of creation. Now, the outlets for reproductions (because this is what they are) range from high street shops to the Internet, but this is merely the extension of the marketplace.[141] When William Hogarth decided to embark on a career as a printmaker, parallel to his (then) rather

140. I apologise unreservedly to Ray Davies for misusing his lyric so prodigally.

141. Pockets of bad taste will always exist, despite themselves: it's simply impossible to explain the appeal of the famous *Green Lady*, beloved by hundreds of purchasers in the 1950s and '60s, and the new millennium has echoed to the sound of dropping jaws as reproductions of Jack Vettriano's meaningless paintings have set the tills ringing.

uncertain career as a painter,[142] and extra to his activities as a 'hack' illustrator, he knew what he wanted to do with his etchings and woodcuts, but he needed a game plan, a SWOT analysis to establish where and how big his audience was, who they were, and the depth of their pockets.[143] He was one of several in the same boat, but the results of his market research were remarkably exact, not least because he set something of a precedent, pitching for business by inviting a target audience to subscribe to his print series, thereby avoiding major financial loss through speculation. It is tempting to propose that the rest is history, and, as a not-so-primitive marketing strategy aimed at intelligent and cultivated people, it was, because others followed his lead. Yet the etchings of Hogarth's 'Modern Moral Subjects', such as *The Harlot's Progress* (1732), *The Rake's Progress* (1735), and his several satires on Society, such as *Marriage à la Mode* (1745), *The Four Stages of Cruelty* (1751), with much else, were merely the beginnings of the true history of printmaking in Britain.

In today's terms, Hogarth's vanity, his ambition, and an ambiguous stance as a moral-satirical documenter-cum-vulgariser, make for a fairly repellent combination of characteristics, but they made him into a major social commentator of his time, and his strident self-publicity assured his status as one of the founders of an 'English School'. Nevertheless, it is arguable that Hogarth's real importance was much more far-reaching than this, and neither did it lie in his technical proficiency, nor the barbed humour of his subjects. In the long term, his materialistic preoccupations caused new and different forms of mimetic art to be available for British public consumption, in turn creating an increasingly discriminating public, who began to want to own the stuff.[144]

The point is simple. People like to decorate their surroundings, and, in the absence of flights of china ducks, they usually do this by placing available two-dimensional images on their walls. Recognise yourself? This social phenomenon at least suggests the existence of individual levels of discrimination, active or passive, caused at root by conditioning, or by education, or both, and resulting in choice. The certainty of that well-worn phrase 'I know what I like' has a long and reasonable pedigree. Simply examine contemporary painted or engraved depictions of eighteenth- and nineteenth-century domestic interiors and note the frequent presence of 2D imagery on walls, no matter how poor the dwelling. You'll probably find a print there, pinned (but not wriggling), nailed or framed.

142. Hogarth's origins were lower class, and he was very much a self-made man, however he chose to present himself as his fortunes improved.

143. See, for this and very much else, Bindman, David, *Hogarth and his Times*, British Museum Press, 1997, and Bindman, David, *Hogarth*, Thames &

Hudson World of Art series, 1981.

144. In purely Hogarthian terms, this led to a massive demand for his work, and for that licensed to copyists before and after his death: in his lifetime a healthy market existed for 'bootlegged' material, and Hogarth was forced to act to prevent this. He was by no means alone: the great

French landscape painter Claude Gelée, aka Claude Lorrain, had earlier been forced to act to prevent imitators from forging his works.

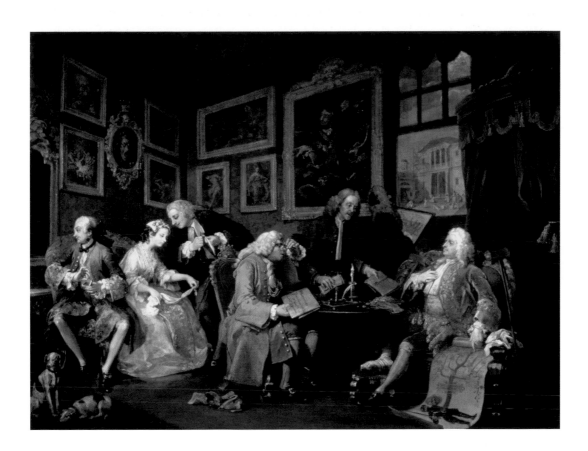

William Hogarth
*Marriage à la Mode: 1 – The Marriage
Contract*, (before 1743)
oil on canvas
70 x 91 cms
National Gallery, London, UK
The Bridgeman Art Library

Before Hogarth, and at the bottom end of the market, woodcut images were often used to illustrate cheap books and 'broadside' pamphlets, or to advertise public events, and performances of every kind, including public executions.[145] Broadsides were so named because their texts (and images if they existed) were printed only on one side: illustrated copy might therefore also serve as decoration. The format continued for centuries[146] and, for us, it suggests a level of visual appreciation that Hogarth was keen to exploit, possibly improve, and did, by reducing his prices. Nonetheless, it is important to emphasise that Hogarth thought of his *oeuvre*, whatever its mediums, singly or in series, as direct artistic expressions, and certainly intended his prints to appeal to the developed visual intelligence and appreciation of educated men. He opened the way for more of the same, and great social satirical prints appeared, after his death, most famously from the hands of Thomas Rowlandson and his contemporary James Gillray...[147] which was as far as they went (and they went some distance), and where British printmaking effectively stagnated for the better part of 40 years: 'stagnated' rather than 'died', because work of great quality was executed in the same period, especially in the medium of wood engraving, by masters such as Thomas Bewick and, later, William Harvey. Their freelance imitators and followers ranged across the continent of Europe, passing on the best attributes of British fine art engraving to others, to the point at which – almost inevitably – it found its own way home, at the hands of the French artist and engraver Gustave Doré.

OK: there's one in every crowd, and in this case William Blake was the exception to the rule. Eight stops short of Upminster or not,[148] Blake was undoubtedly one of the greatest and most unusual artists of his era, and as technically accomplished an engraver as any of his contemporaries. His undoubtedly peculiar lifestyle is a matter of record, however, and this has played havoc with his posthumous reputation. Today's audience see him either as a fascinating nutcase in his own right, a thinker, writer and printmaker, author of a staggering, sometimes bamboozling body of work; or as the oddball author whose visual output and ideas proved so attractive and influential to the younger John Linnell, and to the equally youthful Samuel Palmer, working and living at Shoreham, Kent from 1826–35. But that is to digress. Aged 14, Blake was apprenticed to Basire, the engraver to the Society of Antiquaries, where he was surrounded by classical imagery. Here he probably

145. The 'broadside' was a source of information and popular song/verse rolled into one, and available from sources that ranged from street hawkers to booksellers. The earliest British broadsides date back to the early sixteenth century. Internet sources are extensive: www.nls.org.uk/broadsides and bodley.ox.ac.uk are only two of many useful sites.

146. Remember this the next time you see the famous declaration 'Bill Stickers Will Be Prosecuted'.

147. Of the two, Gillray is more usually compared to Hogarth: his social satires were more pugnacious.

148. If you don't understand, a map of the London Underground's District Line will be useful.

William Hogarth
Gin Lane, 1751
engraving
36 x 34 cms
Bibliotheque Nationale, Paris, France,
The Bridgeman Art Library

began to put flesh on visual and conceptual ideas and conjectures that ranged from the colossal to the universal, and in which he was the sole believer. Evolving his own spiritual lifestyle, Blake unhesitatingly went on to live out this self-determined, gospel-based 'system'. His apprenticeship over, and already a superlative draughtsman, he rejected an education at the Royal Academy in favour of his own interests, which had less to do with the classical styles of the High Renaissance and more to do with a determined streak of what we might call intuitive mediaevalism, strongly laced with pure Catholicism.[149] More than merely a maverick, he became an outspoken critic of authority and of convention, and for a time was a voluble supporter of revolution and republicanism, when such behaviour was unacceptable,[150] and it is instructive to compare his work as a fully-formed artist with that of some of his peers, including Fuseli, James Barry and Turner.

As an innovative printmaker Blake was outstanding, not just for his extraordinary subject matter, but for his versatility, particularly in 'reversed image printing', a laborious technique involving paste or glue and considerable energy spent hand-colouring the images in watercolour. To anyone working today, this is a positively mediaeval process, but its results were extraordinarily rich: see them throughout his *Songs of Innocence* (1789).[151] *Illustrations of the Book of Job* (1825) was almost certainly Blake's most completely successful engraved work, but he is probably better-known for his self-penned and engraved *Jerusalem: The Emanation of the Giant Albion* (1804), to which he added repeatedly, parts of whose symbolic text remain paradoxically obscure and yet as outstanding as the artist himself.[152]

See Blake as you wish: with hindsight, he can appear a front-runner for every kind of reactionary. In this respect his brief association with Samuel Palmer was immensely important, not so much for any visual baton-passing, but much more for the considerable impact upon Palmer of Blake's ideas about life, the universe and everything. Conversely, the visual impact of Palmer's output, in all media, on future generations of British printmakers was pretty much full-on. Graham Sutherland, Paul Nash, FL Griggs, Paul Drury, John Piper, Robin Tanner and many others drew deeply on Palmer's work and thinking, but note: even as printmakers, they responded as strongly to his watercolour drawings as to his etchings, and

149. Like his contemporaries, Blake's understanding of religion was better than his appreciation of art historical chronology, but there were at least artefacts for him to study, and he was no fool.

150. Remember what the French had achieved just over the water?

151. Fascination with the technique brought together the great Spanish artist Joan Miro, and the now-almost-forgotten author Ruthven Todd, to attempt an understanding of the process.

152. See any number of authors on Blake.

William Hogarth
Beer Street, 1751
engraving
38 x 32 cms
Guildhall Library, City of London
© The Bridgeman Art Library

it shows.[153] Even Palmer's activities, distanced from the rest of the world, were to be echoed by some of those later followers, at various times.

By 1850 Blake had been dead for a quarter century, and British printmaking was a rudderless hulk. Younger artists of promise were still working as hack illustrators, but they were at least reaching an increasing audience: their work was often to be found between the covers of books, or of lesser works sold by instalments, and in the growing number of illustrated or periodical magazines, especially those under the direction of the Dalziel family.[154] Future Pre-Raphaelites and their contemporaries had excellent drawings transformed in this way: these later luminaries included Frederic Lord Leighton, John Tenniel, Edward Burne-Jones, Simeon Solomon and Edward Poynter, who all had to make ends meet somehow. The general growth of literacy in Britain (the Dalziels became pre-eminent for some time as distributors of 'comics' or 'penny-dreadfuls'[155]) was matched by an increasing market for illustrated hard-backed books, ranging from the popular imagery of the Beggarstaff Brothers (William Nicholson and James Pryde) to top-end luxury items, published by the Kelmscott Press (established in 1889 by William Morris), or the Golden Cockerell Press, where, before 1900, buyers might find Burne-Jones, the Charleses, Ricketts, Shannon and Gere, and Arts & Crafts tendencies… with Aubrey Beardsley not far behind. The possibilities of wood engraving in Europe were transformed by the 'arrival' of the influence of Paul Gauguin, and were cemented in Britain by Roger Fry and Post-Impressionism. The medium remained exacting but gained enormously in expressive potential, moving in very different directions during and after the First World War through the work of Paul Nash, Edward Wadsworth, Horace Brodzky, Leon Underwood, Gertrude Hermes, and John Buckland Wright, each possessing a different claim to fame within this particular pantheon.

Good news for lumberjacks then, but not for copper-beaters. Despite the energetic activities of Turner, Blake and others, the establishment view of etching remained myopic, and the medium remained confined to second-class status. Small wonder that by the later 1850s British etching badly needed a makeover. It got one, big-time, thanks to the determination of Sir Francis Seymour Haden and his younger brother-in-law James Abbott McNeill Whistler, together with Palmer, and slightly younger supporters. In their different ways, they began to treat etching as a

153. Palmer didn't start to etch until 1850, which, as simple arithmetic will prove, suggests that his later admirers had at least 25 years of work in other media to draw upon.

154. See Houfe, Simon, intro., *The Dalziel Family, Engravers and Illustrators,*

Sotheby's Belgravia, 1978.

155. To a large extent the Dalziels were responsible for the birth of the comic book in its original format, with a cast of characters that lived ridiculously long lives, including – eventually – the Fattest of Fat Boys, Billy Bunter.

John Piper
Brighton from the Station Yard (coloured
by John Betjeman) 1939
aquatint
21 x 28 cms
Private Collection
The Bridgeman Art Library

James McBey
Strange Signals, The Long Patrol, 1918–19
etching
25 x 20 cm
© Aberdeen Art Gallery / Reproduced by kind permission of the family of James & Marguerite McBey

McBey painted *The Long Patrol* as a series of watercolours recording the Australian Camel Corps in the Sinai desert during 1917. *Strange Signals* was eventually etched, and surprised everyone by becoming the most expensive print by a living artist during the 'Etching Boom' of the 1920s

medium worthy of much more than relegation to the realms of illustration. From 1857 Haden and Whistler moved into top gear with superbly executed images of the Thames; Whistler was the better technician of the two: they fell out in 1865.[156] Haden went on to found the Society of Painter-Etchers in 1880, but Whistler would not join: his etched series of Venetian scenes (1879–80) was editioned and sold at The Fine Art Society, to invited subscribers, as Hogarth's work had been, 150 years before. Discerning clients reacted quickly. As a relatively recent convert to etching, Palmer himself responded positively to the revival, and other topographical scenes were executed by great hands, or those lesser-known but equally adept. Just as interesting was a European-realist influence, led by Alphonse Legros (soon to be Slade Professor in London), and including the French ex-pats James Tissot and another late starter and Whistler imitator, Theodore Roussel. The momentum was considerable, and a true revival of interest in etching was created and sustained. Whistler's status as an etcher grew to a point at which it justifiably equalled his reputation (or notoriety) as a painter, but some might say that the best was still to come, in the enormous variety of etched imagery executed during the first 20 years of the twentieth century: almost too much to consider coherently.

The English artist usually credited with securing the link between Whistler and a younger generation was Frank Short, author of many atmospheric, flat coastal horizons, and of informal realist vignettes, but there were young giants in the wings, and several were Scottish. The respective talents of DY Cameron, Muirhead Bone and James McBey were recognised at the time, and swept much before them: taken together as printmakers their works reflect so much of the very best of British representational etching at the time, but even their most powerful (and expensive) work only accounted for a fraction of this vast market. The backwash of hard-edge abstraction might be found after 1918 in many different places, including advertising posters, or at the Royal College of Art, which was where Paul Nash became so influential for a later generation: those not of the quality, such as Wadsworth and Underwood, did their own thing, and passed on ideas to others. Young Moore and Hepworth were both taught briefly by Underwood, then firmly under the influence of Meso-American imagery: don't think that it didn't rub off, whatever they didn't say. Underwood's impact, and that of his interests on other pupils, including the quietly explosive Gertrude Hermes, speaks volumes, but one should also not forget the

156. The art history of the later nineteenth century is littered with the fragments of Whistler's sundered personal and professional relationships.

mercurial alchemy of Stanley William Hayter, at Atelier 17, in Paris, where his experimental printmaking was as important for the European avant-garde (including Picasso and the Surrealists) as for the many other individuals he mentored.

Underwood was merely one magnet for younger artists whose rejection of convention led them to steer courses away from Paris, and where he advocated the Americas as sources of meaningful aesthetic expression;[157] there were others of the same period who looked to their own backyard. Among these was Graham Sutherland, one-time trainee railway engineer, whose etchings in the manner of Samuel Palmer combine intensity and nostalgia and tug at the one-plain-two-pearl heartstrings of a Britain removed from itself. Compare Sutherland's early prints with the expressive, sub-futuristic lino-cuts of Claude Flight and his Grosvenor School groovers, and you see before you not only the breadth of printmaking potential available to artists of that era, but the consummate brilliance of a generation of young artists for whom painting could never entirely be the embodiment of mass appeal. In Cyril Power especially, connoisseurs discovered a lino-printmaker whose skills easily communicate the steely-distant echoes of the London Underground, the chill of the towpath, or the sharp inhalations of the sports stadium.

Printmaking in the 1920s and '30s received a boost from its reinvention as advertising, principally in the form of lithographic prints for Shell fuels, then intent on driving Britons off their settees and onto the roads, as fervent discoverers of their own past. Shell's was an interesting posture, partly because of the history of the engraving as an antiquarian artefact, descriptor of the present situation of an imagined past: many of the established artists working for Shell in the '30s chose to depict antiquarian sites, but just as many were younger individuals whose work for Shell comprised commercial renditions of their own concerns. The superb and highly influential American E McKnight Kauffer was among the former, with an image of Stonehenge as memorable as that by Constable; among the latter were British artists such as Paul Nash, Sutherland, or the Johns Piper and Tunnard, or relative newcomers, glad to be in Britain, like Hans Feibusch and Peter Strausfeld.[158] The business of creating prints as advertising opened up new vistas of appreciation. The Second World War would deal kindly with the older Walter Spradbery, and the younger Abram Games and Frank Newbould, and there is surely no dispute that,

157. To the end of his life, Henry Moore never recorded his debt to Underwood, who showed him what Mexico and South America might offer anyone alive to the power of that continent's diverse visual languages.

158. Peter Strausfeld's combination of woodcut and wood-lettering designs for posters for London's Academy Cinema were a familiar sight for years on the London Underground from the 1950s until his death in 1980: as corporate advertising they were arguably better and more attractive than that produced by many of the larger conglomerates in this time.

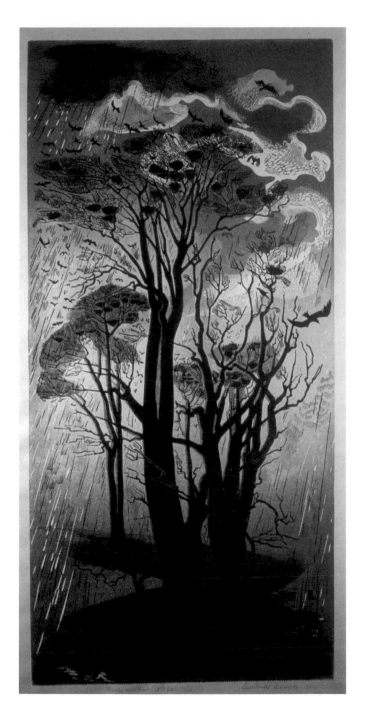

Gertrude Hermes
Rooks & Rain, 1950
linocut
76 x 36 cms
© By kind permission of Judith. H Russell

Hermes was one of the greatest of British twentieth-century wood-engravers: a stylist, and a profound interpreter of the natural world

214

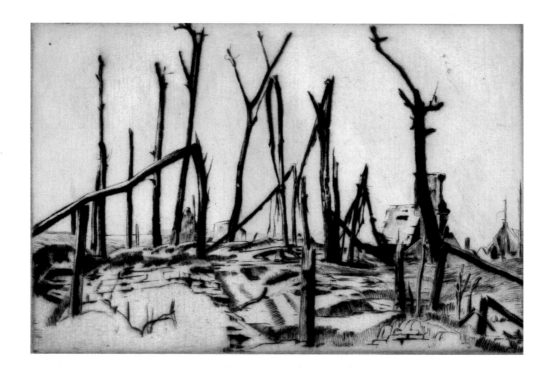

Sir William Rothenstein
Untitled; The Western Front c1917–18
etching
15 x 22 cms
Private collection

A strong image in an unfamiliar medi-
um for this establishment figure-
turned-war-artist

from 1939, the general public quickly became more visually and critically aware than ever before. Monotypes and lithographs were pressed into government service at every level: an extension of this process resulted in Brenda Rawnsley's idea to create the famous series of 'School Prints' (1947) to enhance the visual horizons of school children.[159] From one viewpoint, the results were excellent; from another, such mass-production once again weakened the status of fine art etchings until the 1960s, with only a few major figures keeping the copper hot: the importance of Anthony Gross cannot be over-emphasised in this respect. Then, when artists such as Hockney, Michael Rothenstein, Elizabeth Frink, Paula Rego, Norman Ackroyd, Patrick Procktor and Valerie Thornton dragged the medium, with all its fascinating permutations, back into focus, the status quo was again restored.

Of all recent developments in art, Pop has had the greatest impact on British print-making, not least because of the ubiquity of multiples by the tiresome St Andrew of Warhola, which have somehow come to comprise the carrot with which so many students are nowadays enticed to the gates of Art.[160] Oh dear. And OK. But if that *was* the case, what were the results for British Pop? Its combination of gaudiness with ephemeral or trashy imagery is arguably less important than it may seem. Although some of Richard Hamilton's own suggestions for the definition of a new 'Pop' art (1957) do appear appropriate to printmaking, especially '...popular (designed for a mass audience)... Low cost, Mass produced, Young (aimed at youth), Witty, Sexy, Gimmicky, Glamorous, Big Business',[161] suggesting a visual equivalent of fast (even junk) food, embodied in particular in screen-printing and lithography, the truth is rather different. Yes, screen printing is here to stay: myriad practitioners throughout Britain can attest to the fact, inspired by the likes of Peter Blake, Allen Jones, Howard Hodgkin and tens of others. But other media are just as important, and their use dates from the same period. Any exhibition of contemporary prints will confirm that anything continues to go in printmaking, where contemporary artists, alive and dead, old or young, execute work using everything from fine etching and every other engraving technique, through lithography and monotype to photocopying. The outcomes can be in single sheets or in multiples, editioned or in veritable books. Lisa Milroy, Chris Ofili, Gillian Ayres, Ian McKeever, Ana Maria Pacheco, Julian Opie, Helen Chadwick, Ken Campbell... with hundreds of others, make multiples that, by reaching more than one person, make a difference to the visual

159. See Rawnsley, Brenda, with Elyan, David, *The Story of School Prints*, edition of 150, Aldine Press, Malvern, Worcs, 1990. School Prints are still available on the open market.

160. I can prove this. These days it's Warhol: it used to be Dali. What next? The mind recoils.

161. In this instance quoted from Spalding, Frances, *British Art Since 1900*, Thames & Hudson, London, 1986.

216

1.

2.

Ken Campbell
1. & 2. Double page spreads from
Firedogs, 1991
inks on paper
38 x 25 cms

3. & 4. Double page spreads from *The
Word Returned*, 1996
inks on paper
48 x 34 cms

3.

4.

From 1975 until 2000, Ken Campbell wrote and illustrated 20 books, extended poems, hand-printed and published in limited editions, set against, and increasingly within, his own images, all suffused with wordplay and meaning. The different titles transform subject-matter from myth, history, reality and allegory into sensory, spiritual, sometimes knuckle-hard text. Campbell is one of the most important, uncompromising and self-critical talents within this medium in British art today. With *A Knife Romance*, Campbell's work began to integrate word and image more fully, to surprise and enhance the reading and viewing process. Divorced from their parent books, the beauty of Campbell's individual printed pages renders them compelling, enigmatic artworks: their visual differences, evident in their individual, cannibalised base-boards, begin to do the rest, often using computer technology in their evolution with found artefacts of all kinds

experience of Great Britain. That similar experiences can be encountered everywhere else in Europe makes the business of printmaking no less a national phenomenon in the UK, no less capable of accounting for much that we would take for granted within the continuously changing and multi-layered sub-culture of our odd little islands... and no less capable of providing that connoisseurship that cannot be confined to the plan-chest or the bedroom.

Claude Flight
Winter, 1926
linocut, from 5 blocks on oriental laid
paper from the series 'The Four Seasons'
26 x 31 cms
Courtesy of Osborne Samuel, London

Flight was a confirmed modernist at
heart, and his teaching at the
Grosvenor School of Art during the
1920s embodied and combined the
best of the robust and attractive ele-
ments in the visual languages of
cubism and futurism

Victor Pasmore
Points of Contact – Linear Developments (7), 1970
screenprint; proof aside the edition of 60
47 x 47 cms
Courtesy of Osborne Samuel, London

Pasmore cut his abstract teeth at the 1951 Festival of Britain; by 1970 his continuing journey through abstract painting had also resulted in several series of highly refined prints

11 Clubbing:

You Need Friends

In 1880s' Britain, the Royal Academy was a force to be reckoned with. Founded by Sir Joshua Reynolds and others in 1768 as the centre of taste in British art, it had begun as a teaching and exhibiting institution, and had grown into a club, a very big one, whose membership enjoyed a large public following, as several Academicians went on to record.[162] The Academy's popularity, with that of the National Gallery, was then based on its narrative painting, enjoyed in increasing numbers by the British middle classes, and caused, at least partly, by official encouragement, disseminated through magazines and newspapers, in a drive for more widespread intellectual and visual awareness. As a result, the RA was steadily transformed into a comfortable, populist hub of British art, and thus, eventually, into a target of contempt for every artist who believed that art should be restless and questing. It was a reasonable view. Leaving aside the great and the real departed (Constable died in 1837, Chantrey in 1841, Turner in 1851), posterity has been fickle, endorsing the importance of some higher Victorians, and leaving others shipwrecked on the atoll of indifference. Lord Leighton's range of ability as a polymath ensured his reputation, Sir Edward Burne-Jones achieved fame as a Pre-Raphaelite Brother, yet his equally important brother-in-law Sir Edward Poynter is barely remembered;[163] indeed, many of the narrative painters who commanded such audiences are beginning to be overlooked. GF Watts, Landseer, Frith, Etty, Eastlake, Millais, Fildes and many others were very much a pre-Hollywood elite, with their houses in London's Holland Park creating as much popular interest as anything in Beverley Hills in the 1930s, sometimes with lifestyles to match.

It hadn't always been this way

In art, as anywhere on the greasy pole, it's lonely at the top,[164] and art needs communicating practitioners to sustain the potency of visual activity. Britain's geographical position makes it a homeland, a way-station, and a constantly swinging pair of doors to anywhere else, so the changing nature of the art that happens there has been, and remains, one of its more three-dimensional cultural phenomena. At one extreme of British art history, many artists have exchanged fashionable disrepute for (at least) discreet acknowledgement, and there has been a resulting need for clubs and art societies to support or endorse their changing professional practice at different times. These clubs often resembled, or contributed to, small artistic uni-

162. For example, GD Leslie RA (1914), *The Inner Life of the Royal Academy*, John Murray, London.

163. Sir Edward Poynter is a fine example of an eminent Victorian who has – for most – been consigned to oblivion, for no really good reason. The first Slade Professor at University College, London, Poynter was also the Director of National Art Schools (known as 'the South Kensington System'). Director of the National Gallery, and President of the Royal Academy. Good list, but the later 1890s saw a decline in his painterly qualities, which is probably why he's not up there in the top ten now.

164. Just ask Randy Newman.

William Hogarth
Portrait of Captain Coram (c1668–1751),
1740
oil on canvas
239 x 148 cms
Coram Family in the care of the Foundling
Museum, London
© The Bridgeman Art Library

verses whose planets move at different speeds. Until 1945 they tended historically to comprise those who were white, male and literate, and who represented what in different eras has passed for sweet reason, such as the members of the Royal Academy; or those who have pursued technical or aesthetic interests, such as print-making or watercolour. But clubs also represent artists who will be bound by no one. In 1886 the Royal Academy faced true secession from within its ranks, by artists drawn to continental developments that the RA was not over-keen to endorse: the backwash of Impressionism had created a situation in which visual–ideological and technical differences caused some younger artists to lose sympathy with the RA's established stance. The result was the New English Art Club, and following this, more determinedly independent societies or clubs grew shoots: some, such as the London Group (1913), still stand for independence, and continue to survive, support-ing ever-changing interests, with members who join or leave (sometimes for the Academy) at will, or as circumstances alter.[165] The key to much secessionist or inde-pendent activity up to 1940 lay in a condition that ranged from inclination to deter-mination, among individuals and groups, to imitate developments in France or, to a lesser extent, Europe, and to free themselves from the jurisdiction of hanging com-mittees, juries and other semi-official coteries, who even then represented what some today call 'state-approved art'.

Into this solar system have come other exotic planets, with satellites, that, since the 1890s, have turned the immigrant experience in Britain into a forcing ground for social and cultural integration: Jewish, Chinese, Asian and Afro-Caribbean immi-grants, and, following hard on their heels after 1960, others whose art is distinctly political or gender-based. Others still, whose need, or bloody-minded determination, to push out the envelope, puts them at odds with 'the establishment', wax and wane regularly. But to rebel at all there has to be a reason and, in every decade since 1840, the prevailing status quo has unfailingly provided at least one: education.

By the 1830s, art and design education in Britain was begging serious philosophical questions, many of them related to Britain's position as a waning industrial power. (Yes, already) Art and Design were unquestionably discrete but, whilst bureaucra-cy thought it knew what Design was for, that still left Art. What was its purpose in society? How did the artist 'fit in'? How would art remain meaningful in the Britain

165. See Wilcox, DJ, *The London Group, 1913–1939: The Artists and Their Works*, Scolar Press, 1995 and Humphrey, Jane, (ed.), *The London Group: Visual Arts from 1913*; The London Group, London, 2003.

of the future? Enlightenment logic called for rational thinking, for definition, for rules, and rules need boundaries. There was only one RA, and to go forward, to make sense of art in Britain, more teaching institutions were desirable. A series of well-intentioned but deeply flawed attempts by central government followed (with 'expert' advice, naturally), to formulate a *raison d'être* for art and design education and practice,[166] but all ran aground, and a comprehensive series of changes to art and design teaching were progressively introduced in the years after 1845.[167] They included structured art-teacher training, a centralised examination system, and, most importantly, a national system of art and design education, which by the end of the century inclined strongly towards Fine Art. Only with the publication of the Coldstream Report in 1960[168] were any truly fundamental alterations made to those arrangements. Imagine. A fully functioning (if slightly archaic) system left virtually untouched by bureaucracy for over a century. Astonishing. However, *that* was the National System. And the Academy was... well, The Academy.

Artists *aren't* conformist by nature. In general they *are* curious, often highly literate, sometimes scientifically orientated, broadly educated, and restive. It wasn't so surprising, then, that even with a reasonably workmanlike system of national art education in place, as French Realism began to percolate across the English Channel during the 1860s and '70s, many British artists began to seek new visual (and less often, philosophical) stimuli, inside and outside the UK. These artists were of both sexes, usually under 40 years old, and from every part of the island. Their most frequent complaint seems to have related to dull (the word most often found in histories is 'outmoded') art teaching methods, especially at the RA Schools. What did they want? Life drawing. Less formality. Co-ed classes. French art. Getting it real. When did they want it? Now. It sounds horribly familiar, but it wasn't change for its own sake.

Bobbing across the backwash of such discord, across the decades that followed, were many technically orientated clubs, among them the Royal Watercolour Society (RWS; 1804), The Old Etching Club (1838–85) and the Junior Etching Club (1857–64). All faced similar tribulations. Their survival, in various forms, is little short of miraculous: white-knuckle rides on the rapids of penury, internecine backbiting and good old-fashioned public indifference, despite lists of past and august

166. You did know, didn't you, that it was to enrich you, to make your life better. You didn't? Hard luck.

167. The whole sorry saga, with all its peaks and troughs, is admirably described in Macdonald, Stuart, *The History and Philosophy of Art Education*, London University Press, 1970 repr. 2004 by Lutterworth Press, Cambridge.

168. More formally known as the Report of the National Advisory Council on Art Education, Coldstream's key recommendations involved the imposition of contextual/art historical studies into art teaching, so that students might better understand the sources from which their studio practice was drawn.

members, such as Haydon and Whistler. The impact of watercolour on all areas of British nineteenth- and twentieth-century art has been critical to the survival of painting as a medium, as high art and as a television spectator sport; as for print-making, its elevation to the Fine Art peerage occurred in most British art schools after the Second World War. Its ability to reinvent itself, conventionally, via the Royal Society of Painter-Printmakers[169] (1989), or by pushing the boundaries of reproduction by using new tools, including inkjet printers or the photocopy, has merely extended its range.

For those iconoclasts for whom the unorthodox is a prerequisite in art, that prefix 'Royal' represents safety and sameness: all cutting edges are the same as a carton of razor blades, and even these go blunt eventually. To understand the iconoclasts, one has only to turn to conventional Art History to re-examine an essential 'truth': that every noteworthy anti-establishment 'ism' owns a determined core membership and a willing supporters' club, responsive to a fundamental belief. 'Back in the day',[170] to use a colloquial phrase, when literacy was more widespread, art was dug over on entire pages of broadsheet newspapers, and debate spread from conversation to prepared, printed manifestos, or formed as a result of magazine articles, cheap pamphlets or – later – paperback books.[171] This kind of interaction, where sides were taken, lines were drawn, and where posturing or bullshitting was common practice, has been inextricably linked with, yet eternally opposed to, aesthetic pedagogy for centuries. It is a natural condition of Art.

Until the 1930s, British art coteries outside the RA tended to flex muscles, but were otherwise not especially proactive. Some, like the Friday Club (1905–20s), The Camden Town Group (1911–13), the London Group (1913 onwards) and The Euston Road School (1937–39), had strong associations with The Slade; there was much transmanche fertilisation, and continental tendencies were constantly absorbed and amended. The optimism of new visual, technical and philosophical concepts was, however, too often peppered with bickering, jealousy and confusion. For Britain, twentieth-century modernism was a series of provocative affairs. All the early and mid-century European movements – Fauvism, Cubism, Futurism, Constructivism, Surrealism – provoked varying levels of creative urgency that often meant that the making of Art was two-ended (and a double-edged sword); that, sometimes, the cart

169. See www.banksidegallery.com for information on both the RWS and the RSPP.

170. That's the 'day' where the sun rises in 1850 and sets around 1920.

171. Head for any bound periodicals library and examine examples of newspapers and illustrated magazines to see the extraordinary lengths to which columnists went to report and comment upon art.

Ford Madox Brown
The Last of England, 1852–55
oil on panel
82 x 75 cms
The Bridgeman Art Library
© Birmingham Museums and Art Gallery

An important Pre-Raphaelite painting,
showing the sculptor Thomas Woolner,
en route for Australia; he came back

was put before the horse in order to try to make sense of events as they happened, and so in this respect true independence was at a premium: one could not afford to operate totally alone. Friends, groups, clubs were vital. Germans received Expressionism, in all its jagged glory; Italy, the swish-swoosh of Futurismo. In Britain, Camden Town, Bloomsbury and Vorticism took art at a gallop from realism to abstraction in less than the 60 months constituting the period 1910–15.[172] And additionally, and increasingly, *words* became important in artists' efforts to shock, to explain, to position evolving groupings. At any time from 1910 until 1960, a text, a *manifesto*, might, sometimes did, cement shaky artistic alliances in the eyes of artists and public, or it might not, but a major result of such activity was the politicisation of Art, in the period before and immediately following the Second World War. Non-representational art, like music, had become 'difficult', and required textual explanation… and sometimes it had just disappeared up its own backside and needed a good kicking. In today's Britain, both avenues continue to attract adherents, worse luck. There's some safety in small coteries, but start to propagate and the problems will follow.

On the whole, British groups have tended to follow certain patterns. Once again, geography has proved to be important, and London, though a magnet and a major exhibiting centre, has not always been pre-eminent as a forge for new ideas. British art at both ends of the nineteenth century experienced strong pulses from different locations. The Norwich School was exactly what it said it was, but perhaps the first *art colony* worthy of the name was led by Samuel Palmer, during his 1826–35 stay in the Shoreham Valley, Kent – *the Valley of Vision* – which commanded the temporary attention of artists and connoisseurs alike. By 1885, painters in Newlyn, Cornwall, had gained a platform at the RA, following their respective adaptations of French realism, as introduced by Jules Bastien-Lepage. The fishing village of St Ives began to assume similar importance shortly afterwards, finally overtaking Newlyn to become a centre of the modern movement in Britain by 1940.[173] For many artists cutting their teeth c1890–1910, it could be vital to work in a colony. Laura Knight famously wrote of her time with others at Staithes, on the North Yorkshire coast, that '… it was there that I found myself and what I might do',[174] and Kenneth McConkey[175] notes the equal gravitational pull of Cockburnspath, Helensburgh and Moniave for Glasgow-based painters; of Staithes itself, of Cullercoats, on the North-

172. And don't believe that every 'signatory' to every manifesto you ever read actually signed: often as not, they didn't. To name but three, the shades of William Roberts, David Bomberg and Jacob Epstein will come back to haunt you if you take their names in vain in relation to Vorticism.

173. See McConkey, Kenneth (1995), *Impressionism in Britain,* exh. cat. Yale University Press in association with Barbican Art Gallery, London; also Fox, Caroline and Greenacre, Francis, 1979 *Artists of the Newlyn School 1880–1900,* Newlyn Orion Galleries.

174. Knight, Laura, *Oil Paint, Grease Paint,* Nicholson & Watson, London repr. in Haworth, Peter 1936, *Paintings by Members of the Staithes Group,* privately published 2002, p. 8.

175. McConkey, K, *op. cit,* p. 27.

Jules Bastien-Lepage
Pauvre Fauvette, 1881
oil on canvas
163 x 126 cms
© Art Gallery and Museum, Kelvingrove,
Glasgow, Scotland

In the French corner: Bastien-Lepage is
widely credited with the introduction
to England of diluted French realist
influence…

Stanhope Alexander Forbes
The Health of the Bride, 1889
oil on canvas
152 x 200 cms
Tate, London 2006
© Estate of the Artist

...In the English corner: Forbes was a
key member of the Newlyn Group, and
images such as this show the extent to
which some artists quickly took French
realist influence to heart

west coast of England; and of Walberswick, Suffolk. Artists made meaningful discoveries against the turn of the tide, in those places and in others inland, and, so, consequently, did some of their audiences.

But Britain was never a cuddly island. By 1900 most major British cities and towns had artists' associations, but some, such as Liverpool's Sandon Studios Society (1905),[176] were more proactive than others in their pursuit of the up-to-date. Scotland and Ireland had developed their own Royal Academies (the Royal Scottish Academy and the Royal Hibernian Academy), and in both regions, and in Scotland especially, independents flourished by the end of the nineteenth century: the 'Glasgow Boys' are merely one important example. Elsewhere, as the century unfolded, new groups formed and dissolved like the titles to *Doctor Who*. By 1919 London's avant-garde had lost Vorticism and gained the 7 & 5 Society (up to 1935, with a regularly changing membership),[177] which included some of those who would eventually gravitate to Paul Nash's short-lived Unit One (1933). Surrealism arrived in 1936, to squeeze a cheek onto the same bench. Nevertheless, the 1930s' groups could not keep their self-avowed doctrines on any kind of straight-and-narrow (the variable socialism of the Artists' International Association from 1933–53 was an important example[178]), and it was inevitable that several artists rose from within group memberships to achieve fame or notoriety above the rest. The Second World War aided this process: the better, older artists, among them Moore, Nash, Nicholson, Piper and Sutherland, moved into the limelight for reasons that owed as much to their recognition of the value of British subject matter as from any earlier espousal of European influence. After the war, that momentum continued.

It's a long, long road. In the years since 1945, British art has changed almost beyond recognition. In the twenty-first century there's little need to club at national level: aggressive-defensive groupings aren't necessary when so many artefacts possess or convey so little meaning, because spin-doctor-dealers do the selling. Decadence is a condition that nowadays represents a reckless willingness to make meaningless objects, and is an increasingly used term, despite its *fin de siècle* undertones.

And now? Aside from groups that have survived the decades since 1880, and those formed to exhibit specific subject matter – portraits, marine painting and so on – few

176. Augustus John was Professor of Painting at Liverpool University from 1901–4, and his light shone all around: the Sandon Studios Society was founded as a reaction against establishment interests.

177. The 7 & 5 originally represented seven painters and five sculptors; members included Henry Moore, David Jones (1895–1974), Christopher Wood (1901–1930), Ivon Hitchens (1893–1979) and Jessica Dismorr (1885–1939) amongst others.

178. Morris, L and Radford R, *AIA: The Story of the Artists' International Association, 1933–1953*, exh. cat., Museum of Modern Art, Oxford, 1983.

artists form groups any longer: art spivs do that, through 'spin' and 'hype', and the gullible crane their necks to see better. The Young British Artists of the 1990s found their public in this way, as did many lesser 1970s and '80s Conceptualists before them. Their major achievement was to deny the British public the right to codify the art made within the shores of the UK. No more neat categories and finite boundaries – that's rather unfair, but you take the point.

After 1945, groupings, clubs and individuals continued to reflect Britain's stumbling progress towards modernism, despite the attentions of the President of the Royal Academy, Sir Alfred Munnings, who weighed in viciously against it. By the early 1950s the search for meaningful British art was being fought with increasing bitterness. The era was not so much a melting pot but a bedlam. Posterity will have the variable figuration of 'The Kitchen Sink School' (Bratby, Smith, Middleditch and others) vying with David Bomberg's Borough Group (Bomberg, with Auerbach, Freud, Kossoff, Creffield, Richmond and others), the legacy of Neo-Romanticism, in the work of Clough, Sutherland, Minton, and, in the mid-1950s, the increasing inroads being made by the Independent Group, where Hamilton, Paolozzi, with colleagues who were architects and designers, were gaining an audience. As Pop went the weasel in the later 1950s, and with the arrival in the early '60s of 'New Generation Sculpture', led by Antony Caro, the importance of art clubbing was just about done. Artistic groupings were important, but, just like Hollywood, a star system was beginning to evolve. Bacon, Freud, Auerbach and Kossoff were major independent artists. Behind them followed Hockney, Kitaj and several others. With their peers, they were among the last major British independents of any value. Yes, that's what I said. Others have dusted off the term 'decadence' to describe the superficiality of artefacts made in Britain during the 1980s, '90s and since, and there is good cause to set that idea in stone.

With what stands for art in Britain so wide open to interpretation, and so much of it already down the drain, it's hard to see how groups could function efficiently or effectively today. This isn't to bemoan their disappearance, but to note their achievements, many of which are as solid as the Rock of Gibraltar. Clubbing is best in situations where groups pit themselves against accepted 'norms': they'll never change the world, and even John Lennon recognised that. But healthy secession is fruitful; and anyone with a nose for trouble will understand how productive clubbing for

William Holman Hunt
Our English Coasts, 1852 ('Strayed
Sheep')
oil on canvas
43 x 58 cms
© Tate, London 2006

We're poor little lambs who have lost
our way…

234 artists can be. But remember: artists are only human, just like the rest of us, and –
to mix metaphors – the Emperor's new clothes need to stay in the wardrobe. I'm
talking about a sense of perspective... remember? That old Renaissance idea...?

Eduardo Paolozzi
Will the future ruler of the Earth come forward from the Ranks of the Insects, 1970 screenprint with offset lithography on laminated astrolux paper from an edition of 100 entitled *Zero Energy Experimental Pile* 84 x 58 cms
Courtesy of Osborne Samuel, London

Better-known for his (later) sculpture, Paolozzi was a printmaker and collagist all his life. In 1956 he took part in the Independent Group exhibition *This is Tomorrow*, which gained a public for what became British Pop art. Then, like Richard Hamilton, Paolozzi used comic books and advertisements to create

witty collages, and these continued to appear regularly throughout his career.

Your Ugly Mug

12

Your Ugly Mug

Helen Chadwick
Vanity, 1986
cibachrome photograph
11 x 8 cms
Birmingham Museums and Art Gallery, UK
© The Helen Chadwick Estate

Beauty's only skin deep, and Chadwick
used a highly developed awareness of
the fact to point to our more grotesque
features

Just what is it that makes other peoples' faces so attractive, especially when there's always the chance that their owners can be so miserable or repellent in life? As an art form, Portraiture is a fascinating and tangled web. *Mimesis* is at its core: at its most serious, this is the business of creating an accurate representation of someone else's appearance. Remember, however, that the words *mime* and *mimic* come from the same root, and no art is entirely without wit: conceit, flattery, satire and caricature all feature in the way individuals are made to appear, in media that include every kind of art, from the highest heights of painting and sculpture through the cowpats of schoolyard graffiti; from the carelessly caressed profiles on coinage, to the self-adhesive postage stamp. Somehow, our largest protuberances seem to make it into every visual extreme.

It's an arresting thought that, of all the available subjects in the visual arts, the human head features most regularly, in all its glory, youthful or aged, hairy or bald, pale, spotty or rubicund, grim or grinning, full-frontal, in profile, slightly turned, raised… or what you will, and always attached to bits of body that range from the merest hint of a shoulder to the full magnificence (and sometimes they are perhaps a little too full and magnificent) of the God-given human frame. Wow. Or not, as the case may be, because the so-called 'absentee-portrait', the representation of personal effects without the human presence, can be as affecting or engaging as any image of a humanoid, as Frances Hodgkins and William Nicholson have proved.

Going Back

It takes little effort to cast the mind back to one's earliest remembrances of portrait types, and it is surprising just how old and odd those examples can be. Many are antique: Egyptian sarcophagi and classical sculpture all play roles in such memories, and the idioms in which they were first executed have mostly continued through the ages, rolling steadily into contemporary usage. To be an identifiable figure present in any artist's world's eye view is enough to confer some status on an individual, but it helps if the work has quality. It doesn't really matter whether the artist was an anonymous Egyptian or a Roman medallist, the German master-painter Hans Holbein the Younger, Gwen John, Sir Gerald Kelly or Sam Taylor-Wood. Their works have all transcended time to become documentary records, spe-

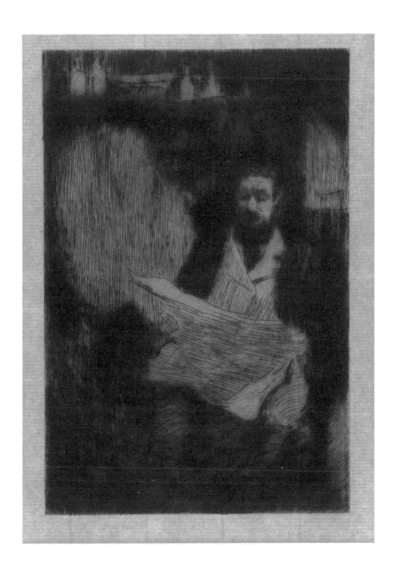

Horace Mann Livens

The Shopkeeper, undated
drypoint on Ingres paper
15 x 10 cms
Private collection

The economic line and tonal qualities of Livens' portrait engraving shows the simplicity of drawing that attracted van Gogh to his work: they were contemporaries at the Antwerp academy, and corresponded for some time – in English. Now condemned to obscurity, Livens was well-known and respected in his day, chiefly as a painter of fowl.

cific references for posterity, at many different levels, and with as many meanings. By the same token, and as the same clock ticks, portraits are just as capable of existing as informal objects, simply because, in our own era, we have begun to look at them in different ways, from different viewpoints: the frame of reference has widened. Nowadays portraiture isn't confined to the entrance halls of large houses, to denote the status of the owner and the quality of the craftsmen on call. Today we can stroll, disinterested, through the halls of art galleries and museums, oblivious to the booming echoes of history. We might be detained by a portrait from any age for any one of many different reasons: medium, sex, race, colour, shape, costume, period – you name it – but it may just as easily be the result of gut feeling: that peculiar and compelling response to the delivery of an image that can't be ignored at any price. We might call that effect 'presence'.

With time also, portraiture has been made to admit technological advances made in photography and film. These have opened up new avenues of perception in ethnic and nationalistic terms, worldwide, and, also on a global scale, have caused conceptual developments in portraiture that were previously bound up only in high art: that 'absentee' portrait is merely one (excellent) example. Does all this fall within the experience of portraiture in Britain? Oh yes, and more. In recent years our understanding of each other in our odd little islands has had much to do with our closest encounters, person to person. Or not, as the case may be.

Of all the 'high arts', surely portraiture is the one in which the lines between private and public expression are the most finely drawn, and in England, those lines are always fascinating. British portraiture owes much to the arrival and staying power of major foreign talent, at almost regular intervals, such as Holbein, hired as a court painter by Henry VIII, and the Dutchmen Sir Peter Paul Rubens and Sir Anthony van Dyck,[179] who both worked for Charles I. The fact that all were proficient in other artistic formats is usually overshadowed, simply because some of the most famous representations of the great and the powerful of their eras came from their workshops; aside from written texts, their representations of the celebrities of their day are foremost amongst the few images with which we can colour our understanding of those times.

179. Both Rubens and van Dyck were knighted by King Charles I, and both are well worth intensive further study.

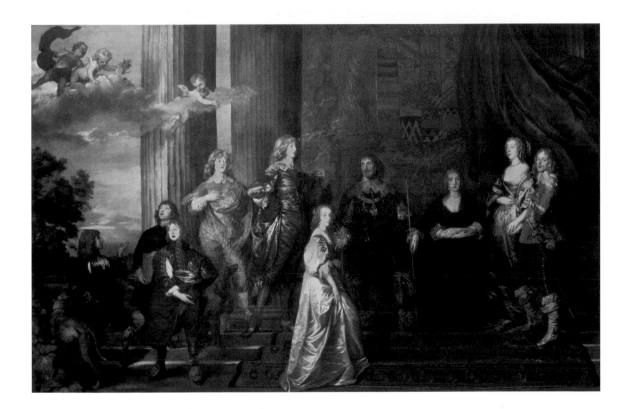

Sir Anthony van Dyck
Philip Herbert (1584–1650), 4th Earl of
Pembroke & his family, 1634
oil on canvas
279 x 432 cms
The Bridgeman Art Library
© Collection of the Earl of Pembroke,
Wilton House, Wilts

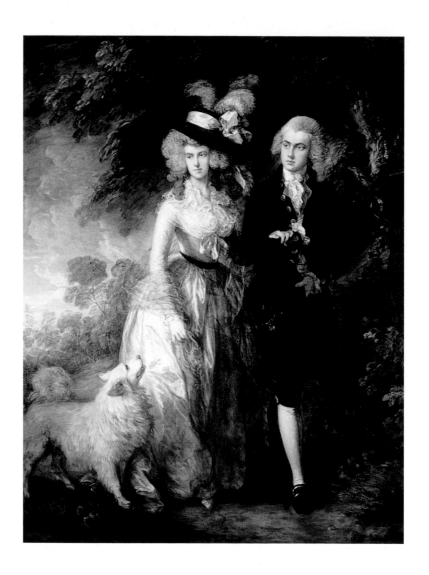

Thomas Gainsborough
Mr & Mrs William Hallett (The Morning Walk), c1785
oil on canvas
236 x 179 cms
The Bridgeman Art Library
National Gallery, London, UK

Portraiture is not only of fundamental importance as documentation within national histories of every kind (looks are everything when you're climbing the greasy pole) – but it has also been crucial to local technical and stylistic developments and traits. Whatever an artist's status, and whatever the relationship of portraiture to his or her output, the mere presence of the genre, and the status conferred on it, has stimulated debates in British art for generations. The existence and persistence of Sir Joshua Reynolds was not only critical to the inclusion of classical motifs in British portraiture, but also to the theory and practice of painting in this country, and to the establishment of the Royal (English) Academy of Art. Reynolds might not have achieved this had portraiture not been almost universally accepted as one of the highest of the visual arts, in the salons of Europe at least. The practice of Reynolds' great rival Thomas Gainsborough can be deployed in different ways: to illustrate a visual position in opposition to that of Reynolds; to offer contextual imagery in support of other artistic activities of the time, including 'The Bath Season', literature and music; and, through Gainsborough's earlier work, to convey the importance of topographical drawing to various British artists for whom portraiture ranked second as an art form.

If there's a social tradition connected with portraiture it is an association with what is known as 'Society', and sometimes the higher the society the better. During the eighteenth and early nineteenth centuries, London was a Wild West town for portraitists, where the new kid had almost to await the demise of the local gunslinger before moving in on their territory. And there was a pecking order. Thus, entrenched interests effectively deflected attempts by major out-of-towners such as Thomas Lawrence and Francis Hayman to gain patronage in London society. If George Frederic Watts, Sir Edwin Landseer and James Abbott McNeill Whistler represented the spread between later notions of 'established' and 'unconventional' Victorian and Edwardian portraiture, those in the 'establishment' frame needed to be very good indeed to gain and sustain reputations. By the end of the Victorian era, and if you could afford him, the American John Singer Sargent was the man to paint your family, closely followed by James Jebusa Shannon and Solomon J Solomon.[180] At their best, what critics called their 'slashing' styles remain attractive; their por-

180. Their initials were uncommonly similar: JSS, JJS, SJS; John Singer Sargent, James Jebusa Shannon, and Solomon J Solomon (not to be confused with any of the earlier Solomon family of painters, who are themselves well worth investigating for all manner of reasons).

traits command, often compel, and emphasise the business of painting, as much as the need for expression. It was a fact of life quickly absorbed by new talent following close behind.

Look at Me: I'm Wonderful

That's portraiture: so many winding roads for author and viewer to travel, each lined with laurels that might as easily be bestowed upon the artist as upon the subject; that might be a defining feature of a self-developed myth, or conferred on the basis of technical excellence, or because of personal elegance. Watts, arguably the most Victorian of Victorian painters,[181] had them all, in fair measure, but underestimated his own potential as a portraitist. Eventually known as *Il Signor* to his many female admirers, who fell at his feet for portraits that he preferred not to paint.[182] Watts stood at the core of High Victorian taste,[183] and we may reasonably view him as a rather unusual pop idol of his own era,[184] and mentor to intellectual equals: his list of confidantes would eventually include the pioneering portrait photographer Julia Margaret Cameron.

There have been other portraitists less moderate, and sometimes they offer unusual comparisons: for example, Watts's hard-won portrait of the irascible philosopher Thomas Carlyle (1795–1881) with that of the same sitter by the self-mythologising American ex-pat James Abbot McNeill Whistler. The differences between the pictures are wonderful to behold, and the techniques employed make all the difference. Watts nails his cantankerous subject as exactly as possible: his painting tries to peel off skin, whereas Whistler has painted an icon: his Carlyle is seated, leaning forward, uncomfortably statuesque in a grey, half-tonal no-man's land of the painter's own devising, a Wildean railway-waiting-room of a space. This Carlyle is important and impressive all right, but that's about the sum of it.

Something Old, Something New

How many portraits since that time have been conceived and executed against similarly divergent backgrounds? Don't bother to count, but we need to acknowledge the presence, at the back door of the nineteenth century, of Walter Richard Sickert

181. See Dakers, Caroline, *The Holland Park Circle: Artists and Victorian Society*, Yale, New Haven & London 1999.

182. Watts wasn't too keen on portraiture as a genre: he much preferred weightier subjects, but his contemporaries and posterity had other ideas.

183. In this, Watts had some very gifted friends, foremost among them Frederic, Lord Leighton, who was every inch a polymath.

184. The completely bonkers 1960s–'70s ukulele-wielding Tiny Tim comes to mind, though heaven knows why.

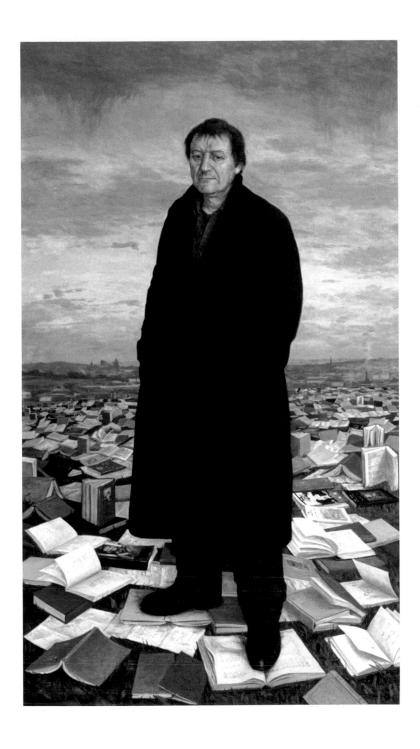

Cluis Stevens

Portrait of Tony Harrison, 1994

oil on canvas

210 x 120 cms

© Reproduced by kind permission of the Artist

Stevens' large portrait of the poet and playwright Tony Harrison (b 1937) confirms the sustained importance of portraiture in the twentieth century, in the hands of a new generation of artists

(1860–1942), young friend and imitator of Edgar Degas... and ex-studio assistant to JAM Whistler. Did Sickert herald a new dawn in portraiture? Yes,[185] and, as a by-product, a new approach to documentary painting also. See, for example, at the front end of his extraordinary, multi-faceted career, any of his justly famous music-hall paintings:[186] *Le Lion Comique* (1887, a diminutive Degas doppelganger if ever one existed), *Miss Minnie Cunningham* (1892), or *Little Dot Hetherington at the Bedford Music Hall* (1889–90), all of them drawn and re-drawn from successive visits to the Halls, and much nearer to Gainsborough than to Reynolds. Compare these with Sickert's later portraits, often taken from photographs, even sometimes including the agency name, for example, in at least two of the actress Gwen Ffrangçon-Davies.[187] In itself that wasn't new, but Sickert's intentions aren't entirely clear: his entire career lacks absolute transparency, but his distinctly sardonic views about representations of the human figure[188] surface regularly. And why not? Here was a man given to representations of himself in different guises, with or without facial hair, wearing odd clothes, in curious colours, every one of them a self-portrait, despite their oddness.

Deceptive Appearances

The business of dressing up or of depicting sitters whose dress offered other visual possibilities was nothing new either. In 1740, William Hogarth had painted *Captain Coram* (1740) in his bright red bridge coat, Gainsborough had dressed up a servant lad to become *The Blue Boy* (c1770), and soon afterwards the brilliant Scottish portraitist Henry Raeburn transformed the Scottish tartan from a revolutionary red-chequered rag into a tantalising pictorial motif, as *Niel Gow* (c1793) and *Colonel Alasdair McDonell of Glengarry* (1811) confirm. Others sometimes used everyday clothing to make social points: George Stubbs looked long and hard at the stablemen in *Hambletonian, Rubbing Down* (1806), Johann Zoffany's group portrait *The Tribuna of the Uffizi* became one of the most notorious examples of social climbing through portraiture ever, and the several portraits in Ford Madox Brown's remarkable *Work* (see also Chapter 9, Smut, Art & Industry) executed between 1852 and 1865, were dependent upon the mixture of dress:[189] the focus and complex imagery of this painting allow most useful comparisons with the socialist imagery in paintings of the same era by the Frenchman Gustave Courbet.

185. The author Patricia Cornwell thinks that Sickert was Jack the Ripper, and went to some lengths to prove it, including mutilating one of Sickert's greatest paintings. Poetic, eh? Not.

186. See Greutzner Robbins, Anna, 'Sickert: 'Painter-in-Ordinary' to the Music Hall' in Baron, Wendy & Shone, Richard, (eds), *Sickert*, exh. cat., Royal Academy of Arts, London, and Yale University Press, 1992, pp. 13–24.

187. For example, *Miss Gwen Ffrangçon-Davies as Isabella of France in Marlowe's Edward II: La Louve* (1932).

188. Readers should refer to Greutzner Robbins, A (ed.), *Walter Sickert: The Complete Writings on Art*, Oxford, 2002

189. *Work* has quite a history. Those intrigued will find an excellent intro. in Nochlin, Linda, ed., *Realism and Tradition in Art, 1848–1900*, Prentice Hall, 1966; by the same author, *Realism*, Penguin, 1990

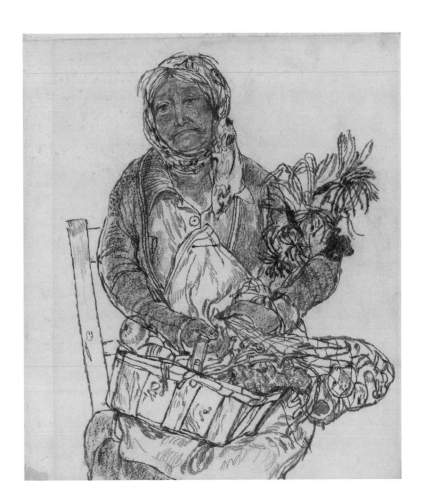

Muriel Pemberton
The Gypsy Model, c1970's
pencil and conté crayon on layout paper
50 x 40 cms
Private Collection

The human figure was fundamental for Pemberton, one of the most important players in post-war British fashion (she drew the Paris fashions for the *News Chronicle* amongst other papers) and art (she was the first Head of Fashion at the Royal College). This portrait was one of many executed whilst working in the studio with students.

By the 1880s, everyday/realist subjects in French painting became established sources for many British painters, and a few sculptors also: Jean François Millet and, especially, Jules Bastien-Lepage were important sources for British artists seeking realistic imagery. Among the earliest to move that way, George Clausen, Luke Fildes, Hubert Herkomer and Alexander Stanhope Forbes had started out as jobbing illustrators. Using portraits – well, what else is the deliberate portrayal of a specific figure? – they and others, in and outside London, began to make social points, set in an increasingly identifiable (and identified) range of backgrounds in British cities, streets, lanes, fields and on shorelines. Certainly their images were thematic: they wanted to make points, and the figures in their paintings were often those of studio models. Nevertheless, portraiture was here, perhaps one step removed from its usual function, but active nevertheless. Audiences were changing; their work might make a difference.

Tough at the Top

Among those artists whose stars went into swift ascent during the early twentieth century were Augustus John (brother of Gwen) and William Orpen. Both were Celts (John was Welsh, Orpen Irish), both were brilliant draughtsmen in youth, and their sometimes unconventional lifestyles made them as different as their respective approaches to painting. In later years, John's bucolic lifestyle hastened the waning of his abilities, but as a younger man he had quickly commanded a very widespread and favourable reputation, in Britain and in the USA. His ability to experiment (and especially to understand the impact of Cézanne) allowed him to range from what might be described as acceptably 'establishment-debonair' to 'expressive-impressionist'. John's portraits and group scenes of gypsies and farm folk were widely appreciated in Britain and the USA before 1914, but although he retained his reputation after 1918, the same could not be said of his overall *oeuvre*, which contained masterworks but was otherwise very variable. Orpen was John's *doppelganger* as a student, but the symmetry stopped there. An Anglo-Irishman with a fine sense of observation and a sharp, sometimes acerbic, sense of humour, Orpen inherited Sargent's mantle as 'the greatest' as the American's powers waned. He was next in line,[190] and he deserved it: as a portrait painter, of others and of himself, Orpen

190. See Arnold, Bruce, *Orpen: Mirror to an Age*, Jonathan Cape, London, 1981, p.106.

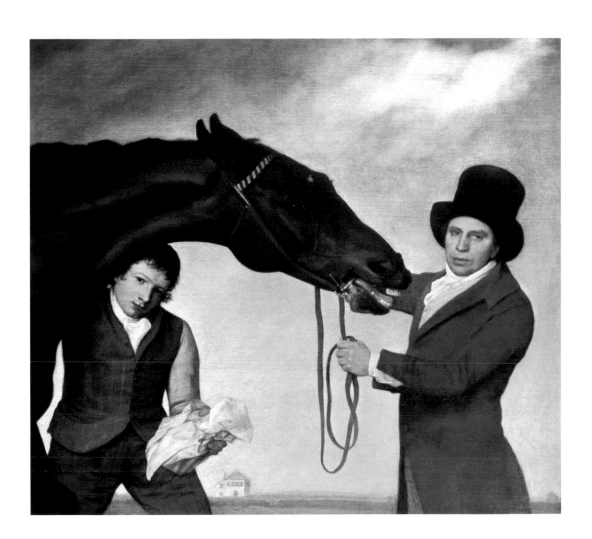

George Stubbs
Hambletonian, Rubbing Down, c1800
(detail),
oil on canvas
209 x 367 cms
Mount Stewart, County Down, National
Trust
The Bridgeman Art Library

Horse and stable staff are celebrated in
this image: the owner is nowhere to be
seen

combined an acute understanding of colour and form to create some of the finest images in British art of the early twentieth century, modernism notwithstanding. Unjustly neglected by posterity, his portraiture alone is worthy of remembrance for its beautifully understated humanity; elsewhere, his pointedly allegorical work, whether executed for private or public consumption, may have gone unappreciated, but it was of no lesser stature.[191]

You'd expect that the august representation of the great and the good in British portraiture would reflect one of the most entrenched social hierarchies in western Europe, but it hasn't been the case, especially in recent years. On the whole, British portraiture has kept pace with evolving ways of seeing, and especially with the business of self-expression. However much a portrait's 'psychological insight'[192] might be applauded, in conventional terms one may go only so far. This is perhaps one reason why so many artists have chosen to make their sitters less, rather than more, august in recent years. A glance at the walls of the modern collections of the National Portrait Gallery will quickly establish the images with staying power, and here it may fairly be said that smaller is arguably more beautiful. There are fewer soldiers on display these days, the Royal Family are well represented, and so-called 'household names' appear in paint and photographic format. Yet there's still a sensation that, whether the image is of Sir Bobby Charlton, PD James or the late Queen Mother, the artist is now at least on equal terms with the sitter: less the paid servant-cum-makeover artist, and very much more of a commentator. This is not especially new, even though it has become an expected feature of recent 'official' or 'celebratory' portraiture. The concept is excellently exemplified in the superb mid-century work of the Scot, James Cowie, and perhaps cemented earlier in England by Orpen, one of the least servile of British portraitists. Most recently, John Wonnacott and the younger, less reverent Stuart Pearson Wright have followed similar traits, most entertainingly.

Carving a Career

What sort of power can a portraitist exert over his or her sitter? We can gain some understanding if we consider the impact of portraiture in sculpture. The impact of foreign influence is as strong in this medium as in paint, visible in the realistic

191. See Upstone, Robert and others, *William Orpen: Politics, Sex and Death*, Tate Britain, Imperial War Museum and Philip Wilson, London 2005.

192. It is wise to remember that Freud and Kant made most impact after 1900.

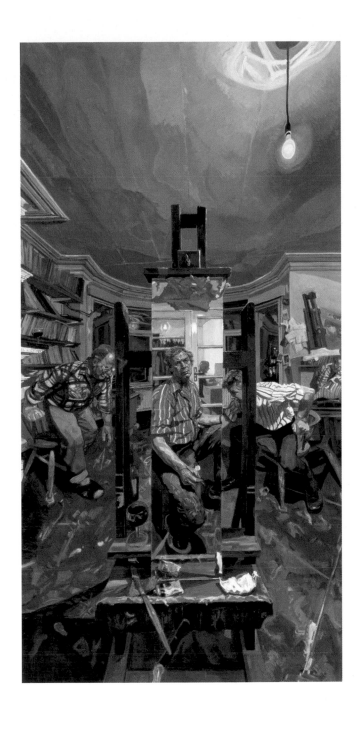

John Wonnacott
Studio Conversation I, 1993–4
oil on board
244 x 122 cms
Tate, London 2006
© Estate of the Artist

qualities brought to the British portrait bust in the 1730s by the Belgian John Rysbrack who, like so many foreign artists, set an early benchmark to which British practitioners might aspire. A generation later, Sir Francis Chantrey, a sculptor of great excellence, became the wealthiest artist of his age. His portraits ranged from the 100-foot high monolithic figure of the ('Black') Duke of Sutherland (1833–34)[193] to less prominent figures, with more distinctly carved features. Compare these with the hundreds of portraits of Queen Victoria carved for public consumption on the occasion of her Golden Jubilee in 1887,[194] and *those* with other public sculpture of the High Victorian era, and it soon becomes evident that in *that* society public sculpture could and did play a major role in at least one element of portrait activity. Nor has that process ended.[195] The arrival on the scene of Jacob Epstein in 1907,[196] and after him of Frank Dobson, presented two artists whose abilities encompassed expressive and sometimes clinical figuration, as well as abstraction, to great distinction. Few have risen to the challenge since, but in so-called 'New Media' we may, if we wish, accept the follies of Gilbert and George, and of other, site-specific installations within the realms of portraiture. Stand up Sam Taylor-Wood, and tell us how you would define your work. Intelligibly, please.

That the artist has emerged as hero in later-twentieth-century Britain is borne out by the increasing appearance of self-portraiture in the public domain. For centuries artists used this activity as a secure way to experiment privately with new techniques, and they still do, but in Northern Europe it has also served as a private, often self-serving process.[197] In time, many of these works have become public, and at their very best have enhanced both reputations and general understanding of artists' ideas and activities, as well as the conceit of their authors, and Britain has been no exception to this trend, from Hogarth to the present. Whatever the studiousness of the Victorians, great artists' self-portraits became much more commonplace from the early 1900s. After the Johns, Orpen and the Williams Nicholson and Rothenstein, work in painting and line by Mark Gertler, Stanley Spencer, Leon Underwood, Laura Knight and Eric Kennington is merely indicative of the range and vitality of such activity, and of the breadth they brought the genre by portraying others – and sometimes themselves.[198] The lineage has hardly weakened, and ideological standpoints have joined with visual ones to create some remarkable imagery. Since the 1940s, Leonora Carrington, Paula Rego, Pauline Boty, Alison

193. The Duke of Sutherland was not the most popular Anglo-Scot of his era. His monument is sited on the far North-East coast of Scotland, a local landmark for the towns of Brora and Golspie.

194. Those by Thomas Brock (1847–1922) and George Frampton (1860–1928) will serve as excellent examples.

195. See Read, Benedict, in Nairne, Sandy, and Serota, Nicholas, et al., (eds.) *British Sculpture in the Twentieth Century*, exh. cat. Whitechapel Art Gallery, London 1981 pp. 39–49.

196. Epstein, born New York, came to London in 1905 and was eventually naturalised.

197. Rembrandt is probably the best-known example, but the list becomes lengthier the nearer we find ourselves to the present.

198. Stanley Spencer was a famous example of such activity: his surviving work and the large literature on his life provide many examples of this trait.

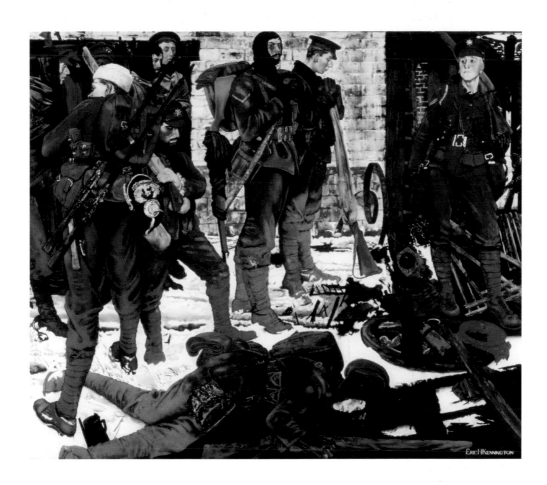

Eric Henri Kennington, RA
The Kensingtons at Laventie, 1914, 1915
oil on glass
140 x 152 cms
© The Imperial War Museum, London, UK

**The nameless heroes of the rank and file
receive their first outing in the hands of
one of their greatest supporters**

Paula Rego
The Artist in Her Studio, 1993
acrylic on canvas
275 x 180 cms
The Bridgeman Art Library
© By kind permission of the Artist &
Leeds Museums and Galleries (City Art
Gallery) UK

Watt, Jenny Saville and Helen Chadwick have all created determinedly self-specific imagery, as have male artists such as Lucian Freud, John Bratby, Peter Blake, John Bellany, Anthony Green, Adrian Wiszniewski, Richard Billingham or Stuart Pearson Wright...

... we might go on. As we probably shall, always keen to see what someone else has made of us, together or apart, and now, as technology moves ever onward, capable of reversing an artist's decision without having to consign that hated paintwork to the bonfire of history.[199]

199. Lady Clementine Churchill, wife of the famous Sir Winston, famously destroyed a portrait of the great man by Graham Sutherland; GS had, presumably, told nothing more than the visual truth.

13
Hashed, Bashed & Despatched:

Sculpture

Henry Spencer Moore
Sketches of a Reclining Nude, 1950s
Private Collection
© Gavin Graham Gallery, London, UK /
The Bridgeman Art Library

Anyone foolish enough to attempt a timeline of British sculpture is in for an experi-ence at once tantalising and frustrating. Although the pace of intelligible develop-ment has perhaps mercifully slowed, as an art form its tangled history flexes between glorious daylight and stygian gloom, and some of the actions of its partici-pants reflect that process also. These can range from what we would now describe as positions of remarkable transparency (forget Kinetics) to situations in which eth-ical behaviour has simply evaporated. British sculpture is just huge, and in the last century it was increasingly fuelled by ideological and intellectual debates of a breadth and an intensity that you won't hear anywhere near a supermarket check-out. Such unusual activity is the reason for the twentieth-century weighting of this essay.

Sculpture ought to be the most demanding art form in this sceptred isle, but because many people will be more familiar with art in two dimensions (pictures do suit most living environments more easily) it has tended to be sidelined, rather than integrat-ed within the scope of popular understanding of what art is, or can be. Result: the arrival of anything that appears to break the bounds of acceptable sculptural con-vention always faces the happy prospect of a good kicking, and in recent years, there's been a lot of worthy footwork going on. You thought I'd say something about Henry Moore? OK: like many others, our 'Enery isn't properly evaluated in the classroom. Too many art students hear about him only in the context of their study of 'Natural Forms'. They aren't told that some of his sketchbook ideas were so far out it was beautiful, or that, in their very size, Moore's work also played a major, early role in the protracted last phase of grotesque triumphalism in British sculp-tural history. The context is absent, and good Sculpture can't easily be understood properly without it.

The other side of this coin? Don't think of one coin, but a heap of them! Since the 1960s, rather too many artefacts unworthy of a public with reasonable visual liter-acy have found their way into central spaces in urban areas... and some have been placed in the strangest locations, from shopping malls to Brutalist piazzas, and traf-fic roundabouts. This stems directly from the nasty habits of Victorian Brits, who looked to the classical past – to Rome especially – for focal forms of visual inspira-tion (the idea of an object commanding a space is important) which are only so-so at

best in terms of mustard-cutting quality. Just think of all those statues of Victorian worthies, not to mention the monarch herself, that were merely a part of what became known as 'Statuemania' at the end of the nineteenth century.[200] As an early example, Nelson's Column is, well, a column with EH Bailey's sailor on top.[201] Great sculpture? No, but it's not seaside rock either. In purely chronological terms, it seems as remote as it could be from Gormley's 1998 *Angel of the North* – but is it really? One difficulty in any consideration of British sculpture is that, at its most potent, and no matter the author, it can be a match for anyone else's. On the other hand, Britain's worst sculptors are equal to the lousiest sculptors to be found elsewhere, and it's a measure of the fact that sculpture, more than painting, is an art of the possible; that some who would practise it dare to believe that the most misbegotten objects contain some intrinsic merit. Just look at some of the work in the Saatchi Collection. And, elsewhere in our heap of coins, and embracing all this, there are places from which British sculpture needs to be hauled, taken out of the bran-tub of art history, dusted down and re-assessed. Just how does British sculpture shape up alongside a long and important tradition of European work, much of which pre-dated it, from the Renaissance until the eighteenth century? How important was its progress during the time in between, until Sir Alfred Gilbert, the impact of Lanteri and then Cubism? And what happened to it after the flood tide of Moore, Hepworth, Eric Gill, John Skeaping and the rest? Did Reg Butler, Ken Armitage, Lyn Chadwick and co *really* hold off American influence during the 1950s? The answers to all these questions are variable, but on the whole, we did all right. A more recent and perhaps more urgent concern is whether or not British sculpture can be rescued from the delta of mediocrity that flows to and from the mythical land of 'art without boundaries': that triangle of nothingness where meaning often vanishes without explanation.

All change for a parochial angle, so check your dates. The Venus of Willendorf wasn't British. Sul Minerva was. John Michael Rysbrack wasn't British, but having made Britain his home from home, he made friends and influenced people. Louis François Roubiliac (neither a medical condition nor an exotic vegetable) settled in England but was originally French, but Joseph Nollekens and Joseph Wilton were British. Antonio Canova wasn't British, but John Flaxman was. And so were Sir Francis Chantrey, and Sir Alfred Stevens, whatever he did or didn't achieve.

200. See Curtis, Penelope, *Sculpture 1900–1945*, Oxford 1999 pp. 38–52.

201. '…in his habit, as he lived', to quote a contemporary account. EH Bailey RA (1788–1867) began his career carving ships' figureheads. Highly appropriate, eh? He soon moved on to higher things – Nelson's Column was completed in 1844. For contemporary details, see www.victorianlondon.org.uk

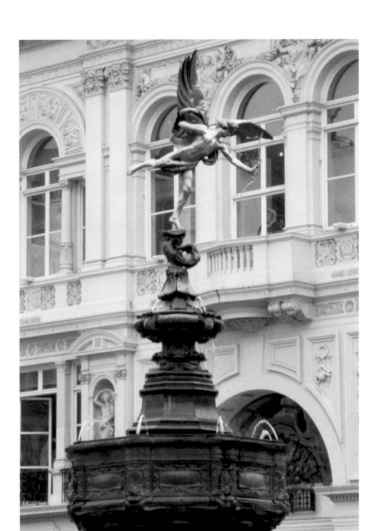

Sir Alfred Gilbert
Eros (The Angel of Christian Charity),
at Piccadilly Circus, London
1893
bronze
239 cms
The Bridgeman Art Library

Auguste Rodin wasn't British, but... well, anyway, Hamo Thorneycroft certainly was, and so was Charles Sargeant Jagger. And if Jacob Epstein (a class act whatever his nationality) wasn't exactly British until he became a naturalised Americano-Brit, Leon Underwood, Henry Moore and Barbara Hepworth were, although Constantin Brancusi wasn't. And Eric Gill, John Skeaping, Ayrton, Chadwick, Elizabeth Frink... oh, you name 'em. Victor Pasmore, and Robert Adams and Kenneth and Mary Martin, and Hubert Dalwood, Philip King and George Fullard (what a silly game this is), and so what if the antecedents of Antony Caro and Eduardo Paolozzi were a little... un-British: Michael Sandle, Bill Woodrow and David Nash are very different Britons. And (uh oh) so are Antony Gormley, Dame Rachel Whiteread and Richard Long and the accursed Damian, with Emin, Lucas and the unheavenly Chapmans. Whatever you may think, this irritating babble is intended to suggest something of the breadth of British sculpture; that, despite the sometimes regrettable tendency to relegate it, either to a secondary position against painting, or in relation to contemporaneous activities in Tate's Turbine Hall, it remains a seam of art containing more nuggets than a prospector might dare to hope for, and, whatever its state, entirely complementary with all other pursuits anywhere.

When CS Jagger[202] wrote *Modelling and Sculpture in the Making*[203] in 1933, his *Royal Artillery Memorial* at Hyde Park Corner, London (see Chapter 15, It's War) was nearly ten years old. Its unveiling in 1925 might have made the soundless cannonade of its stone howitzer the shot to start a sculptural revolution, but that didn't happen. The moment is important because of what did. The *Royal Artillery Memorial* was a work by a relatively young artist[204] and it perpetuated the classical tradition in British sculpture in a way acceptable to most Brits who cared to think of such things. For many of them, the event it recorded remained a recent and vivid nightmare. Its setting perpetuated the concept in which a sculpture is designed to occupy a place within a given location, in this case on London's busiest traffic island (and it always was). The RA memorial is huge; is both commanding and moving; and, yes, it is commemorative, and thus the terms of its execution were undoubtedly constraining... but even at this point Jagger's ideology and practice implicitly deny the existence of European developments in sculpture that were growing alongside his own creations, and of which he was well aware. By the time his book was published, this interesting man was entrenched in his views.

202. *Another* Yorkshireman! First Jagger, then Moore, Hepworth... whoever next? Jagger (1885–1934) was born in Kilnshurst, Sheffield. Was there some cabal?

203. Jagger, CS, *Modelling and Sculpture in the Making*, The Studio, London, 1933.

204. Jagger was in his fortieth year.

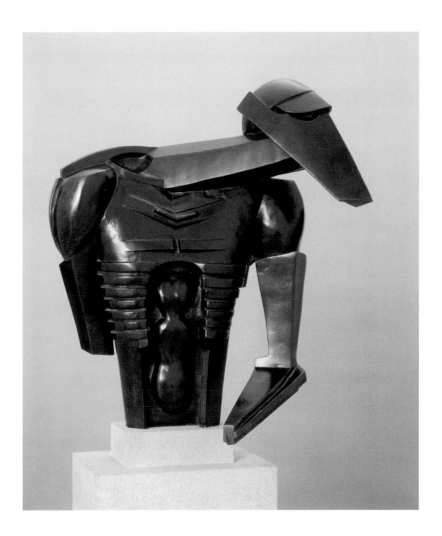

Sir Jacob Epstein
Torso in Metal from 'The Rock Drill',
1913–1914
bronze
70 x 58 x 44 cms
Tate, London 2006
© Estate of the Artist

Did Epstein really cut his driller figure
in half at the waist to show his disgust
at the mechanised horrors of the
Western front? If so, the dates given for
the sculpture are probably wrong

1.

2.

Charles Sargeant Jagger
1. *Royal Artillery Memorial*, Hyde Park
Corner, London, 1921–25
South face, with bronze figure of an
Artillery Captain

2. *Royal Artillery Memorial*, Hyde Park
Corner, London 1921–25
West face: bronze figure of a Royal
Artillery Driver

3 & 4. *Royal Artillery Memorial*, Hyde Park
Corner, London, 1921–25 and detail
West face: Portland stone relief of
Artillery activity during the Great War
Photographs by George Lewis

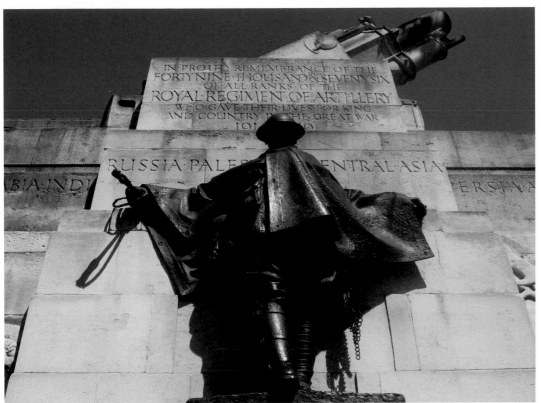

3.

4.

The positioning of the Royal Artillery Memorial caused arguments from the start. It finally came to rest in its present location so that it benefits from the lie of the ground at Hyde Park Corner: originally designed to face north, it now faces south, so that its footings maximise the way the ground rises towards it. However, an unascribed theory exists that the monument was originally designed to face east, but was bureaucratically rotated south so that the massive stone howitzer could not point towards the Palace of Westminster: the type of symbolism no-one could ignore

Jagger's career path wasn't unusual but it was longer than most of his peers, beginning with an apprenticeship as a steel engraver for Mappin & Webb in Sheffield, through Sheffield School of Art, and thence he entered the Royal College, under Lanteri – an important event. Jagger won the *Prix de Rome* in July 1914, just before the outbreak of war that August, enlisted, survived two serious wounds, and went on to make a post-war reputation with a series of major, commemorative projects,[205] monumental in every respect, of which the *Royal Artillery Memorial* was the apex. His book brought into print a lifetime's concern with technique, in which his activities as a figurative sculptor required him to combine style and content to form a coherent outcome. It all sounds so simple, but for Jagger, and for anyone with similar concerns, working like this was a battle in which experience and emotion were forced to compromise with public taste. He is a key example of a maker whose bread-and-butter practice led him to create a personal ideology that simply could not admit the fundamental importance of modern European sculpture for British art in the post-1919 era. Not while it was happening, nor after the event. No Lipchitz, then. No Zadkine, Modigliani, or Archipenko. Brancusi. Arp. Nothing.

By 1933 Rodin was a past master; Roger Fry died in 1934: the importance of both was perhaps greatest because of their different, and (r)evolutionary, approaches to Form. Long before writing *Modelling*, Jagger's evolving working practices suggest that he was 'thinking' (and re-thinking) Form, and that his creative responses were intuitive;[206] his text confirms that clay was a hugely tactile medium, made animate in his hands, and that boundaries and lines might be abstracted in the interests of expression:

'*...we are* [really] *making a piece of sculpture, and in doing so we are fully justified in taking reasonable liberties with the forms of nature according to the requirements of our subject. Exaggeration and modification of the forms of nature are the undisputed prerogative of the creative artist, and it is only the abuse of their legitimate licence which results in revolting deformity and malformation.*'[207]

Is that a marker? So far and no further, eh? We haven't quite finished.

205. The quality of his work enabled him to corner the market: see Compton, Ann (ed), *et al.*, *Charles Sargeant Jagger: War & Peace Sculpture*, exh. cat., Imperial War Museum London, 1985; also Freeman, Julian, 'No Easy Grace: The Great War Sculptures of Charles Sargeant Jagger',

Military Illustrated Magazine No.5, Feb/March 1987, pp. 15–21.

206. Jagger, CS, *op. cit.*, p. 16.

207. *Ibid.* p. 28.

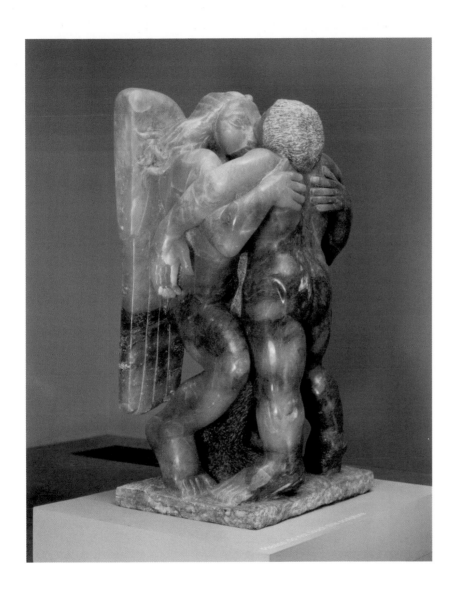

Sir Jacob Epstein
Jacob and the Angel, 1940–41
alabaster
214 x 110 x 92 cms
Tate, London
© Estate of the Artist

A superb offering, multi-layered in
meaning, and a renaissance for Epstein
after years in the wilderness

270

Jacob Epstein
The Tomb of Oscar Wilde (1854–1900),
1909–12
stone
The Bridgeman Art Library
Père Lachaise Cemetery, Paris, France

Père Lachaise cemetery, Paris, and
Oscar Wilde's last resting place. If a
kiss could bring him back to life, the
plinth of Epstein's first great master-
piece testifies to the enduring love of
every sort of admirer

'...in all sculpture of massive size, vigorous movement and actions should be avoided, excepting only in relief'.[208]

So Moore and Gormley got that part right then. But now Jagger shows his true colours, as he continues:

'it is my own conviction that a subject must always dictate its own treatment or method of expression. It is wrong to suppose that the same formula can always be applied. For instance, any emotional subject, teeming with drama and human tragedy, can only adequately be expressed by grim realism controlled and directed by the artist, whereas an abstract subject such as Day or Night can only be suitably expressed in abstract shapes or symbols, and in such an instance realism would be inappropriate.'[209]

Think about it: this is a man of (forgive the pun) stature, whispering softly between the lines of a 'how to do it' book for an interested, informed, but technically untutored 1930s' mainstream audience, whose influence, owing to his education and experience, would have ensured that 'Sculpture' – no matter the continental incursions of the previous fifteen years – should continue to be interpreted as Representation that at least erred on the side of the (Graeco-Roman) classical tradition. And Jagger's examples of 'Night' and 'Day' as 'problem' subjects weren't plucked from the ether either. He's almost certainly referring to the two large works of the same names (both 1928–29) by Jacob Epstein, one of the most brilliant, avant-garde and reviled British sculptors of the earlier twentieth century. Officially commissioned by the architect Charles Holden for the new London Transport headquarters building,[210] Epstein's two works were swamped by an ebb tide of critical effluvium following their unveiling. The word 'hammered' takes on an utterly different meaning in this context, and Epstein's reputation suffered an enormous setback.[211] Five years after the uproar, along comes Jagger, to slide yet another stiletto into Epstein's wounded figure, and, in passing, declare his own, anti-abstract, interest. Voltaire would have laughed: Epstein's fate should surely have warned others with similar aesthetic inclinations to think twice before risking a critical mauling,[212] but by 1933 Moore and Hepworth were exercising their own 'undisputed [abstraction-related] prerogative[s]', to enable their subjects to dictate their own methods of

208. *Ibid.* p. 51.

209. *Ibid.* p. 70.

210. At 55 Broadway, near St James's Park: it's still there, and so are the sculptures by Epstein, and by everyone else (including Gill and Moore) who was commissioned.

211. See Cork, Richard, *Jacob Epstein*, Tate Gallery Publishing, London, 1999. The BMA sculptures were serially defaced by order of the Rhodesian Government during the 1930s, on spurious grounds. Their sorry remains are on plain view above the Strand in London to this day.

212. See Voltaire (1759), *Candide*, in the course of which the French commentator offers a barbed account of the execution by firing squad of the British Admiral Byng, who failed to hold Minorca against the French in 1757, and so was executed for cowardice 'to encourage others'... in other words, as a warning.

expression. They achieved this because they were still relatively unknown, and because, unlike Jagger, but together with several of their contemporaries, they had been looking hard at European sculptural activity since the 1920s. The impact of what is called 'international' influence would not have been possible without the existence of Cubism, and they knew it. It's just that most people took much longer to understand.

Importantly, everyone kept the faith with cornerstone practices of research. In Britain, interest in direct carving grew stronger during the 1930s,[213] and, regardless of ideological shimmying and shaking, the would-be carvers and the modeller-casters returned to the museums for their ideas. With 'Truth to Material' so fundamental to the language of much northern sculpture, even Jagger found that the departments of Western and oriental antiquities at the British Museum were indispensable for sculptural research and development. It was a bridge in a continuum, without which Epstein would have had a tough time dealing with the Wilde Tomb in Père Lachaise (1909–12, with or without fig-leaf), Leon Underwood's undoubted (if brief) 1920s' influence on Moore and Hepworth would have been acutely diminished, and a host of other important connections between British and European artists would have been lost, unplugged or unresolved.

And the real impact of Europe and America at this time? As mainstream northern sculptural activity art-deco-ed itself towards 1939, the influx and impact of abstract ideas, the heave-ho of 'Carving versus Casting', and of 'Truth to Material' became undeniable: forces to be reckoned with.[214] Among the players were Henry Moore, Frank Dobson, John Skeaping, Ben Nicholson and Barbara Hepworth, Eric Kennington, and several others, each with different agendas, but often responsive in some way to the activities of – among others – Brancusi, Arp, some Dadas, Constructivists, such as Naum Gabo, or Bauhäusler en route to the USA. The famous holes (the word we use is 'pierced', my dear) that appeared in the work of Hepworth and Moore in 1936–37 offered new possibilities for sculptors continuing to explore three dimensions in time-honoured ways: that is, the final outcome would be the positioning of those objects in a space. Yet despite all this exploration before 1940, that urgent British need to nail a fact or a moment and call it something – an 'ism' perhaps – is to a great extent denied, because there wasn't always much of any

213. See Curtis, Penelope 1999, *op. cit.*, pp. 79–95.

214. See Harrison, Michael, Bowness, Sophie and Collins, Judith, *Carving Mountains*, exh. cat., Kettle's Yard, Cambridge, 1998; also Read, Benedict, *Sculpture in Britain Between the Wars*, exh. cat., The Fine Art Society Ltd, London, 1986.

Dame Barbara Hepworth
Tides I, 1946
part painted wood (holly)
34 x 63 x 30 cm
Tate, London 2006
© Bowness, Hepworth Estate

274　substance to drive the nail into in the first place. Britons were aware of the Surreal, of international styles, and of Neo-Romanticism, but although each had its strengths, none was predominant. In today-speak, the period was a window of opportunity utilised by all. More important, however, the disjunction of 1939–45 proved a godsend, because it allowed a new post-war generation to reflect on, and react to, what had become a generally acceptable range of sculptural possibilities, still often dependent on natural stimuli. In the later 1940s, British sculptors such as Butler, Armitage and Chadwick began to react against those positions, in tandem with newly emergent ideas, not only from Europe, but increasingly from the USA. By the time everyone had flexed their muscles, the previous generation were, if not venerated, then established, and those newer, younger voices were beginning to be heard more clearly.

Don't Just Stand There: Construct Something!

No matter how it is delivered, Sculpture is inextricably linked with spatial issues, the three-dimensional, with the inevitability of Time, as past, present or future; as celebratory or yearning; as commemoration, as aspiration or conjecture. If there was one sculptural process to challenge the carvings of Moore and Hepworth before 1939, that was Construction. With its roots in ideas generated by Cubism, Russian Constructivism, Dada, and its brain-child Surrealism, newer and very different types of fabrication were becoming increasingly accepted in British art on every tier. Relief collage, assemblages, constructions created from pre-formed, or pre-existing, objects, or with materials that were increasingly industrially produced, such as Calder's 'Mobiles', became profoundly important in the immediate post-war period. They not only affected sculpture, but also, increasingly, domestic and interior design, in objects from chairs to furnishing fabrics.[215] You didn't need to carve this stuff: you joined its pieces by welding. Just think: all those wartime processes put to good use. Swords into ploughshares, what? Forget it. The Americano-European Alexander Calder, and his colleague David Smith, King of the Acetylene Frontier, had been making this stuff in the USA before 1940, and before *them*, the life and career of the Spanish sculptor Julio Gonzalez had pointed the way to all who cared.

So, let's go back to your childhood... yes, the smell of sour milk, damp clothing and

215. For merely one example, see the designs of Robin and Lucienne Day during the 1951 Festival of Britain and after.

Sir Anthony Caro
Piece LXXXII, 1969
painted steel
44 x 121 x 146 cm
Tate, London 2006
© Anthony Caro / Barford Sculptures Ltd

Maurice Blik
Survivors' Monument, Maquette, 1994
bronze
74 x 84 x 33 cms
Artist's collection
Reproduced by kind permission of the
Artist

Maurice Blik
Survivors' Monument, Maquette; 1994
detail

lacquered parquet flooring... and powder paint and glue. What did you think when you were compelled to make your first 'junk sculpture'? Can you remember what materials you used to make it with? How you arranged it? Who helped you? The colours you selected? Its size? And the mobile? Yes, of course it's important. From 1951–54 it was certainly important to Victor Pasmore (reinventing himself after a highly successful career as a painter), to Kenneth and Mary Martin, Adrian Heath and other artists[216] who determinedly experimented in Britain with sculptural reliefs made from pre-fabricated materials, industrially formed objects (whole or fragmented), and who used these forms to attain balance. Their abstraction was as much attuned by long experience of painting, and the balanced, scientific formality of their various works demands comparisons with the very different, earlier kinetic activity by Calder and Gabo, as much as to Mondrian and de Stijl in general. And think: their ideas found ways into your school classroom. Some bright spark understood that balance and symmetry are many splendoured things, as attractive to children (who might just understand them better) than to their supposedly more-sophisticated peers. Mmmm. Still here? Compare this stuff with the knocked-up constructions of Karel Appel, and of *Art Brut* of the same period, and constructed sculpture begins to take on very different complexions. So many names... so easily forgotten, so for examples of this inherent and prevailing truth, fast forward to the present.

Was Jagger right? No, he wasn't. Notwithstanding the arrival of the most sensitive forms of sculptural abstraction, figurative and representational sculpture has endured in Britain, for the better, in carved and cast format, and alongside conceptual activities that have often been testing, and sometimes extreme. Its best post-1945 exponents – Ayrton, Armitage, Frink, Sandle – exemplify conceptual excellence by authors for whom no other method of communication was possible, period, and more recently, artists such as Ron Mueck have made work that suggests similar ideals. Where that leaves Antony Gormley is anyone's guess: his one-note activities are merely the latest variants on ideas of construction in use since the 1960s,[217] when Anthony Caro, all-Moored-up,[218] became a focal figure at St Martin's School of Art. There, the 'Situation' group, with Caro, Philip King and William Tucker, ensured that producing painted metal, bolted, welded or what you will, might serve as a meaningful intellectual activity to go hand-in-hand with painting on both sides

216. For extensive and illuminating discussion see Grieve, Alastair; *Constructed Abstract Art in England after the Second World War*, Yale University Press for the Paul Mellon Foundation 2005. From 1951, Pasmore, the Martins, Adrian Heath, Gillian Wise, Anthony Hill, Robert Adams, Stephen Gilbert and John Ernest shared very similar views, often exhibiting together, even in the context of large mixed shows like that of the London Group.

217. What *Angel of the North*???

218. Sir Anthony Caro worked as one of Moore's studio assistants before a legendary encounter with David Smith, in which – no doubt of it – the white light and heat of welding was discussed, and a conversion made.

of the Atlantic including, increasingly, in Europe. They'd been pre-empted by Reg Butler, back in 1953, whose work for a sculpture competition on the theme of *The Unknown Political Prisoner* won faint praise as a middle way between mediocrity and cutting-edge *avant-garde* work, itself a component of what one critic called 'the geometry of fear', a category within which the young Eduardo Paolozzi and William Turnbull were mistakenly bracketed.[219] Behind them, critics and theorists muttered darkly of likeness, of 'high' and 'low' meaning, and of much else. This doesn't mean that British sculpture of the 1960s and '70s was entirely humourless: just that most of it was, and there's still fun to be had with Bill Woodrow or Bruce Lacey, but two swallows do not a summer make. It is hard to reproduce in blanket format the expectations of everyone who wanted art to move from the disaster area of the Second World War, to newer, more challenging horizons, and originally all this was valuable: it sought answers to problems that truly existed in painting and sculpture in a post-war era fraught with Atomic portents, not all of them political. But the power faded, and while new generations of critics mutter on, they do so in tongues whose complexity is nowadays too often matched by utter meaninglessness. Sculpture, in its Jaggeresque form, became unrecognisable, as the Space replaced the Object in pole position, the human figure went walkabout (it's still out there, somewhere), and the art world welcomed that naked emperor once again, in the guise of Minimalism and Conceptual Art. Both weighed in, in attempts to validate the concept that, in sculpture, Words and Deeds were now intermarried, but you can only fool some of the people some of the time: rhetoric is fine when it's capable of rational evaluation, but not when the results are so slender that interpretation can only be reached after an endoscopy; and too many Americans, such as Bruce Nauman and Jeff Koons, must bear responsibility for influencing some of the most fatuous and cerebrally abject creations ever made in Britain.

Interventions

As British sculpture began the long, fruitless trek towards another International Style, some earlier conceptual journeys took on more meaning, not least because they made extensive use of that indispensable modernist accessory, the camera. In particular, American Earth Art of the later 1960s defined itself by using the term 'intervention' for what its supporters achieved in the name of sculpture.

219. See Causey, Andrew, *Sculpture Since 1945*, Oxford, 1998, specifically pp. 71–83.

Leon Underwood
Totem to the Artist, 1925–30
wood & metal
110 x 25 x 27 cms
Tate, London 2006

Underwood's totem looks suspiciously like Brancusi's concept for his spiralling Endless Column. And continental influence was strong in Britain in that period...

280 It's certainly some intervention if you create vast earthworks like the late Robert Smithson, or tear up swathes of untouched landscape with an earth-mover like Mr Heitzer, but what outside influences – especially Christo – gave the British was an understanding of the need to record: Christo is pretty nifty with a pencil but British land artists haven't exactly excelled in that area, so the camera became an essential sculptural tool. Unfortunately, early British Land Artists such as Richard Long and Hamish Fulton suffered from an acute bout of Minimalism,[220] so that their otherwise fair photographs of inaccessible, sometimes vast, sites and events, were not blessed with coherent commentary to relate these to their 'actions'. Right on, far out and so what? When artists such as Andy Goldsworthy and Chris Drury made (they'll hate this) more intuitively accessible actions, and recorded them in colour, for publication in popular book format, British Land Art was transformed, and the lie revealed. And yet every so often, a land artist comes along with something that really does the business; opens the mind to new possibilities; takes you to the infinite if you want to travel, backwards and forwards in time. It's been said earlier, but David Nash's *18,000 Tides* does that; a modern wooden henge monument made of beach groyne posts set in a municipal parkland setting, profoundly memorable, illuminating and perplexing, as long as you're capable of thought. *18,000 Tides* is a sculpture about anything you want, but most of all it is about the turning of the world, and so why not also the world of British sculpture, off on a tangent, out on a limb, or in the vortex with the rest of the ship of fools? And those tides can be a commentary on what might be, on the certainty that British sculpture can still speak.[221] It's a matter of balance, as much as one of conjecture. Name as many artists as you want: sculpture is the most unforgiving medium. Do you really need posterity to tell you whose work is ephemeral, what is shallow, or dross? The answer to that question ought to be 'no'. But be assured: in Britain, as elsewhere, fashion is fickle, 'Now' is a state of mind and, with a bit of luck, sense and sensibility ought to have the last laugh. It might take a while, but there'll be a few bullets with names on them. Perhaps Dada had a point.

220. Long still suffers.

221. Abundant evidence is available at the Yorkshire Sculpture Park (est. 1977) and at the Cass Foundation at Goodwood, West Sussex (est. 1994).

David Nash
18,000 Tides, 1996
weathered oak groynes recycled, shingle
& oak logs
mixed media sculpture constructed
in ten parts
diameter 8.04m, tallest timber 4.04m,
smallest timber 2.44m

Manor Gardens, Towner Art Gallery,
Eastbourne
© Reproduced by kind permission of the
Artist
Photograph: Julian Freeman

14
Watercolour:
It's in the
Wash

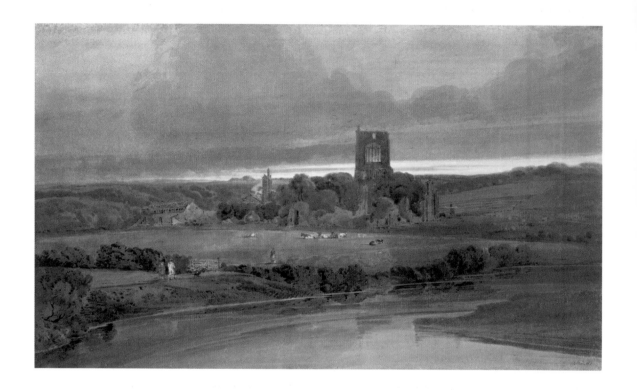

Thomas Girtin
Kirkstall Abbey, Yorkshire–Evening, c1800
watercolour on paper
32 x 52 cm
The Bridgeman Art Library
Victoria & Albert Museum, London, UK

If art forms were ever offered up as national characteristics, then watercolour would be the British medium. That might offend the shades of artists of the past, some of whom saw the process as a means to an altogether more august and oily end, but watercolour is not simply 'of' misty, moisty Britain. It does the business, a medium with an inherent and continuous capability to surprise, and with an extensive potential for personal discovery. There have been artists at the core of British art history, such as John Sell Cotman, Thomas Girtin or Turner himself, all of whose activities were based in different ways on their watercolour paintings; and it is not strange to hear of seasoned practitioners who, having resisted the medium for years, experiment, and stimulate unsuspected creative juices. But watercolour isn't a speculative medium, something to play about with. It's a serious business, and you'd wonder why, at the other end of the scale, perhaps absurdly, it has become the most popular medium for many who seek simple pleasures in painting. It seems incomprehensible that some of us begin our struggle for self-expression by attempting to work within what is without question one of the most unforgiving techniques available to any artist. Perhaps it's because, like Everest, it's there, but that's not a good enough reason. Art-as-self-expression is a modern phenomenon, and, if anything, it's the obverse of its original purpose: record, or documentation, following training in observation. Where watercolour fits in is in its ability to link visual, mental and emotional activity, according to individual need. Forget those television programmes now.

In Britain, watercolour was never a 'stand-alone' medium, even in its earliest manifestations.[222] Throughout a history that easily embraces Nicholas Hilliard and the sixteenth century, one of its greatest assets has been its ability to interact with pen, pencil, metallic applications, inks and crayons of different descriptions, or other water-based tinctures; or as a studio practice, on many different weights of available paper, with different surfaces or edges, and this is true of its lifespan at the heart of every 'British school' you'd care to mention.[223] The greatest Pre-Raphaelite artists knew this, especially DG Rossetti, and younger followers also: to see the oil techniques of Brown, Holman Hunt or Poynter[224] is to understand the debt they owed to watercolour. Yet a key element of watercolour painting, or of any water-based medium, is its inherent portability, recognised by Thomas Girtin, Turner and Edward Parkes Bonington during the early 1800s, and only slightly later by Edward

222. See Reynolds, Graham, *A Concise History of Watercolour*, Thames & Hudson, London, 1971, amongst others, for a survey of the early use of watercolour.

223. That is to forget the ill-tempered arguments about 'right' and 'wrong' watercolour technique that bedevilled British watercolour societies during the

mid-nineteenth century (broad washes versus stippling).

224. Artists who thought of watercolour as 'drawing'.

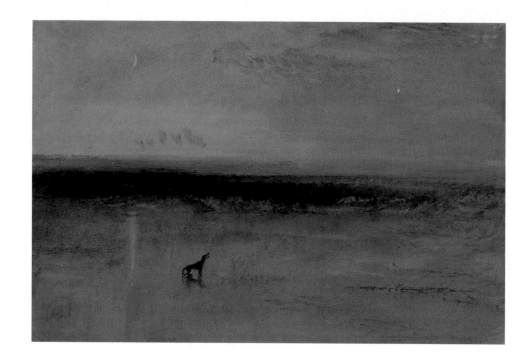

Joseph Mallord William Turner
Dawn after the Wreck c1841
25 x 37cms
The Bridgeman Art Library
© Samuel Courtauld Trust, Courtauld
Institute of Art Gallery

Thomas Girtin
Pont-y-Pair, 1798–9
watercolour on paper
38 x 58 cms
© Tate, London 2006

Turner wrote of Girtin that if he had
lived '…I should have been a poor
man.'

288 Lear and the Orientalist JF Lewis: the same possibilities that it still offers to anyone who wants to set aside the digicam and 'engage' with an outdoor subject, or, in the case of Lewis and his images of the near East, outside an indoor one.

No one will disdain the glittering effects of watercolour applied to best advantage: in the early twentieth century, Paul Klee and August Macke, Swiss and German respectively, found it the only satisfactory means to record the spellbinding effects of light that they experienced on a 1914 journey to North Africa.[225] In Britain, the same era was truly remarkable for the huge range of usage to which the medium was put. The 1890s saw the Scots Arthur Melville and Charles Rennie Mackintosh develop watercolour in ways that would offer a wealth of diverse, semi-abstract possibilities, conveyed in turn by big, dense washes, or by delicate, yet bold linear variations on natural forms. These men were the absolute antithesis of Cézanne: just as determined to seek the essence of form in watercolour as in oil, but, in the ways that each used the medium, representative of what was possibly the best and broadest awareness of the potential of water-based media within early twentieth-century British art. Indeed, it is arguable that this situation has continued to the present, right across the board, for reasons that have to do with the (literally) brilliant chromatic possibilities of the watercolour palette, and the welcome that bright colours receive from Celtic, Scottish and Northern audiences.

If watercolour is dogged by anything it is the common perception that it is a medium for landscape, and yet it can be as rich, if not richer, when used in response to still life or to the intricacies of more closely observed subjects. It is arguably at its strangest when used to depict the human figure, and anyone approaching British twentieth-century water-based media will discover some excitingly diverse, and often curious, examples of this. Yet when artists achieve fame because of their use of water-based paint they have often come close to undermining the value of the medium: as, for example, in the case of Sir William Russell Flint. Flint was trained as an illustrator, but in time became a watercolourist whose illustrative fluency lay wholly in contrivance, usually through his application of fluid, yet rather featureless watercolour washes, most often in depictions of provocative and décolleté young women. Whatever the effect of Flint's figures on the male imagination, they certainly obscured his very adequate skills as a landscape artist. Additionally, Flint's combination of watercolour and subject matter lowered the medium's status for main-

225. It is worth researching the rapturous reactions of both artists to their experience of light, if only to justify the existence of watercolour as a suitable medium for such documentation.

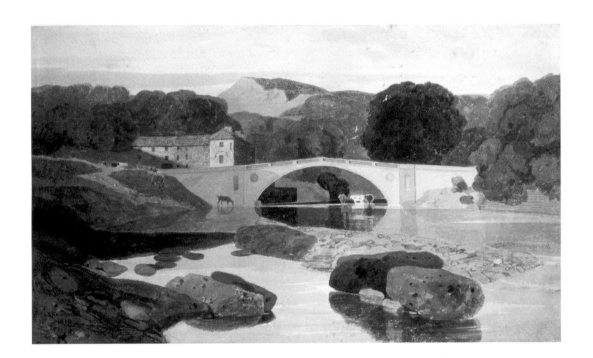

John Sell Cotman
Greta Bridge, Yorkshire, 1810
watercolour on paper
30 x 50 cms
The Bridgeman Art Library
© Norwich Castle Museum and Art
Gallery

stream audiences, drawing them away from newer artists who have used water-based media to deal with human subjects, and whose reputations have gained or waned accordingly.

In many ways David Hockney exemplifies this trait. One of the most successful British painters since 1950, Hockney famously forced himself to attempt watercolour extensively for the first time in 2002. His motivation is unclear, but the results were trumpeted triumphantly. We may never truly know what the practice holds for him but, certainly, Hockney's watercolours own few of the robust techniques he has deployed in the past in oil and acrylic paintings. Their simplicity may charm, but the images themselves are sometimes unconvincing, and suggest serious shortcomings in their painterly qualities, and beg more general questions concerning the relationship between established reputations and the undulations of the art market. And Hockney's attempts at direct figuration in watercolour make interesting comparisons with those by David Remfry, who began to enjoy commercial success and imitation at the beginning of the 1980s, and whose personal style was at one time as recognisable as Russell Flint's, with real focus on his subjects and none of the superficiality of the older men. Somehow, Remfry managed to find a way of dealing with human beings in watercolour without selling out. A couple of close calls, perhaps, but he's still up there, as sound a representative of the twentieth century in his own medium as any other.

We're being previous. Britain's great watercolour awakening took place in the early-twentieth century and, in Edward Burra, Britain had one of its most unusual and original painters,[226] a sick man, but born to boogie, who for years travelled the world at the drop of a hat (yes, really) but always returned home to Rye, East Sussex, itself located at the rim of one of the oddest, most dislocated landscapes in Britain, the meeting-place of sea, shingle beach, sky, horizon, and a fund of objects that fed his responsiveness to the bizarre, to the strangely, razor-sharp-edged, spikey-strange, and to the ordinary, every-day surreal. Compared with Edward Burra, Remfry is safe as houses, and Hockney an inhabitant of dullsville. The lead content in oil paints made Burra dangerously ill, so he drew in ink and painted only in watercolours – and what paintings they often were: enough to stop anyone in their tracks, from the cosmopolitan hubbub of New York bars, and the streets of Harlem, to the

226. For accessible details on Burra see Causey, Andrew, and Melly, George, *Edward Burra* (1985), exh. cat., Hayward Gallery, London, 1985, which is generally available, though rather poorly illustrated. Those who are deeply smitten should definitely see Causey, Andrew, *Edward* *Burra Complete Catalogue*, Phaidon, Oxford, 1985.

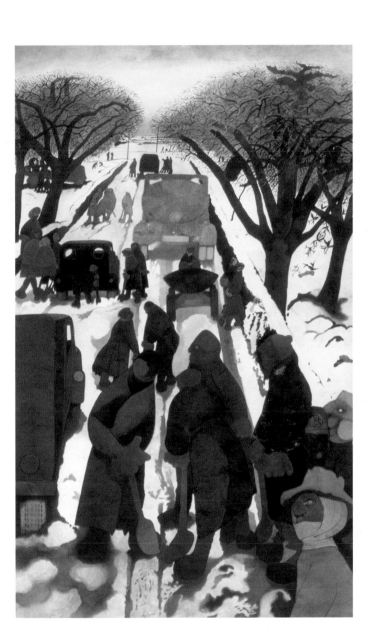

Edward Burra
Winter, 1964
watercolour on cardboard
135 x 80 cms
The Bridgeman Art Library
© Arts Council Collection, Hayward
Gallery, London, UK

soft weather of the Burren of Western Ireland, through the Wye Valley to the decid-
edly odder inhabitants of Cornwall or the Romney Marshes. In Burra's paintings
human beings are experienced as much as they are observed, and imaginatively
embellished; landscapes are enhanced with a seam of sardonic watchfulness.
Burra's were big boots to fill, and his presence, right in the middle of the twentieth
century, is an unusual and useful focus for much that passed before and after in
water-based media.

Burra's immediate peers still have major reputations. In different ways Henry
Moore, Ben Nicholson, John Piper and Paul Nash are his equals, simply because of
their utterly different achievements in watercolour, and for what they wrote about
painting. Burra worked real wonders within the medium, but compared with others,
his was a provocative, sinister and maverick spirit. During the 1930s it would be
The Others who wrangled about what they thought painting should be, and at the
time much of that paint was oil-based. It was Piper who wrote[227] that he wanted to
return to 'the tree in the field' as a step away from abstraction towards a realistic
point of reference, and that comment remains an important point of aesthetic and
intellectual difference. Elsewhere, Edward Bawden and Eric Ravilious used their
abilities to create powerfully nostalgic imagery, often for an imagined England. In
their wartime painting, each drew upon infectious depths of spiritual and sensory
inspiration that he had previously developed, to deliver expansive and intense per-
ceptions. On active service as an Official War Artist from 1940–42, Ravilious's
watercolours are often barren, echoing and bleak. They convey with some intensity
chill nights on the English Channel, Icelandic fjords, and the bleak expanses of
Scapa Flow: sensations acutely echoed among the huddled figures of Bawden's
freezing Italian interiors of 1943, and through a multitude of images whose loca-
tions range from the British Isles to Addis Ababa, all of them distinguished by an
innate ability to translate climate and a sense of being into meticulously observed
record. In this, these artists, and especially those most closely associated with the
so-called 'Neo-Romantic' idiom of c1940–50, were exercising stylistic traits that
owned what was – at that time – intrinsically 'British' restraint. For Paul Nash,
Ravilious and Bawden, this meant the dry effect of thin washes and regular marks
on not-very-good paper, sometimes deliberately stylised, and the visible use of pen-
cil lines as part of the structure of an already-simplified, yet clearly recognisable,

227. Piper, John, 'Lost: A Valuable Object',
from Evans, Myfanwy, *The Painter's
Object*, Gerald Howe Ltd, 1937.

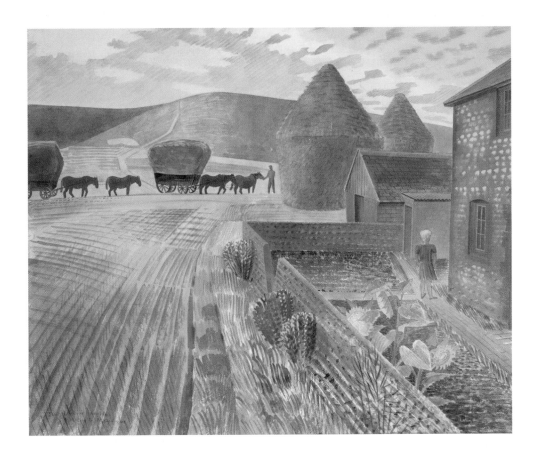

Eric Ravilious
Furlongs, 1936–7
The Bridgeman Art Library
© Private Collection

Furlongs was the home of the artist
Peggy Angus, in the heart of Sussex
downland

observed image; for Piper, Sutherland and others, it might (but did not always) mean soaking washes of earth colours or of intense green or blue, or, for Ayrton or Minton, a combination of all, together with a spiky pen and wash treatment. Whatever, it is important to recognise that they were the tip of the iceberg; and that, irrespective of their qualities as art, time has transformed such images so that they have come to provide a point of recognition for later generations; not pictograms, but visual symbols that identify the era. The same is true to varying degrees for every era before or since, but Britain's stratified cultural history has more up its sleeve, in the form of the unjustly overlooked watercolours made for the American-financed Pilgrim Trust's *Recording Britain* scheme of 1940–43.

During the Second World War, the Pilgrim Trust underwrote the execution of a very large series of watercolours to document a Britain thought by many to be on the verge of disappearance, either through the ravages of wartime invasion (you couldn't be sure, and no one was prepared to put money on it) or under the developer's ball and chain (always worth a claxon of protest). Many of the British watercolourists who participated in this project were household names at the time, or went on to establish reputations on the basis of their activities within the project; the 'also-rans' were merely unfortunate.[228] The fact that they aren't all remembered today says something about the impact and supremacy of modernism within all British art forms of the period, but it cannot delete these artists from British art or social history, for no reason other than their presence in many forms of daily life outside the gallery. Some of those employed by the Pilgrim Trust were already old-established academicians, among them Walter Bayes and AS Hartrick. Others were becoming known for their illustrations in books, on magazine covers or as illustrations, or as topographical artists for the various railway companies, whose compartments often bore their works, reduced but very widely reproduced; for advertisements for London Transport under the far-sighted Frank Pick; or for Shell, whose interest in promoting an awareness of the countryside took a rather more materialistic form. Such examples merely indicate the spread of availability of watercolour imagery, and some of the locations in which subliminal or direct public awareness of their work was possible.

That breadth of activity was exemplified in the work of the Sussex watercolourist

228. See Palmer, Arnold, (ed.) *Recording Britain*, 4 vols, Oxford, 1946–49; and Mellor, D, Saunders, G and Wright, P, *Recording Britain: A Pictorial Domesday of Pre-war Britain*, David & Charles, Newton Abbot & London, 1990, for the only recent survey of this project.

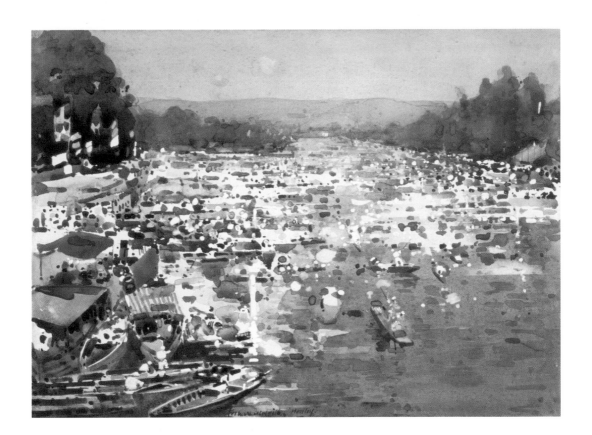

Arthur Melville
Henley Regatta c1800
watercolour, bodycolour, pencil & surface
scratching on card
27 x 36 cms
The Bridgeman Art Library
© Whitworth Art Gallery, The University of
Manchester, UK

The lusciousness of Melville's washes is
a trademark, but he is even better-
known for the rich tones of his
Mediterranean paintings

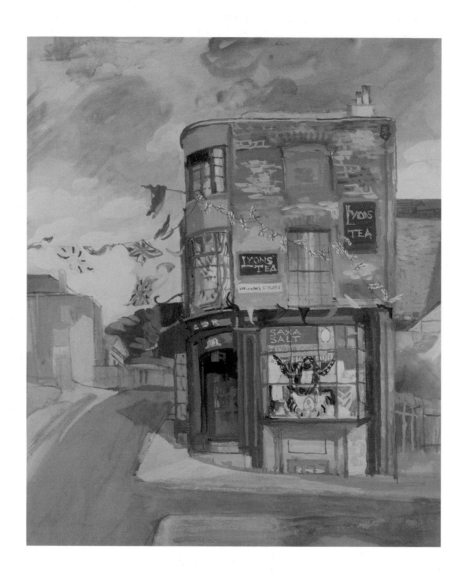

Dorothy Coke

Old Grocers Shop Behind the [Brighton]
College of Art, 1953
Gouache
43 x 38 cms
Private collection

Dorothy Coke used gouache in this
image of a (now demolished) Brighton
side-street during Coronation year
(1953). She would later use convention-
al watercolour with unconventional biro
to chart the destruction of the Brighton
College of Art (out of sight on the right)

Charles Knight, a key figure in *Recording Britain*, who made inn signs and illustrations for the railways, in addition to his teaching and painting. The career of Clifford Ellis, a core figure in the establishment of the Bath Academy of Art at Corsham, was similar: like others, he was employed by Shell. Younger artists, such as Thomas Hennell and SR Badmin, whose images were published for years afterwards in *Radio Times*, Dick (RT) Cowern, Rowland Hilder, Michael Rothenstein, Phyllis Dimond and Barbara Jones – not forgetting Piper himself – represent a selected few from the latest, and long-running, phase of a British watercolour landscape tradition in which representation remained a core feature, and which proved agreeably open to differences in interpretation.

If this all sounds comfortably secure, with a bright shiny future before it... you guessed: it wasn't. We need only rewind this chronology back to 1937 to discover that the 'valuable object' deliberately ignored by Piper, but later unearthed in response to a nagging artistic conscience, was Representation, in some identifiable form. Before that moment, watercolour had proved entirely suitable in the development and promotion of abstraction in Britain for the better part of three decades. Indeed, its gestural qualities had been easily assimilated in different ways by the warring arms of modernity in pre-1914 southern Britain, in the forms of Bloomsbury and Vorticism. Many of Bloomsbury's core adherents – Roger Fry, Duncan Grant, Vanessa Bell, Phyllis Keyes among them – contributed in some quantity to its strongly decorative tendencies, and in the event their water-based media, even in the forms of trial designs, are arguably as good as, if not better than, the final outcomes, as these were eventually applied to furniture or ceramics. The calculated, saga-like animosity developed by Wyndham Lewis towards Roger Fry[229] can, however, divert viewers from the very reasonable suggestion that, within the often glowing watercolours of the Vortex, whether they were by Dorothy Shakspear, the prolific Helen Saunders, Lewis himself, Roberts, Wadsworth, or anyone else, their hard-edged linear constructions in watercolour are among their greatest achievements: fully in tune with the machine-age ethos of that association, yet, for all Lewis's bombast,[230] incapable of cutting the last ties between total abstraction and the British past. Oddly, despite its stylised hard edges, Vorticism's determination to move into a world that was as non-naturalistic as possible did not result in any reduction of organic intensity in its watercolour practice. For reasons that

229. See 'Clubbing', Chapter 11.

230. See *BLAST* No.1, 1985, repr. by Black Sparrow Press, Santa Barbara.

seemingly have much to do with collective longevity, that would be a problem encountered to a greater extent by the Bloomsbury artists, but it is interesting that the application of watercolour in so graphic a manner was widely avoided by most British artists of the inter-war period. The sole exception was Charles Rennie Mackintosh, who moved south from Glasgow in 1914: the visual (and often perceptual) brilliance of some of his watercolour landscapes and still-lifes from the 1920s have a magnetism of their own, but the quality of their structure and their deliberately designed format offer them up as fluid and representational extensions of Vorticist watercolour activity. They weren't.... but you'd be forgiven if at first glance you thought they were.[231]

Since 1940 the line between documentary observation and expression within water-based media has developed in every area of Britain, to the present. Whilst William Gillies was creating some of his most masterly images in 1930s Scotland, so, as the decade progressed, outside influences were becoming more evident. The arrival in Britain of refugee artists, such as Josef Herman, Jankel Adler and Martin Bloch, extended visual horizons for many home-grown watercolourists. Perhaps the most unusual arrival was Hans Feibusch. A latter-day fresco painter, the diminutive Feibusch (a five foot nothing from Frankfurt on Main) combined astute and confirmed expressionist tendencies with an acute understanding of Impressionism, and used gouache for preference in his daily work. It was a medium in which he excelled, in his preparatory mural studies, in his work for Shell, and most especially in his landscapes. In these, the mythical past, local history and the Bible are dispensed with, in favour of Nature: an antidote for all ills, usually underpinned by a disarmingly facile understanding of light. Always unassuming, and never a leader, Feibusch was nevertheless to some extent representative of the evolution of a more independent, flexible, expressive approach to water-based media in mid-century British painting among a younger home-grown generation, in which good training was important, but where the medium might serve equally as a way-station on the path to a larger outcome in other media, or in which it might prove to be entirely adequate in itself.

In the century since the end of the Great War, watercolour in Britain has reinvented itself continuously, and often spontaneously, so that it not only provides docu-

Robin Richmond
The Orchard, Dordogne, France, 2005
Watercolour on paper
29 x 29 cms
© Reproduced by kind permission of the
Artist

Ian Potts
St Mark's Venice, 2004
After the downpour arrives the sunshine
watercolour
57 x 77 cms
Private collection
© Reproduced by kind permission of the
Artist

David Prentice
Belle Vue – Elevation, 1993
reed pen and watercolour
81 x 81 cms
Private collection
© Reproduced by kind permission of the
Artist

Prentice's approach to watercolour is
more directly in the tradition of the
great figures of the past

mentary, descriptive opportunities to the open-minded, but also opens countless doors to experimentation. At its farthest reaches, its subjects have moved from the mundane to the exotic, and its techniques now admit ideas that would have defied eighteenth-century practices: mixed media wouldn't have occurred to those artists, as such formulae have to contemporaries. And water-based media have developed enormously since 1945. The chromatic possibilities of watercolour have been enhanced through colour chemistry, the versatility of gouache, and the development of acrylic, since the 1960s, from a repellently rubber-like polymer, which formed a skin under which the paint never dried, to the (truly) flexible contemporary medium of today, have simply overturned perceptions. Water-based media, from paint to ink, have become potentially transformative, exotic possibilities, emerging from a medium that began as an acceptable process, governed by certain technical and aesthetic constraints, into something much more adaptable.

When all's said and done, what's watercolour all about? Every watercolour society in the country offers answers, from the purely decorative tourist response to the local landscape, or the permutations that the same view has prompted from indigenous artists. Better by far to be wise and seek depth. The Scottish artists Elizabeth Blackadder, Barbara Rae, Charles McQueen and Douglas Davies have developed colour and expression in different ways that the medium's admirers cannot have foreseen. In England, we've had Remfry and Hockney, but we've also been able to benefit from artists such as Michael Andrews, David Prentice and Ian Potts, or the younger Robin Richmond, who have proved that, in the right hands, large-format water-based painting can have considerable, vital, visceral impact; not only this, but it can also co-exist in any artist's *oeuvre* with equally powerful and expressive oil paintings. The work of all four is deeply responsive to locale: Prentice lives below Malvern Beacon, and nowadays uses watercolour, and other water-based media to respond empirically to experience in a way that owes more than a little to Piper. He has come to believe in that tree in the field. Oil paintings do the rest. Potts is a Traveller, a modern Lear, an analyst for whom the prospect, observation, and painterly form are keys to the same door, and the solution of pictorial problems. Richmond's visual treatments own acute similarities to the evanescence of different works by Paul Nash and Frances Hodgkins, whom she has never aspired to emulate, but for whom the tangible and the spiritual are often in curious, dreamlike contiguity.

Elizabeth Blackadder

Early Spring Anemone, 1977
watercolour on paper
67 x 101 cms
The Bridgeman Art Library
Royal Pavilion, Libraries & Museums,
Brighton & Hove

304 In the twentieth century, watercolour finally made it onto daytime television, for the admiration, criticism (ignorant or knowledgeable) and what-you-will of the armchair critics. Like football, watercolour is easy to criticise when you aren't out there, huffing and puffing. Swearing at the referee is taboo, but any fool can carp, and in this medium, arguably more than any other available to artists today, criticism needs to be tempered with understanding. It may be foolish to claim watercolour as the lifeblood of English artistic practice, but surely, it must come very close, and for this reason those who attempt it must understand the challenge that they set themselves: one that contemporary media of every kind are incapable of replicating or surpassing at any level.

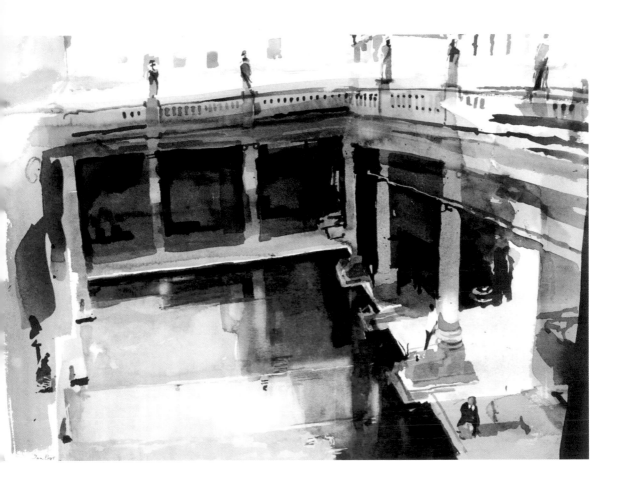

Ian Potts
The Spa Bath, Bath, 2004
watercolour
57 x 77 cms
Private collection
© Reproduced by kind permission of the
Artist

Potts' insistence on drawing is a funda-
mental feature of his land- and city-
scapes, and in many of his images
buildings anchor the view. However, the
depth and limpidity of his washes, layer
upon layer sometimes, give the real
substance to his paintings

15
It's War

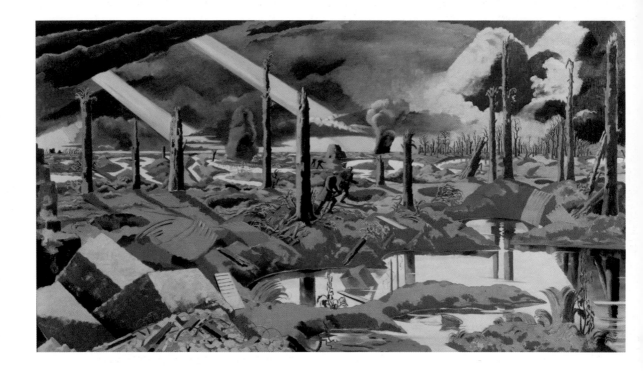

Paul Nash

The Menin Road, 1919

oil on canvas

183 x 318 cms

The Imperial War Museum, London, UK

© Crown Copyright

Nash's classic painting of the Ypres salient… executed in a Buckinghamshire barn

They shall not grow old as we who are left will grow old… at the going down of the sun and in the morning we will remember them.[232]

Laurence Binyon

Age may not weary them, nor the years condemn, but you can bet your bottom dollar that today's young Britons have an altogether different visual understanding of warfare from that of their forebears between 1914 and 1950. Television and video games have come close to neutering the powerful combination of record, cold facts, shock and stark message officially accumulated in Britain between 1916 and 1946 in dedicated areas of fine art, early newsreel films and documentary photography, and delivered in different ways to earlier generations of all age groups. The problem then, as now, lay in the superabundance of available work. War has never been entirely absent from modern Britain, and the meaningful use of art as a way of exposing its many elements should be a matter of concern facing artists and educators everywhere.

Only in Britain has almost the entire gamut of early twentieth-century warfare been recorded, in thousands (yes, thousands) of diligent, determined and sometimes conscience-stricken drawings, paintings and sculpture by as wide a range of British artistic talent as it has ever been possible to find. Nowadays, this body of work[233] has to be regularly redefined and redelivered to audiences who either shy away from images of warfare because they prefer to ignore its existence, or who fail to understand the artist's role as observer, commentator and critic. It was not always this way, and the several differences that define our responses to such work over time are truly worthy of consideration and reflection.

In the wake of centuries of human conflict, intensive artistic activity of all types has followed worldwide. Art about war has ranged from the Arch of Titus in Rome, celebrating the fall of Jerusalem to the Romans in 70 AD, to the Vietnam Veterans' Memorial in Washington DC, a gaunt reminder of national loss sustained during an ill-conceived foreign adventure. Paintings have ranged from Paolo Uccello's *Battle of San Romano*[234] to Peter Howson's paintings of Bosnia. Sculpture might as easily begin with Trajan's Column and include Donatello's equestrian sculpture of the

232. *For the Fallen*, Lawrence Binyon.

233. Much of this work is held for the nation by the Imperial War Museum.

234. One of a series of cut-down lunette decorations for the Medici family of Florence.

mercenary Erasmo de Nari (or Gatamelata) of 1453 and any of Michael Sandle's late-twentieth-century reflections on the Second World War. The intended outcomes of these examples were varied, and reflect the breadth of the subject. Initially, all painting and sculpture was broadly triumphalist. A review of eighteenth- and nineteenth-century battle art should establish that this trait continued well into the nineteenth century, until the point at which – broadly speaking – the growth of illustrated magazines gave an increasingly literate public frequent opportunities to consider a plethora of artistic interpretations of events, of which many were military. By the later 1860s one didn't have to wait for the Royal Academy Summer and Winter exhibitions to see the latest militaristic statement mirroring Britain's imperial growth, when it might be propped up between the honey and the marmalade on any given morning.[235]

The evolution and development of official war art as we now know it in Britain began in 1916 during the Great War, and was resurrected and sustained with even greater success from 1939 to 1946. Official patronage continues to the present, through the activities of the Imperial War Museum, born in the abstract in 1917,[236] and its Department of Art. Before that time, we need to think of it as 'battle painting', or 'battle art': the stamping ground of eighteenth- and nineteenth-century giants such as Benjamin West, John Singleton Copley, Daniel Maclise and Lady Butler – all of them born outside England. Their largely narrative paintings place a cultural imprimatur – a seal – on colonial conquests and on perceived turning points in national history, against a succession of enemies on land and sea, from Quebec to the Channel Islands; from the Nile and Trafalgar to Waterloo, and on into the heat of India and Africa, and the snows of the Crimea. If events made it into paint, they had to be culturally 'right'. Importantly, the earlier images were relatively contemporary, and celebrated British feats of arms, while the old enemy – France – was only just across the water, with a platoon of painters ready and able to laud the military achievements of Napoleon Bonaparte.[237] As a late-comer, Elizabeth Thompson, Lady Butler set herself the unusual task of out-painting the best of the French artists, especially Meissonier, then riding high and taking his place.

If Andy Warhol had wanted to plan his career, he could have done worse than examine that of Lady Butler. Her fifteen minutes of fame began in earnest with *The Roll Call* (1874), a painting set after an action during the Crimean War (1854–6).[238]

235. See Harrington, Peter, *British Artists and War: The Face of Battle in Paintings and Prints, 1700–1914,* Greenhill Books (UK) and Stackpole Books (USA), 1993; also Freeman, Julian, 'War Art', in Holmes, Richard, (ed.) *The Oxford Companion to Military History*, OUP, 2001, pp. 963–71.

236. The IWM was originally called the National War Museum, but the representatives of the Dominions rightly objected.

237. Napoleon's failures were rarely shown in paint, and Meissonier's *The French Campaign, 1814* is a rare exception, executed long after the event.

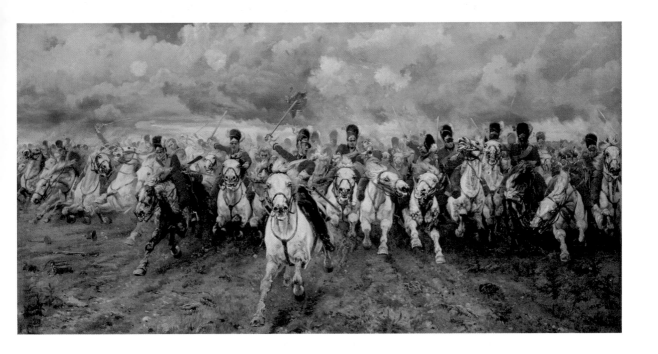

Lady (Elizabeth Southerden Thompson) Butler
Scotland For Ever!, 1881
oil on canvas
102 x 194 cms
The Bridgeman Art Library
© Leeds Museums & Art Galleries (City Art Gallery), UK

The Battle of Waterloo, painted for a Victorian audience and – perhaps – to ensure Lady B's own popularity... 66 years after the event

Those fifteen minutes went on and on, celebrating the British Army's achievements in every conflict since the Napoleonic Wars, always rather retrospectively, and with occasional alarming lapses in technique, until her death. There are some great pictures (among them *The Roll Call, The Defence of Rorke's Drift, Scotland For Ever*) and some wretchedly weak ones (don't ask). By 1914 Lady B's star was waning,[239] and her tendency to illustrate rather than to record will have been one of the reasons for her omission from the list of artists drawn up to work towards propagandist and documentary ends by the British during 1916.

The Great War not only affected the entire structure of all British art, but also – quickly and particularly – all visual imagery intended to deliver what we might call specific 'truths': representations of the realities of war experience, usually for propaganda purposes. If we accept that in art there is no fully satisfactory definition of the words 'truth' and 'reality', it may seem odd that the British government chose to run its wartime propaganda campaigns on the basis of 'sweet reason'. In global terms, British textual propaganda was highly effective, and of staggering linguistic diversity, but its most pressing need was to provide illustrative material that its enemies could not easily dismiss as having been in some way 'doctored'. In today's high-tech IT environment, one might reasonably wonder what all the fuss was about, but the problem was brow-furrowing back in 1914. The chosen solution was to revert to art, not illustration, initially in the hands of established or up-and-coming 'names', in the effort to make friends and influence people.

Successive government agencies controlled the development and distribution of pictorial propaganda during the Great War. All their official artists received contracts that, in the informal terms of the first appointment, defined the essence of their jobs. They were to work for '…the purposes of propaganda at the present time, and for historical record in the future.'[240] The Scottish architectural draughtsman, Muirhead Bone, was the first British official war artist. His placement, in August 1916, amid the wreckage of the Somme battlefield and its rear areas, was as appropriate as his appearance had been opportune. Bone was kept away from security-sensitive areas, and his work was censored, but he was able to send back work for illustrative use without undue difficulty. The rest, as they usually say, is history. Bone's images scored real hits, further artists were appointed and, to cut a fascinating

238. See Usherwood, Paul and Spencer-Smith, Jenny, exh. cat., *Lady Butler, Battle Artist, 1846–1933*, Alan Sutton with The National Army Museum, London, 1987.

239. Surviving documents show that she didn't share this opinion.

240. Letter; Ernest Gowers to Muirhead Bone, 12 July 1916, Imperial War Museum, Bone correspondence. The letter is informal, but the same terms were effective in all contracts offered to others who were sent as artists around the globe by what became the Ministry of Information. For the story of Bone's appointment, consult Harries, S & M (1982) *The War Artists*, Michael Joseph with the Imperial War Museum, London.

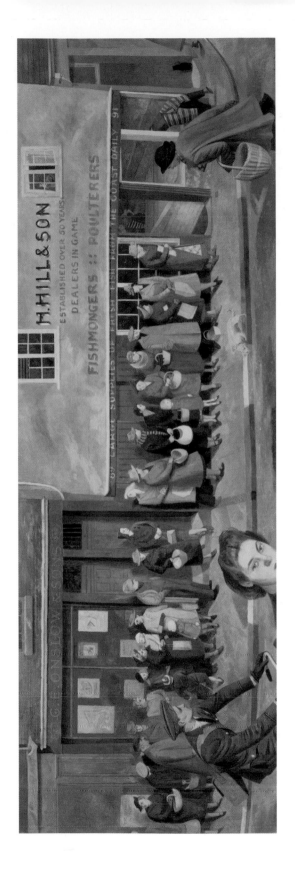

Evelyn Mary Dunbar
The Queue at the Fish Shop, c1941
oil on canvas
62 x 182 cms
The Imperial War Museum, London, UK

At first unjustly ignored by Kenneth Clark, women war artists made major statements about Home Front experience during the Second World War

and complicated tale very short indeed, by 1919 the British government had acquired some 3,000 works of art from just under 300 artists, men and women.[241] Hundreds of drawings had been used successfully to illustrate propaganda pamphlets. Four volumes of colour reproductions were respectively devoted to the work of the artists CRW Nevinson, Paul Nash, Eric Kennington and Sir John Lavery. Travelling exhibitions of work in different media devoted to specific subjects – such as naval pictures – were arranged. It all augured well for the Second World War. Terrific, eh? But the visual outcomes were discordant, to say the least.

How do you make art about modern war? Forget global: the shock of even local conflict is so great that it is arguable that the strongest answers will arrive visually, rather than verbally, and that they'll exist at many levels. Survey John Keane's responses to the First Gulf War of 1990 for proof. Dread continuity meant that the awful experience of 1914–18 overran into that of 1939–45, yet in their art the two remain distinct as collections of events. In 1919 the jury was divided. The artists had been given free rein to express themselves within reason, and the sum of their respective endeavours challenged many preconceived notions. Stylistically, outcomes ranged from prosaically figurative, representational, narrative images, the descendants of traditional pre-war 'death-or-glory' painting,[242] to demanding and often nihilistic modern works, usually by younger artists. Among the latter there was clear evidence that even those not in the vanguard had been affected by pre-war exposure to French Cubism, Italian Futurism[243] and (that creation of the English critic Roger Fry) Post-Impressionism, and that it had all been of fundamental importance.[244] If the new, and military, term, 'avant-garde' was wholly applicable to, for example, Lewis, Nevinson and Roberts, others were at least touched by its passing radiance.

The obvious differences between the British art of the Great War and that of the Second World War are visual and intellectual, and though the former are easily identifiable, the latter are harder to define, and, arguably, still unravelling. The most distinct differences are stylistic and philosophical: how to deal with wartime subjects, given what in many cases were more 'up front' or assured peacetime activities. Most often noted are the stylistic differences between what were often aggressively abstract pre-1916 works by independent artists such as Wyndham Lewis,

241. The Imperial War Museum's Department of Art holds all the correspondence between every war artist and his or her masters in Whitehall or nearby.

242. Let's hear it for Lady Butler, Lucy Kemp Welch, Fortunino Matania, Richard Caton Woodville and several other luminaries.

243. A dictionary definition will deliver the basic facts, some of which are of continuing importance. Futurism was a young man's movement. But however enthusiastically its membership embraced the unknown, some of Futurism's pronouncements were more troubling: anarchic and destructive, some have seen them as the shape of things to come. Which, in some cases, they were.

244. Strictly speaking there's no such thing as Post-Impressionism. Fry was determined to set up the work of Cézanne, and did so by removing the younger (and less-involved) members of

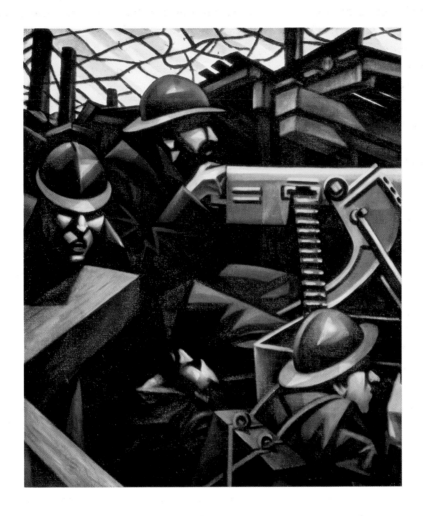

CRW Nevinson
La Mitrailleuse, 1915
oil on canvas
61 x 51 cms
© Tate, London 2006

Sickert called La Mitrailleuse '...the
finest utterance on modern war in the
history of painting'

William Roberts, David Bomberg, Edward Wadsworth and CRW Nevinson, and their later work as commissioned artists, toned-down for wider public consumption. Yet those Great War images ensured truly wide-ranging critical attention, because they contrasted with the many hundreds of purely figurative works gradually accumulated. Think what you want about the ways in which the realities of war affected the modern artists of 1914: there are more questions to be answered here,[245] and problems remain that concern late-twentieth-century educational conditioning (and the presence of all that poetry), and their effect on a balanced understanding of artistic responses to any type of conflict. Objectively, 1916–19 is also an era in which practitioners of the best British realistic drawing and painting can (and do) reasonably claim equal rights with the artistic *avant-garde*: in the right hands, realism is as valid an approach to the creation and distribution of some pretty demanding visual truths as anything within the abstract category. Eighty years on it's still a contentious issue for some, and there are no cut and dried critical positions.

If the artistic developments that preceded the outbreak of the *Second* World War were not always as revolutionary or as exciting as those of 1907–14, many official artists appointed during 1939–45 developed or created new dialects from their personal exposure to evolving European abstraction in order to suggest experiences on land, sea and in the air that were infinitely more universal for Britons everywhere, than they had been during the Great War. As in 1916–19, there were as many figurative artists working between 1939 and 1945 as there were experimental artists and their achievements were just as telling. The difference this time was that many hundreds of artists were commissioned, often to do very specific jobs. The Army claimed Anthony Gross and Edward Bawden; the Royal Navy, Ravilious and the remarkable John Worsley; the RAF, Paul Nash, Keith Henderson and a host of others. Great art abounds within the outcomes of this visual war effort. In quantity, the results hugely exceeded those of the Great War schemes, and in their quality many participating artists equalled the clout of their predecessors, whatever their stylistic differences... and the most austere, ascetic abstraction was not acceptable to authority. So farewell then, Ben Nicholson, at least for the duration. Once again, younger artists, such as Graham Sutherland, Henry Moore, John Piper, Ethel Gabain, Barnett Freedman, Evelyn Dunbar, made strong visual impacts, with older artists still in the frame: Muirhead Bone, Paul Nash, David Bomberg are but three of these. Again, works were toured on exhibition, and new cultural foundations laid

244 cont. the Impressionist circle from the continuum of development. Until recently the French did not concern themselves with such distinctions, although they too recognised Cézanne's importance.

245. See, amongst others, Malvern, Sue, *Modern Art, Britain and the Great War*, London and New Haven: Yale University Press, 2004

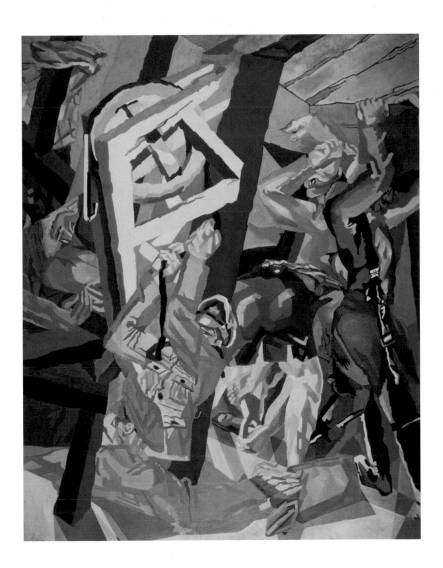

David Bomberg

Study for 'Sappers at Work: A Canadian
Tunnelling Company, Hill 60, St Eloi'
c1918–19
oil on canvas
304 x 249 cms
© Tate, London 2006

The first version of Bomberg's First
World War magnum opus, rejected by
the Canadian government for its cubist
overtones

for post-war Britain in the process;[246] film and photography played major roles in establishing the importance of visual record in every medium.[247] Also, in 1939–45, officialdom used a wealth of talent to cover not only the Service arms but some very specific subjects and situations, from tin mining to the Womens' Land Army. Moreover, 'happy accidents' (such as the failure to recall Carel Weight from war artist service in post-war Europe) and the sharp-eyed observation of artists in the field from Bow, to Belsen, to the South Pacific led to some extraordinary results, as image and record, in every combat area, and on the Home Front. One-off works or series could command equal attention, and did.

The same is also true not only of the many works officially commissioned only yesterday from contemporary practitioners in different media, from Denis Masi to Langlands and Bell, but also many others who have testified in other ways. It's one thing, however, to offer an officially approved version of a war, and it's fine if the public subscribes to that viewpoint, but what about the dead? And what happens when questions are raised about the very morality of participation in military activity?

In the middle of the First World War, Dada, the pan-European anti-art movement, attempted to subvert establishment smugness and comfort from the relative safety of Switzerland, and those lessons were well learned by all who wished to stand against institutional warfare from that time on. In Britain, the unusual situation exists in which, on one hand official patronage continues to support artistic activity where British troops are embattled; and on the other, visual pressure groups attempt to subvert official viewpoints. One of the best and most concerted attempts took place during the Falklands War of 1982, when a hitherto unknown organisation called Leeds Postcards despatched manila envelopes to arts administrators everywhere, containing a series of wildly satirical postcards whose purpose was to ridicule Margaret Thatcher's war effort. As much up-to-date photomontage as anything else, these postcards were collectors' items: it was folly to commit them to the bright red deep of the Royal Mail when one knew that they could achieve nothing, and yet, of course, they stood for protest, and so – it is hoped – this is the way they will stand for posterity. In that situation, in which, had they known it, the public were participating in a retro-chic version of 1914 (new phraseology, just as 'need to

246. The embryonic Arts Council (in all its shapes and sizes) was created during the Second World War, as CEMA: the Council for the Encouragement of Music and the Arts, to be granted a full charter in 1946.

247. The Second World War was recorded by some of the greatest of British and American photographers, including George Roger, Bert Hardy, Lee Miller and Robert Capa, and the British art was the subject of *Out of Chaos*, an unusual, unwittingly amusing, but well-argued film (dir. Jill Craigie, 1944) devoted to the promotion of war art of all types, and to the defence of more abstract tendencies.

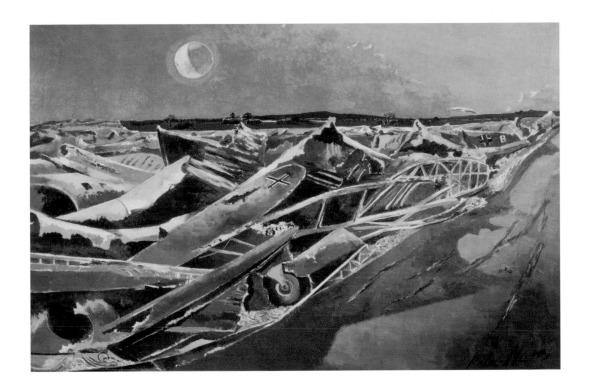

Paul Nash
Totes Meer (Dead Sea), 1940–41
oil on canvas
102 x 152 cms
© Tate, London 2006

Nash set great store in propaganda,
and this painting was intended – and
understood – as a jibe at Nazi Germany

Leeds Postcards
Unknown author/s 1982
10 x 15 cms

Subversive anti-Falklands postcards
distributed at the onset of the Falklands
War in 1982

Leeds Postcards
Unknown author/s 1982
10 x 15 cms

Linda Kitson
Six hundred men a day go through
'Heli -training', 11th May 1982
conté crayon on paper
36 x 51 cms
© The Imperial War Museum,
London, UK

The 1982 Falklands campaign resulted
in the commissioning of Linda Kitson as
the official artist: it was not an easy job,
and the media did not understand what
the expectations were. Where were the
big paintings?

know' took the place of 'secrecy'), even war art looked again to drawing to record events. The artist in question, Linda Kitson, was an illustrator, like many of her predecessors nearly 60 years beforehand. The task proved to be beyond her capabilities, but she was the government's official recorder in the South Atlantic, and Leeds Postcards stood no chance against the rush to publish her works, coupled with the inevitable Thatcherite spin.[248]

Mercifully, in war, the public does not always get what it wants, and the job of a war artist is often utterly confounded by the intrusion of reality. It was hard enough even in 1918, when Professor Henry Tonks, scourge of the Slade, wrote to his friend Robert Ross about his experiences at the Western Front, as a commissioned war artist with a very specific project: '...whatever manner I select of giving expression to these ideas I shall wish I had chosen another.... I seem to have no power of expression.'[249] He was one among many, and his despairing remark is worth committing to memory.

Ah, memory. That most selective of human attributes. The need to document the details of their Great War for the future did not escape the first commissioners of British official war art back in 1916, as they framed the benchmark agreement that would govern Muirhead Bone's employment, and all that followed. What they could not foretell was the ghastly outcome of the conflict: the compound of grief and loss suffered by individuals, families, communities and entire states, and the desperate, often clinging, need to reflect upon some artefact larger than a memento in order to commune with Death. Rolls of Honour were sometimes not quite enough.

Commemorative monuments bear a certain *je ne sais quoi*: the Romans left us some exemplary material at various locations to remind us of the many nationalities who served with their legions in Britannia, and which are touching and pathetic in turn. But forget the Roman Empire; and forget later imitators in France and Germany: in the twentieth century Britons made some of the very best war memorials in existence, public and private, and they confound us to this day, intentionally or not. Sir Edwin Lutyens's London Cenotaph is arguably the best known, but out of hours its power is dissipated. And what of its inscription, *The Glorious Dead*? Surmounted by its life-size stone howitzer, CS Jagger's Royal Artillery Memorial at Hyde Park

248. See Kitson, Linda, *The Falklands War: A Visual Diary by Linda Kitson, the Official Artist,* Mitchell Beazley and the Imperial War Museum, London, 1982. Linda Kitson unwittingly contributed to as powerful a wave of xenophobic jingoism as ever swept the shores of the UK. Her work is best compared to that by Muirhead Bone, whom she does not echo stylistically, but rather in her determination to extract some truths from situations whose desperate realities she quite clearly understood. In many ways Kitson became one of his truest legatees.

249. Quoted by Forge, Andrew in 'The Slade 1071–1900', *The Studio Magazine,* 1960.

Anthony Gross, CBE RA

Chins at War: Village Headman & Family
in Ceremonial Dress at Angami Nagos,
near Kohima, 1943
ink, wash on paper
38 x 55 cms
© The Imperial War Museum,
London, U K

Gross's official career as an official war
artist took him all over the globe, and
into some unusual and very unwarlike
situations

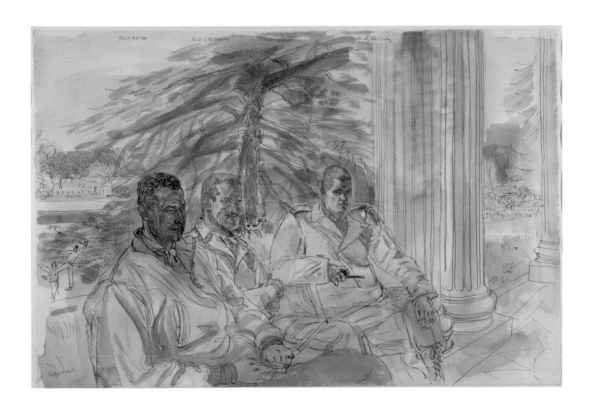

Anthony Gross, CBE RA

1st United States Infantry Division:
Lt-Colonel RH York; Lt-Colonel CT Horner;
Lt-Colonel JT Corley, 1944
ink, wash on paper
38 x 57 cms
The Imperial War Museum, London, U.K
© Crown Copyright

Gross executed hundreds of water-
colour drawings during the Second
World War, recording nearly every
battle-front. This one dates from the
period before D-Day, 1944

Corner is surely one of the finest monuments extant anywhere in modern times, but its author has works of lesser grandeur but of equal note in other British locations. And these are just some of the better known. Every village, town and city in Britain has its memorials, ranging from grossness to greatness: in Edinburgh, for example, reliefs by Alice and Morris Meredith Williams, and by Alexander Carrick for the Scottish National War Memorial are outstanding. In high streets, crossroads and at village greens throughout the British Isles, monuments stand to the dead of two world wars, and to those who have died all too recently.

It would be Lutyens, the architect of Imperial India, who would lead the way in the effort to commit the British dead of the Great War to some hallowed memory, and it is bizarrely appropriate that this architect, whose work and professional reputation are so often linked with that of Gertrude Jekyll (1843–1932), one of Britain's greatest garden designers, should have been so involved in the orderly planning of war cemeteries: gardens of rest, throughout the world, that created a symmetry in death where utter and life-shattering chaos had earlier occurred. The emotional simplicity of Lutyens' Great War cemetery designs was maintained even after the Second World War, and long after *that*, other artists made equally personal and potent monuments to the dead, and to the experience of the living. Two extreme examples were executed by Michael Sandle and Maurice Blik. Sandle's gigantic *Malta Siege Bell Memorial* (1988–92) is a tribute to that island's stand against the German-Italian Axis during the Second World War, a logical outcome of an almost neo-classical absorption in the fall of empires that has permeated his work for years, and a monument that essentially echoes the concept and spirit of Jagger's Royal Artillery Memorial. By contrast, Blik's large maquette is born of personal experience. His flying figure, contorting, thrusting and sweeping itself into the air, is a leap of true faith: a commemoration of the Holocaust, aspiring spiritually and physically to deny any recurrence of the events of 1933–45.

Works such as these are evidence that art and war can go hand in hand. The recent steady politicisation of art has seen off the prospect of latter-day jingoism, and it falls to the artist to demonstrate that art can have a place in documentation and at the same time, be a worthy vehicle of commemoration. When Professor Tonks wrote home from the Western Front in 1918 'I have seen enough to last a lifetime' he probably had. It did not mean that he would ever forget it.

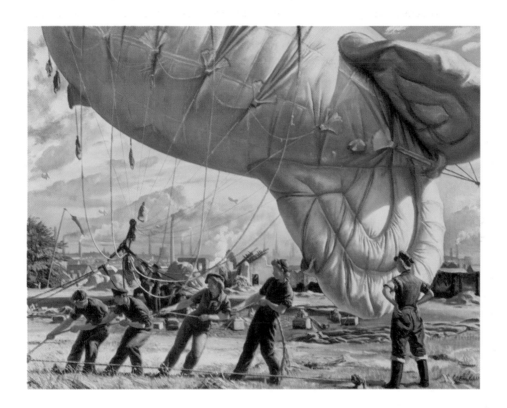

Dame Laura Knight, RA
A Balloon Site, Coventry, 1943
oil on canvas
103 x 127 cms
The Imperial War Museum, London, UK
© Crown Copyright

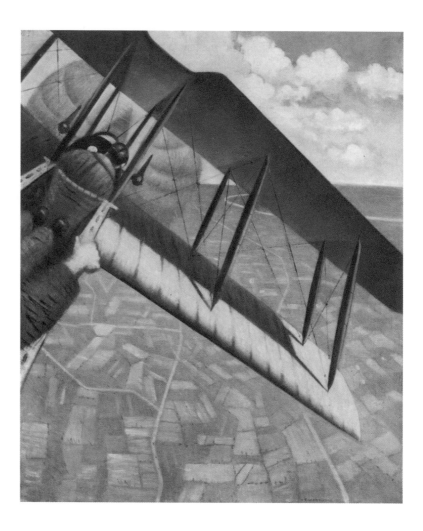

CRW Nevinson
Banking, 1918
Chromo-lithograph
19 x 15.5cms
Private collection

The knuckles are Nevinson's: even a Futurist can be afraid when enduring the most visceral of all futuristic sensations. Nevinson's aeroplane ride was first depicted in 1917 in monochrome, for an officially-commissioned series of lithographs of aerial subjects, but this image was the frontispiece of a 1918 book about his work.

16
Showing Off: Making Waves

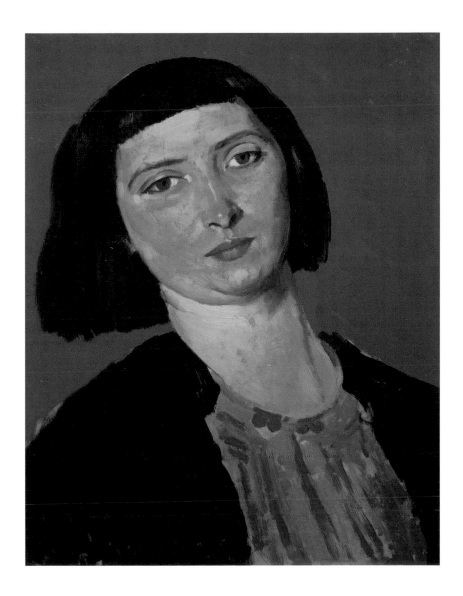

Augustus John, OM

Portrait of a Woman, 1911
oil on wood
40.6 x 32.4 cms
Courtesy of the Artist's estate © The Tate
Gallery

John was one of the twentieth century's
first originals, and just about as non-
conformist an artist as anyone might
find anywhere… a concept the public
began to find attractive

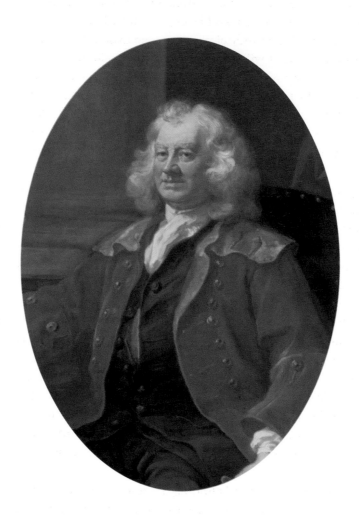

William Hogarth
Portrait of Captain Coram (c.1668-1751), 1740 (detail)
oil on canvas
239 x 148 cms
Coram Family in the care of the Foundling Museum, London © The Bridgeman Art Library

A little cash does help. Coram played godfather to British art patronage: others followed, opening eyes, changing tastes, causing trouble and generally continuing the business of sustaining a true and unfolding sense of Britain's artistic worth and importance, right up to the present. With luck and still more money, the process will continue.

From the very start, Patronage led the way in British art. Yes, a Royal 'By Appointment' sticker always helped to advance a reputation, and there were many who benefited enormously from those over time, from major court painters such as Holbein, to the almost forgotten Sir Gerald Kelly.[250] But whilst association with the Crown will usually guarantee a flurry of interest in an artist, it won't always ensure the sort of public exposure that will keep you in the spotlight, or support your cash-flow. *That's* to be gained from the type of touch-and-go patronage most associated with the art market of the later twentieth century, and in essence it hasn't changed since the eighteenth century: trading has always featured strongly in Taste-making, but whether such practice is wholly ethical in today's aesthetic bear-pit is now an issue capable of generating a rash of breast-beating among participants.

Be that as it may, the best-known example of early, sustained patronage in British art occurred in London, where Thomas Coram, retired sea-Captain, established The Foundling Hospital in London in 1740.[251] As we have seen, Coram was already a friend and patron of William Hogarth, who saw... well, he saw *something,* and as an artist with a developed sense of commerce, Hogarth took his patron into his confidence. Responding to Hogarth's suggestions,[252] Coram bought early works by younger British artists, among them Gainsborough and Richard Wilson, to decorate the hospital buildings, and encouraged the public to visit, in return for a small entrance fee. The hospital, a very worthy charitable institution, would receive a percentage of all takings, artists gained attention and became better connected, and the great and the would-be-good who visited did their Christian duty and went away happy. An embryonic national gallery it may have been... and that was all. Hogarth's fight was for a British art free of excessive continental influence: an untenable position in today's terms. And what public would want to view pictures on that basis alone? There's more than one answer to that one today.

As an informal exhibition space, the Foundling Hospital was one of the best show-cases in town but, in any chronology charting the growth of Taste and visual awareness in Britain, its place in the thinking that led to the foundation of the Royal Academy of Art in 1768 is significant. It has never been easy for artists to find and keep buyers: Taste sees to that. In two-and-a-half centuries, strutting one's stuff before the public gaze... in fact, just *telling* the public that you intend to strut... has

250. Sir Gerald Festus Kelly, PRS RHA HRSA KCVO was probably the most important painter of portraits in the academic manner of the mid-twentieth century. There is still nothing wrong with his work. It has simply fallen from fashion, and he can do nothing about that from the Great Studio in the Sky.

251. Coram was remarkable by any standards, in any time, as a caring individual: he started The Foundling Hospital to care for sick and needy children among the London poor.

252. 'Suggestions' may not convey the forcefulness of his feelings.

always been the hardest task of all for any tyro, author or pamphleteer, old or young. Nowadays we call it 'finding a market'. How very common.

Nowadays, *looking* at art has never been easier, the result of a combination of idealism, money, *nous* and 'spin'. No change there, then. Nonetheless, while dealers still talk-up their artists like fairground barkers, often with good reason, it remains best to stay off the rides in order to gain a clearer picture of commercial reality. And despite the centrality of London, you'd have to be nuts or blind or both to believe that artistic excellence resides solely in the capital, or that only dross is available outside it. Indeed, at the bottom end of the scale, regional and local artistic activity is now increasingly fundamental to personal, visual growth: your own backyard is once more becoming the place in which younger generations take their first steps towards visual creativity, for reasons that are demographic, economic and counter-cultural.[253]

Britain's position in post-millennial art is the result of the impact of visual activities that could only have occurred through the medium of exhibitions: not once, but many times. Only thus could the so-called British School have absorbed modern European art, together with the post-war plethora of incoming trends that followed. No amount of higgledy-piggledy nineteenth-century foreign travel and visual curiosity on the part of a few determined individuals could have achieved such results. The expansion of the art trade in late-Victorian Britain was a cultural phenomenon that went hand-in-hand with what are nowadays called 'public sector developments': the provision of public galleries for the edification and education of all, in most of Britain's major cities and towns, between the 1860s and 1890s,[254] sometimes absorbing the often-rich collections of members of the county squirearchy. In the same period, the National Gallery underwent major expansion at Trafalgar Square in 1864, and the Tate Gallery[255] was opened on Millbank in 1897, as the national gallery of British art. But these events reflect neither the extent of upheavals nor the bitter acrimony of in-fighting beginning to affect British art at its roots; they don't suggest the important, if short-lived, impact of French realist influence via Newlyn after 1880, and the increase in commercially exhibited Impressionist painting between 1883 and 1905,[256] and they certainly don't immediately point to the slow, steady and increasingly vital use of newspapers and

253. A fact-finding visit to many vocational Art & Design courses will substantiate this claim.

254. See Fuller, Peter, 'Fine Arts', in Ford, Boris, (ed.) *The Cambridge Cultural History of Britain Volume 7: Victorian Britain*, Cambridge: Cambridge University Press, 1992, pp. 162–207 for a useful survey of this period.

255. Now Tate Britain.

256. See Flint, Kate (1984), *Impressionists in England: The Critical Reception*, RKP: there was one.

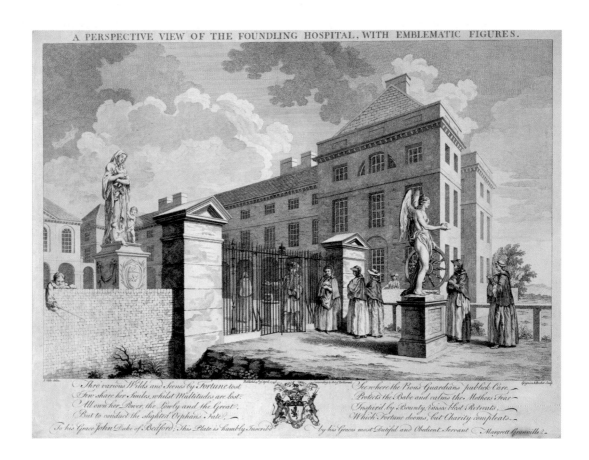

A PERSPECTIVE VIEW OF THE FOUNDLING HOSPITAL, WITH EMBLEMATIC FIGURES.

The Foundling Hospital: without it the
Saatchi Collection would have been
nothing

illustrated magazines by artists, critics, pundits and pamphleteers of every type to develop art-related polemic. Today's wealth of magazine titles covers a swathe of international visual activity of every type.[257] It is worth comment that by the very early twentieth century, Britons were able to subscribe to regular publications such as *The Burlington Magazine, The Magazine of Art, The Studio* or (slightly later) *Colour,* which together gave expansive coverage to art's wide-open spaces; as for the newspapers and magazines of the day, their interest in a good story ensured that British art's more important or flamboyant figures remained in the public domain. Does that sound familiar? A change of the guard was being signalled, however, if only by semaphore, and by 1910, High Victorian perceptions of the successful British artist (almost always an academician) as a kind of cultural patrician, and of the Royal Academy as the centrifugal force controlling British art, were not just all at sea, but making heavy weather.

The RA had never exercised any real thought-control over all that passed for British art, however tightly knit its membership may have seemed during its history,[258] but clear differences were becoming evident. At one extreme were those who had merely decided to exercise independence, and at the other, artists who actively sought to embody in their work that new twentieth-century phrase, the *avant-garde.*

All Change

Early twentieth-century non-juried exhibitions in London blew the biggest holes in public expectations. They quickly established the value (even if muddled) of the 'blockbuster' exhibition, and with that the possibility of *succés de scandale*; also the reality of a fast-growing, private gallery market in Britain, with dealers who represented specific types of indigenous work, or work by specific individuals; and, finally, the value of the *cause célèbre,*[259] often in the form of work from Europe. Before 1914, London hosted two International Society (IS) shows a year,[260] two juried exhibitions from the RA, and, from 1908, the Allied Artists Association (AAA) included many future 'names' from Britain and the continent. For most artists, the business of making meaningful art in their own times lay at the heart of their endeavour, and in context it needs to be understood that, in those days, to be contemporary *and* British necessitated a real awareness of continental developments, and wasn't a risk

257. Without prejudice, here are a few: *Art Review, The Art Newspaper, Art Monthly, Contemporary, The Jackdaw,* not to mention various 'house' magazines, such as *Tate Magazine* or *RA Magazine,* and so on.

258. See, for example, Leslie, George Dunlop, RA, *The Inner Life of the Royal Academy,* London: John Murray, 1914.

259. That's the achievement of swift (and probably deserved) notoriety in matters artistic, mate. Think Surrealism, Tate Bricks, or, if those are too tame, think

Mona Hatoum's endoscopy or Tracy Emin's unmade bed. Ah… you've got the point.

260. The International Society of Painters, Gravers and Etchers held its first show in 1898.

to be taken lightly in an art market harnessed to tradition. More recent applications of hindsight and cultural studies to past events have imbued works with characteristics that take them, or some of their components, in directions other than those originally conceived by their authors.[261] Nevertheless, by 1910, as academic painting continued to occupy the mainstream, a few inquisitive spirits in London, Glasgow and Edinburgh had either made direct contact with representatives of modern European art, or were absorbed by the impact of Roger Fry's 'Manet and the Post-Impressionists' exhibition of the same year,[262] and the ensuing critical lashing meted out by some critics of that show to the living and the dead. Fry and Clive Bell were delighted to defend Cézanne, Gauguin and van Gogh, Matisse, Derain, Picasso and others against such detractors: to the unsuspecting, or to those who went to the exhibition for a good laugh, it wasn't that they were foreign, but that their ideas, their process, their colours, their techniques (*what techniques,* for heaven's sake?) were intellectually pidgin. The arrival in London shortly afterwards of FT Marinetti, Futurism's high priest and chief evangelist, seems, oddly, to have caused less upset. Marinetti was noisy and, after all… *entertaining.*[263] The very integrity of Fry and Bell transformed them into a menace to some, and even art students at the Slade School were advised to avoid anything resembling Post-Impressionist fall-out. Paul Nash famously recorded that '…Eventually, Tonks[264] made one of his speeches, and appealed, in so many words, to our sporting instincts. He could not, he pointed out, prevent our visiting the Grafton Galleries; he could only warn us and say how very much better pleased he would be if we did not risk contamination but stayed away.'[265] According to Nash, he couldn't care less either way. It wouldn't happen today.

The period 1910–14 firmly established exhibitions, a good press, and stimulating and intelligible catalogue texts as integral to the business of keeping art in the public consciousness. Without them, neither modernism nor straightforward representational (or even semi-abstract) painting would have been able to stand against one another, for this was the era in which art dealing really took off, and 'Art for Art's Sake' and 'I Know What I Like' began to take adversarial positions within the marketplace. That position hasn't altered to this day, but it has undoubtedly been neglected. Then, comment combined with patronage of different types in support of art made for public consumption. The British government's Official War Artist schemes

261. See Tickner, Lisa, *Modern Life and Modern Subject: British Art in the Early Twentieth Century,* Yale, 2000 for a splendid and thorough exposition of the key directions in art in this period.

262. Held at the Grafton Galleries, London.

263. The visual and conceptual languages of Futurism are among the most unusual and important survivors of this period, and were to be adapted by many British artists. At the time, however, the movement gained only one long-term adherent: CRW Nevinson.

264. Henry Tonks, Slade Professor, was probably the finest drawing master anywhere in Britain during the period 1909–29.

265. Nash, Paul, *Outline,* London: Faber & Faber, 1949, pp. 92–93.

of 1916–20 were propagandist, but employed the services of a wide range of British artists of all ages, and at different stages of accomplishment. Some 1,000 works were exhibited in London in 1919–20, and divided the critics yet again: it was as if they had expected the war to have put paid to all continental influence. No chance. The War Artist Schemes almost certainly contributed to the growth of the 'boom and bust' market for contemporary British prints, which reached its climax in the 1920s, and at the other, more populist, extreme, the direction of London Transport by Frank Pick (1878–1941) exposed Underground travellers to a wealth of excellent graphic design and illustration, augmented by what were very often 'high art' images and subjects, in poster format, by younger artists, whose visual advocacy of the delights of cross-town traffic remain period pieces: it's easy to see how Pick's interest in transforming the Underground stations into 'a people's picture gallery' bore fruit.[266] Other railway companies followed suit: printmaking was never healthier in Britain than in the inter-war period, and screen-printing and the offset lithographic process enjoyed some halcyon days.[267] The audience for most of this material may not always have recognised the fact that the visual languages used frequently referenced incoming stimuli that ranged from Japanese prints through Cubism and Futurism, to Surrealism. The popular print isn't dead by a long shot: printmaking proved enormously important in touring exhibition initiatives by the Arts Council during the later twentieth century, and is still one of the cheapest ways of starting a personal collection.

A Word to the Wise

The 1930s saw a marked increase in the number of modern British artists going into print. Using personal contact with the foreign artists they most admired to inform their written ideas, their texts haven't always made for easy or clear reading, but the interdependence between text and image in this period is an especially important feature in the development of British art, not only at the time, but for the future, shaping ideas and meaning. One of the most important reasons for this was the wealth of opportunity for cross-fertilisation, between art and design, throughout much of Northern Europe before 1939; another was the altogether different importance placed on writing by all who were drawn to Surrealism. The best British artists adopted their own positions in relation to the available abstract languages

266. See Green, Oliver, *Underground Art: London Transport Posters, 1908 to the Present Day*, Laurence King, London, 2001.

267. You don't have to be an Anorak to enjoy the wonderful colours of London and North Eastern Railway posters: sheer class. Warhol? Forget him!

The Victorian surroundings of
Worcester Art Gallery: an undated pho-
tograph offers clear evidence of French
influence on the curatorial taste of
Elgar's county town

and the unusually compelling possibilities of what is now known as the 'International style': a distilled and much-altered form of Bauhaus-Deco, without any of the crippling clumsiness that the concept implies, but way too comfortable for the champions of International Surrealism. Until the arrival of the Surrealists in London for their notoriously ill-received exhibition in 1936, the modern movement in Britain had been divided between those who pursued total abstraction and those who did not, and, away from the internal dissent that characterised the 7 & 5 Society, its adherents, and those in its orbit, the most important event of the inter-war years was the mini-migration of Mondrian, Moholy-Nagy, Gabo and Kokoschka to Britain from Europe in 1931. It established Constructivist non-figurative work, and elements of Expressionism, as viable practices in Britain, and although its theories were austere (to say the least) such practice survived until well into the 1950s in the fields of sculpture and architecture, well supported with texts.

You're Putting Me On

Much has changed: the experience of the Second World War created more artists, more visual experimentation, a vast range of expression, and a resulting need to display and promote modern visual languages and idioms to a wider public.[268] Public expectations had grown as a result of exhibition tours organised by the wartime Council for the Encouragement of Music and the Arts (CEMA), which became the Arts Council of Great Britain (ACGB) in 1946. For some 20 years, the ACGB organised many important London exhibitions from which visually interested Britons could ground their ideas, and reassess the impact of older British figures such as Bomberg, in the face of major differences of approach and opinion among the younger artists then beginning to establish themselves from out-of-London centres such as Birmingham, Glasgow, Corsham and Sheffield: the Bacons, Butlers, Davies, Hamiltons, Paolozzis and del Renzios, Willings, Smiths and Middleditches, and hundreds of others, all clamouring for space. At the same time, an ACGB touring exhibitions network began to provide a tiered series of different-sized travelling packages of modern art to venues that might not have the physical or financial resources to stage their own home-grown activities.

The impact and importance of those ACGB tours[269] cannot be underestimated: at

268. As already noted, Jill Craigie's film *Out of Chaos* was an unusual moment in the documentation of British art. It recognised that periods of conflict might result in truly profuse imagery derived from an equally wide range of sources, representational, surreal or abstract. The film promotes the acceptability of all of these, and remains a provocative statement, given the moment of its creation: before the end of the Second World War in Europe.

269. The V & A also had an excellent touring department, widely used by many museums and art galleries, from which funding was gradually withdrawn in the late 1970s – a portent of things to come.

their best, they remain one of the finest achievements in the history of what has increasingly become 'State Art'. The exhibitions were often organised by younger art historians or museum professionals with rising reputations,[270] keen to put serious material, simultaneously educative and influential, before open-minded audiences, and their example prompted similar practice amongst emergent museum and gallery networks eager for recognition. It couldn't last, and it didn't. By the mid-1960s the ACGB was compelled to recognise the increasing diversity in British art at national and local levels, including growing contributions made to local visual activities by immigrant social groups in the North of England and the West Midlands. In 1965 the government proposed the creation of Regional Arts Associations, and these formed steadily after 1967, the year in which the advisory committees responsible for activities in Scotland, Wales and Northern Ireland were created national Arts Councils in their own right. Each panel was intended to encourage clients and to act as intermediaries for the disbursement of funds for worthy causes. It was a great way to create inter-regional and inter-institutional friction, and no matter what anyone tells you, it did. What went wrong? It depends whom you ask.

After 1945, the visual world grew to an extent that no one could have foreseen in 1910. While, on the whole, British artists were generally liberal in their responses to strong, new, incoming visual initiatives from the USA and Europe, the fall-out has been exceedingly mixed, and indigenous Brits were less than welcoming to Black artists arriving from the Caribbean. Simultaneously, the British art scene has fragmented to an extraordinary degree, partly owing to the excessive ebullience of early post-war practitioners, whose aggressive stances in some cases caused divisions out of keeping with the real intentions and effects of their work. The signal moments of the 1950s are frequently rehearsed, and include the 1956 exhibition 'This is Tomorrow' by the Independent Group, which pre-empted American Pop by some three years; the 1959 exhibition 'New American Painting' at the Tate, where the New York School reached a wider public for the first time; the arrival of American Pop in the early 1960s, and the successive arrivals of Minimalism, of the post-modern, of Conceptual and neo-Conceptual activity that afflicted so much from 1960 on. More troubling, however, were the printed manifestos and apologia of varying descriptions and levels of ability that accompanied Minimalism and much

270. At this time the ACGB and British Council could call on the services of the young Norbert Lynton, Alan Bowness and many others.

344 Conceptual art. The wheat arrived with the chaff, and the sheep with the goats. Yes, there was some interesting and provocative material, but there was also too much meaningless piffle. Little that was worthless was condemned: moderation and evaluation of work and texts were almost non-existent, and once it became clear to observers that arts funding might be available for meaningless and insubstantial enterprises that at face value offered a glimmer of visual progression, anyone with an eye to the main chance seized the opportunity to make some form of capital. A fleet of bandwagons had arrived at the gateway to British art, and there were many who hitched long rides. The Arts Council was a willing party to such 'cutting edge' pursuits, adversarial to those who chose to argue the toss, and energetically supported their chosen clients with the new language of discourse, a terminology capable of rendering simplicity incomprehensible at a stroke.[271] And remember: this was all available for public consumption.

This is Tomorrow

Similar gimcrack activity has continued in British art, overseen by the Arts Council, ably supported by the British government's Department of Culture, Media and Sport, and since the 1990s a marked change has been apparent among those who would sincerely enhance their own visual creativity. The acquisition of what passes for cultural intelligence is now, too often, superficial: a quick-firing, ephemeral, Toad-of-Toad-Hall approach to visual understanding. What do we want? We dunno, but we want it NOW. Such tobogganing values have had important repercussions on the ways in which Art is perceived worldwide. Two centuries separate the Foundling Hospital from the present, and yes, the Royal Academy remains, but in Britain, where response to art is notoriously fickle, the situation is critical. With sharp imagery on the Internet, or on the high street, together with all manner of other enactments, who needs galleries? Why bother with what some see as intimidating, socially exclusive atmospheres and values when one may choose between a virtual Mall, or website, and 'the real thing'. And why hang out with others to exchange ideas when you can e-mail them? The world is your own personal oyster? Bless!

At the so-called 'top end', the art gallery prevails, but only just. What's happening, man? One of British art's current problems is that, as a self-perpetuating organism

271. A glance at the lists of Arts Council exhibitions arranged during the later 1970s and early 1980s will confirm this, as will the hilarious press reportage and voluminous correspondence surrounding the notorious 'Tate Bricks' (Carl Andre's *Equivalent VII*). Land Art and much else of a conceptual nature are equally profitable subjects for dispiriting research.

The Tate Gallery: money from the famous sugar daddy ensured that British art finally had a place to call its own, though it took the best part of a century to break away from the National Gallery, and much else beside.

346

of many parts, it is presently and manifestly failing to sustain the absolute requirement for literacy that has forever been at its core. Since the Enlightenment, all Western art has acquired an importance far greater than many twenty-first-century viewers might care to agree. For many, The Word has been established as Conceptual subject matter for years, but when it isn't playing mind-games, it needs to work hard to support visual material, some of it vitiated, for which explanatory verbiage is vital in nearly every case: narrative, subtext or criticism, active or passive, suggestion, clarification, position, defence, objection, promotion and discussion. Art has never been stand-alone, period. Art cannot simply Be. Today, at least three decades of inexpert English language teaching within the English[272] educational system have resulted in the inability of at least two generations of would-be artists, makers, movers and shakers to articulate their own ideas, either in response to others, or to clearly express themselves without, like, vague gestures. Overall, one major effect has been that *less* meaningful art has been created with or without coherent explanation, and *more* has resulted from spin, hype and the misplaced attentions of charlatans who pose as art traders and artists, but whose real activities are rather more alchemical: the transformation of dross into lucre. You want proof? Examine the efforts of their agents and dealers,[273] and consider their value. That was quick. Now look at the input of some of their twentieth-century forebears, perhaps even later ones such as Steven Campbell and Adrian Wiszniewski, or earlier ones such as Patrick Heron,[274] RB Kitaj, the honorary Brit, or – another one – Paula Rego, who understood this problem with greater clarity, and recognised the need for intelligence and literacy in making friends and influencing people, or at least setting them straight. In the evolution of British art, word and image are bound together: they always have been, and always will be. Wave your hands and object if you will. Money can't buy you love, and it won't buy understanding either. Throw it around all you want, but as they say in the classics, *caveat emptor.*

And British art? It will continue to be governed by prevailing winds, by the light in the sky and the passing seasons; by romance; and by the political, personal and, increasingly, ecological, strictly elemental, concerns of its authors. British art need not be nationalistic to survive, but it might just help; it need not speak solely of the spiritual or geographical place of its origin, but whatever that origin, and wherever it may be, it will remain vibrant only if its artists and audience eschew the mediocrity of spirit, intellect and activity that are too much a part of its make-up at the present time.

272. The Welsh, Scots and Irish are welcome to wear the same cap if it fits.

273. No names, no pack drill, and no prizes for guessing. There's a lot of it about.

274. See, amongst other works, Heron, Patrick, *Painter as Critic: Patrick Heron: Selected Writings*, Gooding, Mel (ed.), London: Tate Publishing, 1998.

The Royal Academy: final resting place
of the Academy, its Piccadilly home has
come to represent all things to all men.
For Joe Public it represents the art
establishment of all art establishments.

Bibliography

Alley, Ronald
Graham Sutherland,
exh. cat., London: Tate Gallery, 1982.

Allison, Jane with Hoole, John
Stanley Spencer: The Apotheosis of Love,
exh. cat., London: Barbican Art Gallery,
1991.

Araeen, Rasheed
(ed.), London: *Third Text Magazine,*
1985.

Arnold, Bruce
A Concise History of Irish Art,
London: Thames and Hudson, 1969
onwards.

Anderson, Gail-Nina and Wright, Joanne
*Heaven on Earth: The Religion of Beauty in
Late Victorian Art,* Nottingham: University
of Nottingham, Djanogly Art Gallery, 1994.

Auty, Giles
The Art of Self-Deception,
Bedford: Libertarian Books, 1977.

Ayrton, Michael
British Drawings,
London: Collins, 1946.

Bindman, David
Hogarth and his Times,
London: British Museum Press, 1997.

Campbell, Ken
*The Maker's Hand: Twenty books by Ken
Campbell,*
London: Ken Campbell, 2001.

Carrell, Christopher, and others
*Josef Herman, Memory of Memories:
the Glasgow Drawings 1940–43,*

exh. cat., Glasgow: Third Eye Centre,
1985.

Causey, Andrew
Sculpture Since 1945,
Oxford: Oxford University Press, 1998.

Cooper, John
National Portrait Gallery: A Visitor's Guide,
London: National Portrait Gallery, 2001.

Cordingly, David
Painters of the Sea,
exh. cat., London: Lund Humphries, 1979.

Cullen, Fintan
The Irish Face: Redefining the Irish Portrait,
London: National Portrait Gallery, 2004.

Curtis, Penelope
Modern British Sculpture,
Liverpool: Tate Gallery, 1988.

Curtis, Penelope
Sculpture 1900–1945,
OUP, 1999 Oxford.

Dakers, Caroline
*The Holland Park Circle: Artists and
Victorian Society,*
London and New Haven: Yale University
Press, 1999.

Fuller, Peter
Images of God,
London: Chatto & Windus, 1985.

Garlake, Margaret
Peter Lanyon,
London: Tate Gallery Publishing, 1998.

Garton, Robin (ed.)
British Printmakers 1855–1955: A Century

*of Printmaking from the Etching Revival to
St Ives,*
Hampshire: Garton & Co with Scolar
Press, 1992.

Gibbon Williams, Andrew,
William Roberts, an English Cubist,
Ashgate, 2005.

Gilmour, Pat
Artists at Curwen.
exh. cat., London: Tate Gallery, 1977.

Godfrey, Tony
*Drawing Today: Draughtsmen in the
Eighties,*
Oxford: Phaidon, 1990.

Gooding, Mel
Ceri Richards,
Cameron & Hollis, Moffat, 2002.

Grieve, Alastair
*Constructed Abstract Art in England:
A Neglected Avant-garde,*
London and New Haven: Yale University
Press, 2005.

Grose, I
Jewish Artists of Great Britain 1845–1945,
exh. cat., London: Belgrave Gallery, 1978.

Hamilton, James
Turner: The Late Seascapes,
New Haven and London: Yale University
Press, with Sterling & Francine Clark Art
Institute, 2003.

Harrison, Martin
*Transition: The London Art Scene in the
Fifties,*
London: Merrell, in association with
Barbican Art, 2002.

Harrison, Michael et al.,
Carving Mountains: Modern Stone Sculpture in England, 1907–37,
Cambridge: Kettle's Yard, 1998.

Hartley, Keith
'From Blast to Pop', intro. essay in exh. cat of the same name,
Chicago: David & Alfred Smart Museum of Art, University of Chicago, 1997.

Hercombe, Sue
What the Hell Do We Want an Artist Here For?,
London: Calouste Gulbenkian Foundation, 1986.

Ingleby, Richard and Gale, Matthew
Two Painters: Works by Alfred Wallis and James Dixon,
London: Merrell Holberton with Tate St Ives, 1999.

Jones, Merlin
David Jones 1895–1974: A Map of the Artist's Mind,
London: Lund Humphries, 1995.

Kitaj, RB
(intro) *The Human Clay*, exh. cat.,
London: Arts Council of Great Britain, Hayward Gallery, 1976.

Lambert, Susan
Prints: Art & Techniques,
London: Victoria & Albert Museum, 2001.

Lanyon, Andrew
Peter Lanyon,
privately published edition of 500.
St Ives, 1990.

MacCarthy, Fiona
Stanley Spencer: A English Vision,

New Haven and London: Yale University Press, 1997.

Macdonald, Murdo
Scottish Art,
London & New York: Thames & Hudson, 2000.

Macdonald, Stuart
The History and Philosophy of Art Education
London: University of London Press, 1970 (paperback repr. 2004).

Macmillan, Duncan
Scottish Art in the 20th Century,
Edinburgh and London: Mainstream, 2001.

McCormick Edwards, Lee
Herkomer, A Victorian Artist,
Ashgate: 1999.

McGonagle, Declan, O'Toole, Fintan and Levin, Kim
Irish Art Now: From the Poetic to the Political, exh. cat.,
New York: Independent Curators International, 1999.

Malvern, Sue
Modern Art, Britain and the Great War,
New Haven & London: Yale University Press, 2004.

Nairne S and Serota N (eds)
British Sculpture in the Twentieth Century, exh. cat.,
London: Whitechapel Art Gallery, 1981.

National Gallery, London,
intro Erika Langmuir,
Companion Guide,
London: National Gallery, 1995, 2004.

Oliver, Cordelia
Joan Eardley RSA,
Edinburgh: Mainstream Publishing, 1988.

Owusu, Kwesi
Black British Culture and Society: A Text Reader,
London: Routledge 2000.

Palmer, AH
The Life and Letters of Samuel Palmer, Painter & Etcher.
London: Eric & Joan Stevens, 1972 (new ed).

Power, Mark
The Shipping Forecast.
London: Zelda Cheatle Press, with Network Photographers, 1996.

Read, B and Skipwith, P
Gibson to Gilbert, British Sculpture 1840–1914,
London: The Fine Art Society, 1992.

Read, B and Skipwith, P
Sculpture in Britain Between the Wars,
London: The Fine Art Society Ltd, 1986.

Richards J with McGonagle D et al.
Irish Art Now: From the Poetic to the Political, exh. cat.,
Dublin: Irish Museum of Modern Art, 1999.

Merrell Holberton, 1999. Rowan, Eric
Art in Wales: An Illustrated History, 1850–1980,
Cardiff: Welsh Arts Council & University of Wales Press, 1985.

Schwab W and Weiner J (eds)
Jewish Artists: the Ben Uri Collection,
London: Ben Uri Art Society with Lund Humphries, 1994.

Spalding, Frances
British Art Since 1900,
London: Thames & Hudson, 1986.

Tickner, Lisa
Modern Life and Modern Subjects,
London and New Haven: Yale University
Press, 2000.

Timmers, Margaret
*Impressions of the 20th Century: Fine Art
Prints from the V&A Collection*,
London: Victoria & Albert Museum, 2001.

Treble, Rosemary, (intro.)
Great Victorian Painters, exh. cat.,
London: Arts Council of Great Britain,
1978.

Treuherz, Julian
Victorian Painting,
London: Thames & Hudson, 1993.

Various authors
The Slade MDCCCXCIII–MDCCCCVII,
London: Clay & Sons, 1907.

Various authors
*Kunst im Exil in Großbritannien
1933–1945*,
Berlin: Frölich & Kaufmann, 1986.

Upstone, Robert, and others
William Orpen: Politics, Sex and Death,
London: Tate Britain, Imperial War
Museum and Philip Wilson, 2005.

Usherwood, Paul, and Spencer-Smith,
Jenny, *Lady Butler, Battle Artist 1846–1933*,
London: Alan Sutton with The National
Army Museum, 1987.

Warner, Oliver
British Marine Painting,
London: Batsford, 1948.

Watkins, Jonathan *et al.*
*Some of the Best Things in Life Happen
Accidentally: The Beginning of Ikon*,
Birmingham: Ikon Gallery, 2004.

West, Shearer
Portraiture,
Oxford: University Press, 2004.

Whittle, Stephen, *et al.*
Creative Tension: British Art 1900–1950,
exh. cat.,
London: Museums of Oldham, Preston,
Bolton & Rochdale, Paul Holberton, 2005.

Wilkinson, Alan G
The Drawings of Henry Moore, exh. cat.,
London: Art Gallery of Ontario, Canada
and Tate Gallery, 1977.

William AG and Brown A
The Bigger Picture,
London: BBC Books, 1993.

Vann, Philip
Face to Face,
Sansom & Company, 2004.

Yorke, Malcolm
*The Spirit of Place: Nine Neo-Romantic
Artists and their Times*,
London: Constable, 1988.

www.crawfordartgallery.com
1800–1900: a splendid archive-based
account of the impact of art and art edu-
cation on the city of Cork.

www.tate.org.uk/tarzantorambo
(tateonline).

Articles
Hart, Keith
'It's falling apart at the seams',
Times Higher Education Supplement,
3 Sept 2004, p. 22.

Register of Artists

Ackroyd, Norman (b 1938)
Adam, Robert (1728–92)
Adler, Jankel (1895–1949)
Agar, Eileen (1899–1991)
Airey, Anna (1882–1964)
Andrews, Michael (1928–95)
Appel, Karel (1921–2006)
Archipenko, Alexander (1887–1964)
Armitage, Ken (1916–2002)
Armour, Mary (1902–2000)
Arp, Jean (1887–1966)
Auerbach, Frank (b 1931)
Ayres, Gillian (b 1930)
Ayrton, Michael (1921–75)

Bacon, Francis (1909–92)
Badmin, SR (1906–89)
Barry, James (1741–1806)
Bastien-Lepage, Jules (1848–84)
Bawden, Edward (1903–89)
Bayes, Walter (1869–1956)
Beardsley, Aubrey (1872–98)
Bell, Vanessa (1879–1961)
Bellany, John (b 1942)
Berg, Adrian (b 1929)
Bewick, Thomas (1753–1828)
Billingham, Richard (b 1970)
Bine, Muirhead (1876–1953)
Bissill, George (1896–1973)
Biswas, Sutapa (b 1962)
Blackadder, Elizabeth (b 1931)
Blackburn, David (b 1939)
Blake, Peter (b 1932)
Blake, William (1757–1827)
Blik, Maurice (b 1941)
Bloch, Martin (1883–1954)
Bomberg, David (1890–1957)
Bone, Muirhead (1876–1953)
Bonington, Edward Parkes (1802–28)
Boty, Pauline (1938–66)
Boyce, Sonia (b 1962)
Bramley, Frank (1857–1915),
Brangwyn, Frank (1867–1956)

Branscusi, Constantin (1876–1957)
Bratby, John (1928–92)
Brickdale, Eleanor Fortescue (1871–1945)
Brocquy, Louis Le (b 1916)
Brodzky, Horace (1885–1969)
Brown, Ford Madox (1821–93)
Brown, Fred (1851–1941)
Brun, Christopher Le (b 1951)
Buckland Wright, John (1897–1954)
Burne-Jones, Edward (1833–98)
Burra, Edward (1905–76)
Butler, Reg (1913–81)

Cadell, FB (1883–1937)
Calder, Alexander (1898–1976)
Cameron, DY (1865–1945)
Cameron, Julia Margaret (1815–79)
Camp, Jeffery (b 1923)
Camp, Sokari Douglas (b 1958)
Campbell, Ken (b 1939)
Campbell, Steven (b 1954)
Canova, Antonio (1757–1822)
Caro, Antony (b 1924)
Carrington, Leonora (b 1917)
Carson, Rosemary (b 1952)
Cattrell, Louise (b 1957)
Cézanne, Paul (1839–1906)
Chadwick, Helen (1953–96)
Chadwick, Lyn (1914–2003)
Chagall, Marc (1887–1985)
Chambers, Eddie (b 1960)
Chantrey, Sir Francis (1781–1841)
Chapman, George (1908–93)
Christo (b 1935)
Clausen, George (1852–1944)
Clough, Prunella (1919–90)
Coldstream, Sir William (1908–87)
Colquhoun, Ithell (1906–88)
Colquhoun, Robert (1914–62)
Colvin, Callum (b 1961)
Conder, Charles (1868–1909)
Constable, John (1776–1837)

Cooper, Alfred Egerton (1883–1943)
Copley, John Singleton (1738–1815)
Cotman, John Sell (1742–1842)
Courbet, Gustave (1819–77).
Cowie, James (1886–1956)
Cowper, Frank Cadogan (1877–1958)
Cozens, John Robert (1752–97)
Creffield, Dennis (b 1931)
Currie, Ken (b 1960)
Cuyp, Aelbert (1629–91)

Dadd, Richard (1817–66)
Dalwood, Hubert (1924–76)
Danby, Francis (1793–1861)
Davie, Alan (b 1920)
Davies, Douglas
de Morgan, Evelyn (1855–1919)
Dean, Tacita (b 1965)
Degas, Edgar (1834–1917)
Delacroix, Eugéne (1798–1863)
Derain, André (1880–1954)
Dick (RT) Cowern (1913–86)
Dimond, Phyllis
Dine, Jim (b 1935)
Dixon, James (1887–1970)
Dobson, Frank (1886–1963)
Dodd, Francis (1874–1949)
Doherty, Willie (b 1959)
Donatello (1386–1466)
Doré, Gustave (1832–83)
Drummond, James (1816–77)
Drury, Chris (b 1948)
Drury, Paul (1903–87)
Dunbar, Evelyn (1906–60)
Dyce, William (1806–64)
Dyck, Sir Anthony van (1599–1641)

Eardley, Joan (1921–63)
Eastlake, Sir Charles (1793–1865)
Ellis, Clifford (1907–85)
Emin, Tracey (b 1963)
Epstein, Jacob (1880–1959)
Ernst, Max (1891–1976)

Gallery Contact Details

Aberdeen Art Gallery
Schoolhill
Aberdeen AB10 1FQ
+44(0)1224 523 700
+44(0)1224 632133
info@aagm.co.uk
www.aagm.co.uk

The Bridgeman Art Library
17–19 Garway Road
London W2 4PH
+44(0)207 727 4065
+44 (0) 207 792 8509
london@bridgeman.co.uk
www.bridgeman.co.uk

Cartwright Hall Art Gallery
Lister Park
Bradford BH9 4HS
+44(0)1274 431 212
+44(0)1274 481 045
cartwright.hall@bradford.gov.uk
www.bradfordmuseums.org/ch/ch_main.htm

**Ernest Zobole Gallery School of
Humanities & Social Sciences**
University of Glamorgan
Pontypridd CF37 1DL
+44(0)1443 828 812
+44(0)1443 822 055
enquiries@glam.ac.uk
www.glam.ac.uk/gallery/

Imperial War Museum
Lambeth Road,
London SE1 6HZ
+44(0)207 416 5320
+44(0)207 416 5374
mail@iwm.org.uk
www.iwm.org.uk

The John Davies Gallery
Stow-on-the-Wold
Gloucestershire GL54 1BB
+44(0)1451 831 698
+44(0)1451 870 750
daviesart@aol.co.uk
www.the-john-davies-gallery.co.uk

National Gallery of Scotland
The Mound
Edinburgh EH2 2EL
+44(0)131 624 6200
+44(0)131 220 0917
enquiries@nationalgalleries.org
www.natgalscot.ac.uk

Red Rag Gallery
Church Street
Stow-on-the-Wold
Gloucestershire GL54 1BB
+44(0)1451 832 563
mail@redraggallery.co.uk
www.redraggallery.co.uk

Royal Academy of Arts
Burlington House
Piccadilly
London W1J OBD
+44(0)207 300 8000
+44(0)207 300 8001
webmaster@royalacademy.org.uk
www.royalacademy.org.uk

Tate Enterprises Ltd
Millbank
London SW1P 4RG
+44(0)207 887 8888
+44(0)207 887 8878
visiting.britain@tate.org.uk
www.tate.org.uk

Walker Art Gallery
William Brown Street
Liverpool L3 8EL
+44(0)151 478 4199
+44(0)151 478 4190
thewalker@liverpoolmuseums.org.uk
www.liverpoolmuseums.org/walker/

Index

Index of Illustrations